For a long time now Constable has been ranked as a major figure in the history of landscape painting in Europe, but hitherto he has received little attention as a draughtsman. His paintings are acknowledged to be among the most original of his time. Some of his drawings are just as deserving of recognition. This book is the first to be devoted exclusively to his landscape drawings, and the 150 examples of his work reproduced here will give a fair idea of his range and power as a draughtsman.

The study has been arranged to provide a chronological survey of his development, as far as possible year by year, from his earliest known work to the last great drawings of his final years. This is presented almost as a narrative, for with Constable it is hardly possible to understand his art without knowing something of his life.

Many of Constable's finest drawings are in the Victoria and Albert Museum and the British Museum. These collections are well represented in this book, but when a choice has been possible, drawings from less well-known public collections and from private sources have been selected for illustration. As a result, seventy of the drawings shown here have not been published before.

Among the illustrations are examples of work by some of those who influenced Constable in his earlier years. The study concludes with a short section on the artist's sons, John, Charles, Alfred and Lionel, all of whom drew closely in the style of their father.

Ian Fleming-Williams, one of the organisers of the 1976 Constable Bicentenary Exhibition at the Tate Gallery, is also one of the editors of *John Constable: Further Documents and Correspondance*, published jointly by the Tate Gallery and the Suffolk Records Society. In the past few years he has contributed a number of papers on Constable to *The Burlington Magazine*, *The Connoisseur*, *Country Life* and other journals.

ISBN 0 905005 10 4

CONSTABLE LANDSCAPE WATERCOLOURS & DRAWINGS

Ian Fleming-Williams

CONSTABLE
Landscape Watercolours & Drawings

THE TATE GALLERY

Exclusively distributed in France and Italy by Idea Books
46–8 rue de Montreuil, 75011 Paris and Via Cappuccio 21, 20123 Milan

ISBN 0 905005 10 4
Published by order of the Trustees 1976
Copyright © 1976 Ian Fleming-Williams
Designed and published by the Tate Gallery Publications Department,
Millbank, London SW1P 4RG
Printed in Great Britain by the Westerham Press, Westerham, Kent

In England, the paintings of Constable are probably more widely known and appreciated than those of any other artist. For many in this country his pictures epitomize English landscape. To no other artist's birthplace and native countryside is there a comparable summer pilgrimage. No other painter has provided the manufacturers of fancy goods–greetings cards, table-mats, tea-towels, china–with so much pictorial material. This popularity is based on a comparatively small number of his pictures, chiefly on works such as 'The Cornfield' and 'The Hay Wain' which he had painted for exhibition with a public in mind.

Constable's reputation as an artist of European stature is more broadly based. In this reckoning, besides his major works and the large unfinished paintings that were sometimes preparatory material, the estimation is founded principally on a knowledge of his smaller exhibition pictures and the many oil-sketches he painted for his own purposes. To a certain extent his work as a draughtsman has added something to this more informed view, but on the whole he has been recognised mainly as a painter, and it has tended to be his watercolours and more freely painted wash studies that have attracted notice. As a landscape draughtsman *per se* he has received comparatively little attention. Recent studies and publications have begun to change our ideas about him in this respect. They have shown that he was a relatively prolific draughtsman (though not of Turnerian fecundity), that he produced a remarkable variety of work, and that his drawings played a much more important part in his development than had previously been realised.

Our ideas of Constable as a man have also been radically changed in recent years, chiefly by the publication of the correspondence by the Suffolk Records Society.[1] Until the appearance of these eight volumes of letters and documents, all we knew of him as son, husband, father and friend was what his colleague and close friend C.R. Leslie told us in his *Memoirs of the Life of John Constable*, 1843.[2] Leslie's *Life* is a minor classic and will always remain essential reading for a full understanding of the artist, but the wealth of new material brings us closer to Constable the man than was before possible. It also brings us nearer to his art. Indeed when these are studied together in the light of present knowledge there very soon comes a time when it no longer seems possible, were it even desirable, to see the two apart.

Constable was slow to discover the nature and depth of his own genius. This was partly because in his youth he was unacademic and excelled only in penmanship, but mainly because there was no readily available means for him to discover what it was that he wanted to express. For many town-bred young artists–Girtin and Turner for example–picturesque topography provided the discipline and basic vocabulary they needed for their training and advance as landscape draughtsmen. Derived as much from written works as from observation of nature, this was essentially an urban view of landscape, and as such well within the capacity of the town-dweller to comprehend. Constable was introduced to various forms of this urban aesthetic by the successive professional and amateur artists with whom he came into contact. He studied each in turn, but none appears to have agreed with his experience of landscape as a countryman and although he learned something from each, in the end he had very largely to create for himself a language which would enable him to become articulate. This took time. Just how long it took can be seen by turning over those pages of this book which illustrate the work of his early years, the years 1795–1813.

[1]For details see p.12. [2]See p.12.

The carving shown here (Fig.A) was cut into one of the timbers of the family windmill by Constable when he was a boy. An earlier drawing is known, a watercolour of a young girl with a dog in a landscape (c.1789) that is almost certainly by him, but Fig.A is the earliest of his signed and dated works to have survived. The watercolour of c.1789 was said by the artist's son Lionel to have been one of many such compositions that his father did at that time. It looks more like a copy from a print than an original design.[3]

The young copy and imitate spontaneously, and in Constable's day copying was regarded as both a natural and an essential part of an artist's early training. Constable's copy of Nicholas Dorigny's engraving after one of Raphael's cartoons (a large drawing, it will be noticed, see Fig.1) is his earliest signed and dated drawing. It was his work as a copyist that earned him the approval of his first mentor and patron, Sir George Beaumont (1753–1827), and throughout his life Constable continued to make copies of drawings and paintings by the artists he most admired (see Pls.24 & 37). Through copying, stroke by stroke, the young student learned by heart the components of a work of art. He also acquired a facility with pencil, pen and brush. This facility enabled him to imitate the styles of other artists, and to master the various representational systems.

The first work by a living artist Constable is known to have copied and imitated was that of the drawing master, engraver and antiquarian topographer, J.T. Smith, whom he met in 1796. Until Constable enrolled at the Royal Academy Schools in the spring of 1799, he was largely dependent on Smith: for instruction and help with his work (for which there is no mention of remuneration in the Correspondence); for the supply of prints, drawings and books on art; and for the equipment – plaster casts, for example – which a young artist needed to set himself up. Fig.5, a copy of a drawing made by Smith during his stay with the artist's family at East Bergholt in 1798, shows how closely Constable was prepared to follow in his friend's footsteps. A comparison of the drawing of Little Wenham Church (Fig.6) with Smith's pen and wash drawing of a barn near Deptford (Fig.103) shows how completely he adopted Smith's manner. He was fortunate in his teacher. Smith's delicate handling was just the right model for one who was still feeling his way.

The only other identifiable influence on Constable as a draughtsman during this short period around the turn of the century is that of Ramsay Richard Reinagle (1775–1862), a young artist with whom he lodged for a time when he first came to London. The son of a painter, Philip Reinagle A.R.A., Ramsay Reinagle had exhibited at the Academy since he was a boy, and by the time Constable came to know him had already spent some years on the Continent. He was the second of Constable's new artist friends to be invited to Bergholt. Several of his pencil sketches have survived, together with a group of early

6 [3] Coll. Dr. Roy Pryce.

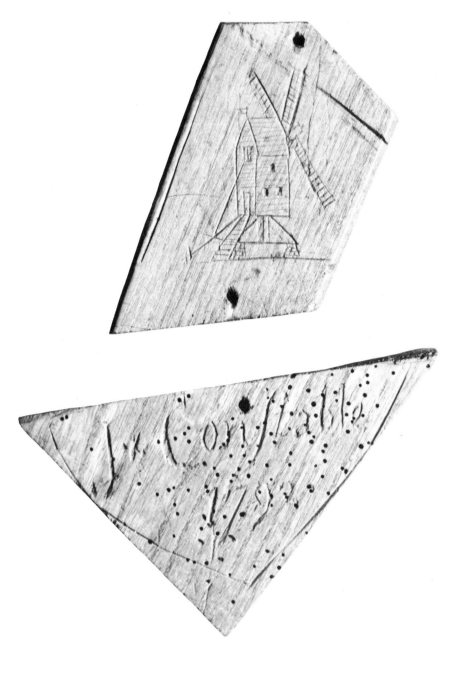

A. Two pieces of timber taken from the Constable family windmill on East Bergholt Heath
 i. Incised outline of a windmill, $4\frac{7}{8} \times 3\frac{3}{8}$ in (12.4 × 8.5 cm)
 ii. Incised inscription: 'J. Constable 1792'.
The Victor Batte-Day Trust, the Minories, Colchester

drawings by Constable (Figs.3 & 8) which had once belonged to the artist's nephew; two of Reinagle's drawings are signed and dated 1799, the year of his visit to Suffolk. Reinagle appears to have adopted what might be called the drawing-room style of draughtsmanship, a style derived from the followers of Gainsborough and Morland and popularised by many drawing masters of the day. For a short time Constable appears to have been impressed by Reinagle's displays of technical skill, and among the early drawings there is a small group in which he seems to have attempted the Reinagle manner. In one of these he is to be seen trying out Reinagle's type of shading – vigorous parallel strokes of the pencil. He adopted this simple device as of real value; later, for a while, it dominated his work with the pencil (see Pl.11; Figs.26 & 29).

We know too little of Constable as a student at the Academy to give a coherent account of his development during the next two or three years, but it is possible to recognise in his work the influence of some of those with whom he associated. At that time, black and white chalk on tinted paper was the medium favoured among students for drawing from the antique and from the living model. Most of Constable's known life drawings, both the early and the later ones, are in this medium. Until 1803, the Keeper at the Academy Schools, the only full-time instructor at the classes, was the elderly sculptor Joseph Wilton. He apparently disapproved of hard outlines, and it was his habit to smudge the offending part of his students' drawings with his spotless white ruffles, saying as he rubbed the black and white chalk together, 'I do not see these lines in the figure before you'.[4] It is likely that Constable took note of Wilton's strictures. Linear clarity is conspicuously absent from the earlier of his chalk life drawings, and his gradual dispensation with outline plays an important part in his development as a landscape draughtsman.

Wilton's successor at the Academy schools was the dynamic Swiss, Henry Fuseli, a sharply contrasting character who disliked what he called a niggling touch, and when making a correction on a student's drawing, would press with his porte-crayon right through the paper and leave a line scored in the board beneath. In his broken English the new Keeper advocated boldness of handling and a greater 'fweedom of tooch'.[5] Before he succeeded Wilton, Fuseli had apparently made use of the life classes at the Academy, for there are pen and wash drawings of the model by him dated 1800 and 1801 and inscribed 'Acc' (i.e. Academy).[6] His influence is to be seen clearly in a great number of the drawings of young women (several with elaborately coiffeured heads of hair) that Constable made later, in 1806, but it is perhaps to be detected also in the quality of the pen-line in his important study of Helmingham dated 1800 (Pl.1). In the Victoria and Albert Museum there is another drawing of the water-course at Helmingham, this time in black and white chalk on blue paper (R.57). This may or may not have been drawn during the same visit in 1800, but it is undoubtedly an attempt to adapt art school practice to study in the open air. Two drawings of Dovedale in the Royal

Museum of Fine Arts, Copenhagen, show that he had the same materials with him, chalks and blue paper, on his Derbyshire tour of the following year, 1801.

In the Victoria and Albert Museum there are twelve drawings from this tour of Derbyshire, and all are in pencil and wash. In none is there a trace of Reinagle's drawing-room style; instead, several could quite easily be mistaken for the work of that very different personality, Sir George Beaumont. In the spring of this year, 1801, Constable had broken with Reinagle and turned to the two elders, Beaumont and his friend Joseph Farington (1747–1821). In 1800 Beaumont had granted him copying facilities in the gallery of his London home; now, a year later, Constable once again took to studying in the gallery and was fired with renewed enthusiasm for his art. In his time, Beaumont was as well known as an artist (though of course an amateur) as he was as a collector, patron, and connoisseur, and his drawings reflect an impeccable training – Alexander Cozens at Eton, John Malchair at Oxford, J.R. Cozens in Italy. In Derbyshire, Constable found Beaumont's manner – cursive looped outlines and two- or three-tone washes – both easy to recall and readily adaptable to the scenes he wanted to record (see Figs.12 & 104).

Beaumont performed a further service in introducing Constable to the work of Thomas Girtin (1775–1802), of whose watercolours there were some thirty examples in his collection. C.R. Leslie tells us that Beaumont advised Constable to study these watercolours for their great breadth and truth. This advice Constable appears to have taken to heart, for very few of his drawings are merely imitative of Girtin's personal style (see Pl.7) and over the next few years there is to be seen in his work a broadening of vision and a new freedom of handling that could well have stemmed from Girtin's later paintings in watercolour (Fig.19): he begins to use watercolour as a medium for painting, not merely for tinting. The view of Eton (Pl.2) is a fair example of this new departure.

An artistic presence that appears to have haunted the minds of Suffolk artists at this time was that of Thomas Gainsborough (1727–88). Although he had moved to Bath long before – in 1759 – Gainsborough had made the countryside around Sudbury, where he was born, and Ipswich, where he had lived, quite inescapably his own, and no young artist of Constable's sensibility could fail to see him 'in every hedge and hollow tree'.[7] Constable's debt to Gainsborough is not difficult to detect in some of his oil paintings; it is less easy to estimate the extent to which he was influenced by him in his drawings. One of Constable's sketching companions on his vacations was the Ipswich artist George Frost (1745–1821), an ardent admirer of Gainsborough, whose

[4] W.T. Whitley, *Art in England: 1800–1820*, 1928, pp.81–2.
[5] loc. cit.
[6] See *Henry Fuseli*, Tate Gallery, 1975, Nos. 199 and 200.
[7] Constable, in a letter to J. T. Smith, 18 August 1799, JCC II, p.16.

work he collected, copied and imitated (see Fig.107). Constable, we know, had a number of Frost's drawings in the manner of Gainsborough in his possession. Until quite recently, a number of these Gainsborough-like chalk drawings by Frost were thought to be examples of Constable's early work. It is still an open question which of the drawings in Gainsborough's manner previously attributed to Constable are his and which are not. Unfortunately, there is not one drawing of this kind which is indisputably by Constable.

Although drawing played an important and sometimes vital part in Constable's working life, most of his advances beyond the frontiers of conventional landscape imagery were made in colour with the oil medium. Only twice in his formative years does he appear to have resolved some of his problems for the first time on paper: in 1805–6 in watercolour (see Pls.5–9; Figs.16–24); and in the summer of 1813, with a pencil in a little sketchbook smaller than a post-card (see Figs.31 & 32; Pls.15a–e).

Apart from his known study of Girtin, it is not possible to account for the rapid development in Constable's watercolour painting and the consequent extension of his vision in 1805–6 by reference to any other artist than Constable himself. Up to now, there had been singularly little homogeneity in his work; he appears to have been constantly shifting his ground, imitating this and that hand, trying out successive techniques. Now, from drawings such as the 'Stour Valley' of November 1805 (Pl.5), we can follow him almost step by step through to the remarkable watercolours of the Lake District that he made in the autumn of 1806 (Pl.9; Fig.23). In so doing we find ourselves witnessing the emergence of a new personality.

Of equal originality is the series of pencil drawings that he made during his tour of the Lakes. A draughtsman in the field is faced with the problem of deciding how many of what sort of marks have to be made on the paper in order to convey the notion of foliage, when every normal tree or bush carries leaves of a number it is beyond the power of man to compute. When using pen, pencil or chalk, most landscape artists have adopted the etcetera principle to overcome the difficulty. This is a principle in which a few represent the many, a relatively few repeated marks – loops, comma-like touches, scallops, dots and so forth – indicating the presence of a multitude of leaves angled in an innumerable number of ways, there being present a silent and tacitly understood, 'etc'. Until now, Constable had been using one or another of the current conventions for foliage which adopted this principle: Smith's delicate separate touches; Reinagle's bold calligraphy; the cursive loops and scallopings of Sir George Beaumont. When sketching in the Lakes he approached the problem from quite a new direction. In some of his drawings of 1805 and in others presumably of the same period, he had begun to build up the shapes of his trees from simple geometrical forms – spherical, elliptical and ovoid – seeing them sculpturally, as volumes rather than as areas of varying texture (see Pls.4 & 5; Fig.15). It is not at present known whether this was his own idea or one that he had adapted from another source, but perhaps it

was no coincidence that the musician Dr William Crotch (1775–1847), a pupil of the Oxford teacher of drawing, Malchair, and a talented artist, had noted a system for the drawing of trees based on a similar schema in 1803 (see Fig.105), and that Constable had come to know Crotch soon after the latter's arrival in London from Oxford in December 1805. In some of Constable's Lake District pencil drawings the initial outlines of the trees are geometrically rounded. In Pl.8 and Fig.22, both probably of Borrowdale, he experiments further, stressing with the new strongly diagonal shading – also a new development–the globular volumes of the trees. In views such as these there is hardly an allusion to leafage. In its most extreme form, this phase of his development does not appear to have lasted for very long, but from time to time in his later work it is possible to detect a reversion to the system, somewhat modified, (see Fig.32 & Pl.18), and in the paintings of his maturity it is always possible to sense his profound understanding of trees as forms in space.

In this year, 1806, Constable produced an unprecedented number of drawings. After this there follows a gap of five years, during which he hardly appears to have drawn at all, a cessation for which it is difficult to offer a reasonable explanation. The next dated drawings are of 1811. Some of these are in black and white chalk on tinted paper (see Pl.11; Fig.26), a medium he does not seem to have used again for landscape after 1812. With one exception (see Pl.10), all the dated drawings of these years are in pencil or chalk; we do not find him using watercolour again with any frequency for some time.

It was with his drawings in the little sketchbook of 1813 that Constable reached maturity as a draughtsman. Here he becomes recognisably 'Constable' (see Figs.31 & 32; Pls.15a–e). This is arrived at quite suddenly, and the lead up to it seems to have taken no more than a few days, but drawings such as the 'Dedham from Langham' (Pl.14) suggest that the momentum which had carried him forward towards this moment of achievement had in fact been building up for some time. Leslie tells us that at this time Constable used to accompany Thomas Stothard R.A. (1755–1834) on his rambles into the country round London. Though it is not possible to say exactly what it is in Constable's drawings of this period that echoes the pencil and watercolour landscapes of Stothard, there is a gentle firmness of touch and a directness of vision in Constable's drawings of 1812–13 which is not to be seen in work of the preceding years, and this could well have derived from these sketching excursions into the countryside with the older man (for an example of Stothard's watercolour drawing, see Fig.108).

Hitherto, the story of Constable's development as a draughtsman has been one of a succession of influences interspersed with his own adaptations and inventions. After 1813 the intensity of his powers of perception, exceeding that of any others with whom he came into contact, appears to have rendered him relatively impervious to further external influence; henceforth, changes and

8

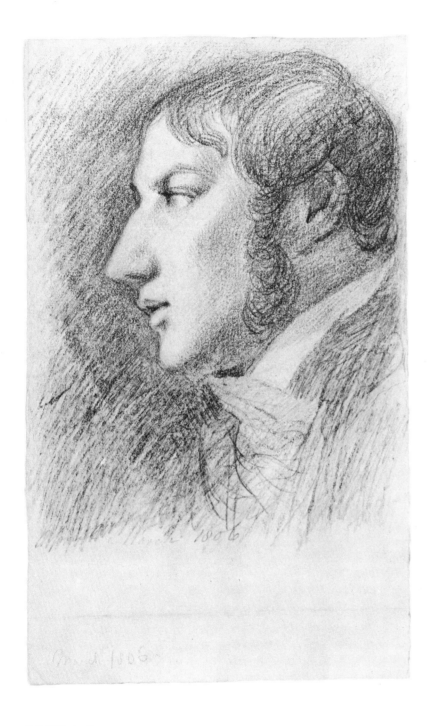

developments originated very largely from within himself.

He began to experiment with his new way of drawing and it proved adaptable. The following summer, 1814, in another small sketchbook, he again made numerous sketches and notes, some of which were similar to those of the previous year, but of which others were drawn with much greater force of expression (Pls.17a & b) and with a clearer sense of purpose (Pls.17c & d; Figs.35 & 36). He started to work on a larger scale and to produce finished pencil drawings that were works of art in their own right. In the Academy of 1815 he had eight works on exhibition;[8] three of his exhibits – Nos.415, 446 & 510 – were drawings so described in the catalogue, and it is very possible that one of these was the view of his father's fields (Pl.18). A similar drawing of East Bergholt Church in the Victoria and Albert Museum (R.177) could well have been another of these exhibits.

Like a marksman on a day when he finds that he cannot miss the target, Constable could now draw with a quite extraordinary degree of accuracy. Hardly ever is it possible to detect tentative exploratory touches in his work; seldom are there signs of correction or erasure. Proof of his sureness of eye and touch can sometimes be obtained by comparing one of his drawings with an original subject that has changed little since his day (see Figs. 39 & 40). In our present day rating, skill of this order does not necessarily rank very high, but for Constable it was an essential part of his equipment and its attainment a major step towards freedom. The magnificent study of elm trees (Pl.22 & Fig.43) could not have been achieved without it.

It is now almost certain that this drawing was exhibited at the Academy of 1818 as, '483. Elms'. No.446 in the same catalogue was described as 'A Gothic Porch'. This, too, was doubtless a pencil drawing, possibly the 'East Bergholt Church' in the Courtauld Institute (Pl.21), but more probably the equally fine study of the south porch of the church in the Huntington Gallery.[9] Constable was never to surpass some of the drawings he made in pencil during the period 1817–21. Many of his watercolours and wash drawings of later years are of comparable quality and possibly rather more striking, but though a master of the watercolour medium, in the main a graphite pencil seems to have provided him with all he needed for the coverage of a whole range of moods and types of subjects. In his sketchbook of 1813 he had found that he could if he wished convey a sense of colour with the pencil. There is 'colour' in many of the drawings of this period, and one feels that some of his pencil sketches of the 'thirties might have been more colourful, had he not given them their washes of blue, green and red.[10]

[8] Two of these, 'Boatbuilding', Fig.117, and 'View of Dedham' – now known as 'Stour Valley and Dedham Village', Fig.116 – were based on studies in the sketchbook 1814.
[9] Repr. *John Constable Drawings and Sketches*, Henry E. Huntigton Library and Art Gallery, California, 1961, No.23, Pl.2.
[10] The pencil and watercolour drawing in the Victoria and Albert Museum, 'The Ruins of Cowdray House' (R.369), which looks so well when reproduced in black and white, for example.

As we have seen, many of Constable's earliest drawings are in pencil, pen and wash. After 1806, it was not until 1821 that he took to using this medium again at all frequently. Initially, he appears to have employed wash over pencil to indicate tone when there was not sufficient time to shade with the pencil-point (see Figs.51 & 53), but in 1824 he was asked to prepare a set of drawings of Brighton beach scenes for engraving and publication, and this started him off on a series of pen and wash studies of life along the shore. These seem to have been drawn in pencil, probably from sketches made on the spot, and then worked up with carefully executed flat washes and with pen or fine brush-point outlines in the same medium. It was while he was at work on this commission that Constable began to plan his next large painting, 'The Leaping Horse'. His first compositional sketches for this work, two of his greatest drawings (Pls.35 & 36), were in the same grey ink and wash, probably because the materials were conveniently to hand in his painting room.

With Constable one has to be prepared for the unexpected. Fig.1 in this book is a copy of an engraving after one of Raphael's cartoons. We have examples of him copying a painting by Salvator Rosa in 1811 (Fig.25), an etching by Ruisdael in 1818 (Pl.24a), and noting a painting by the Dutchman the following year (Pl.24c). We illustrate an apparently faithful copy of a drawing by Claude dated 1825 (Pl.37), and one of his copies of George Lewis's engravings after Claude (Fig.63). All these show him either noting pictures or making close copies of the originals. A chalk drawing recently purchased by the Tate Gallery, 'Landscape with trees and a church tower', shows that he could invent a scene in the style of another artist, in this case Gainsborough, and was not averse to putting his own name to it.[11] It nevertheless comes as something of a surprise to find him apparently planning an important new painting, a view of Flatford Lock, as if it were not himself but another at work, and that none other than the master he revered above all, Claude Lorrain (see Pl.38).

In 1827, Constable and his two eldest children spent a fortnight with his brother and sister, Abram and Mary, at Flatford Mill. It was his first holiday there for ten years and his children's first visit ever to Suffolk; they were 'overcome with delight' at all they saw. For a number of years he had been re-living his Suffolk life during the painting of each in turn of his great exhibition works. From the presence of children in most of these paintings (in the planning stage, if not in the final version), as well as from things he said, it is evident that much of this re-living was an evocation of his childhood. It must therefore have been a moving as well as a slightly unsettling experience to see his own son and daughter in the familiar surroundings, playing, fishing and riding as he had done as a boy and much as he had painted the children doing in his pictures. One or two of the drawings he made during this holiday of 1827 could have been drawn on any of his previous visits (Pl.39), but the remainder are unlike any that he had done there before and seem to reflect an emotional change of some sort. Though

sentimental in feeling, some of these are of undoubted charm (Fig.66), but in others–a drawing of men loading a barge in the Victoria and Albert Museum (R.300) for instance–the sentiment seems merely incongruous.

His next group of Suffolk drawings are similar in feeling. These were done five years later, in 1832, when he took his eldest daughter there to recuperate from an illness. The three dated examples from this group in the Victoria and Albert and British Museums (R.338, 339 & L.B.19a) are in pen and watercolour. They do not look like the work of one able to rest his eye contentedly on what he sees. There is the same unhappy feel about a pen and watercolour sketch of the thatched cottage by the footbridge at Flatford dated 12 November 1832 (R.346). He was there for the funeral of his one-time assistant Johnny Dunthorne, the son of his old Bergholt painting companion, John Dunthorne. This is the last dated drawing of Suffolk.

From the foregoing it should not be concluded that Constable's love of his native countryside had faded or that the scenes of his boyhood had ceased to be an inspiration. The familiar views were still firmly fixed in his head and he appears to have drawn frequently on his memory[12] and upon his store of sketches when in need of a subject for a composition (Pls.44, 47a & b).

After the death of his wife in 1828 Constable virtually abandoned the practice of working in oils out of doors. His last dated oil-sketches are those he painted in 1829 on the final visit to Salisbury.[13] All the thirty or so remaining dated or datable colour sketches from nature are in watercolour. This affected his choice of works to be sent to the Academy. Between 1818 and this last period he appears to have shown oils only. In the years 1832–6 more than half of his exhibits were watercolours and drawings.

In these last years Constable appears to have relied largely on changes in his surroundings to stimulate him into action with his pencil or paint-box of watercolours. His eldest boy was seriously ill at a school in Folkestone; he remained there for a fortnight, and we have a delightful group of watercolours of the harbour and shore (Pl.46; Fig.79). A new friendship took him to Arundel for a holiday and there awoke in him a feeling for landscape which had for some years lain dormant (Pl.48). He was invited to Petworth, and in the surrounding country drew and painted again contentedly (Pl.49). He lectured at Worcester; the visit was commemorated by drawings.

Illness and his responsibilities, social and domestic, took up much of his time in the final years. His motherless children were a prime source of pleasure, but also of anxiety. The attention which he felt to be their due was

[11] 'Landscape with Trees and Church Tower', black and white chalk on blue paper, $6\frac{7}{8} \times 8\frac{5}{8}$ in (17.5 × 21.8 cm), inscr. 'John Constable', Tate Gallery, 1971 (T.1497).

[12] 'Flatford Old Bridge and Bridge Cottage', in the Victoria and Albert Museum (R.324),

for example.

[13] 'A View at Salisbury, from the library of Archdeacon Fisher's house, dated 12 July 1829, and 'The Close, Salisbury', of 15 July 1829, both in the Victoria and Albert Museum (R.311 & 312).

also time-consuming. However, they appear to have been responsible, directly and indirectly, for two of his most important late works, 'Arundel Mill and Castle' (Fig.123) and 'Stonehenge' (Pl.51): the first having been painted on request for his eldest son, John; and the second, the greatest of his water-colours, in the wake of his son Charles' departure on his first voyage to India.

His last known dated drawing from nature is a pencil study of a stream near Bewdley, Worcestershire, inscribed 'Bowlis brook Oct 15 1835'.[14]

Constable drew for many reasons. During his years at the Royal Academy Schools he drew from the antique and the living model for the purpose of study, a discipline from which the student acquired experience and skills considered applicable to professional practice. In his summer vacations he continued his studies in the open – in 1800 he was drawing in the solitude of Helmingham Dell as though it were a life class (see Pl.1). The need for study, the examination of a single object such as the bole of a tree or the observation of atmospheric change, remained with him all his life, and the results are to be seen scattered throughout his work – in oils as well as on paper (see Pls. 32a, b & 42).

Many of his drawings were intended as objects of art in their own right. The earliest of his identifiable exhibited works is a large and now much faded watercolour of the *Victory* at the Battle of Trafalgar which was shown at the Academy of 1806 (R.65). With his oil-painting, 'The Cenotaph', another watercolour, 'Stonehenge', was the last of his works exhibited at Somerset House. An exhibit of 1818, a pencil study of elms (Pl.22), suggests that on occasion he would draw directly from nature with the Academy in mind. There are drawings recorded which he gave away as presents. In 1800 he made a set of four large tinted views of Dedham Vale as a wedding-present for the daughter of a local parson (Fig.9); the watercolour of East Bergholt Church of 1811 (Pl.10) was also designed for presentation. Though finished with equal care, in a slightly different class are the drawings of boats and shore-life at Brighton and Worthing that Constable made for the engraver in 1824 (Pl.34, etc.).

We do not know which of Constable's early landscapes in oils were painted directly from nature and which were made from preparatory drawings, but by 1806 we find him squaring up large pencil sketches in order to transfer the design, presumably to canvas, and we know that by 1812 he was considering painting a picture for exhibition from drawings (see p.38). As he learned to accommodate himself to the annual cycle of public exhibitions, Constable in fact became increasingly dependent on the material he had collected in his sketchbooks, both for inspiration and for the motifs from which he built up his compositions. Two sketchbooks of 1813 and 1814 have survived intact and these are full of details, many of which he later worked into his big six-foot pictures. In the earlier of the sketchbooks he is also to be found spying out the landscape as a photographer might frame the scenes before him through his view-finder. He does not seem to have made much use of these little composed views, but in the sketchbook of the following year, 1814, there are full-page compositions (still on a miniature scale of course) which were later developed into some of his greatest paintings (e.g. Pl.17c & d). Also in this sketchbook are drawings made for a picture while the work is actually in progress (Pl.17a & b); he did not often revisit a scene to collect further material for a painting. It is rare, too, for him to make a detailed study specifically for a painting such as the drawing of the lock at Flatford (Pl.13). Most of the Suffolk drawings he used in the composing of his paintings had been drawn on the spot, their part being to remind him of the familiar scenes so that he could begin to reshape them pictorially. For one of his paintings, 'The Leaping Horse', the initial ideas seem to have begun to generate on paper (Pls.35 & 36).

Constable had other reasons for making drawings. He drew to record; to note a picture at an exhibition (Pl.24c), a plough or cart of a novel design, or the bare facts of a stretch of country observed on a walk (Pl.20). He drew to instruct, and sometimes to entertain. He drew in all moods, on occasion, one feels, in a state bordering despair. But above all, he drew for joy. For him, drawing was as much a part of life as seeing and feeling; it is our good fortune that he felt what he saw and was able to draw what he felt.

[14] In the possession of Messrs Spink & Sons, 1947.

The Artist's Sons: John, Charles, Alfred and Lionel

Before a working corpus of Constable's drawings is finally established it will be necessary to make a careful study of the work of his sons, all four of whom were capable of producing drawings that could be mistaken for his. Several dozen of their drawings are still in the family collection, but most of these are early examples of their work. It may be possible to identify with certainty a few more in public collections, such as the pencil study of a windmill in Christchurch Mansion, Ipswich, an enlargement of a drawing by Lionel Constable (see Fig.98), but it is likely that there are others, the authorship of which it might prove exceedingly difficult to substantiate. The position will undoubtedly clarify when we know more about his sons' later work. Here, we only have space to illustrate a few of their early drawings (Figs.97–102) and to offer the briefest of introductions to them as artists.

With John Charles, the artist's first-born (1817–41), we need hardly concern ourselves, as he died at an early age and as an artist was the least talented of the four. But even he made pen and pencil studies of shipping capable of misleading us into thinking they are scraps by his father. The next son, Charles Golding (1821–79), as a boy was passionately attached to the sea. In the family collection there is a very passable drawing of a dismasted vessel inscribed by his father: 'drawn by Charley – July 4.1835 – Rotherhythe Saturday afternoon'. This was drawn only a couple of months before Charles sailed for Bombay as a midshipman in his first ship, the *Buckinghamshire*. Most of his surviving drawings were made out East during the twenty-eight years he spent afloat; after his retirement from the Indian Navy in 1863 he seems to have done very little.

It is the work of Alfred Abram (1826–53) and Lionel Bicknell (1828–87), the third and fourth sons, which can be most readily mistaken for that of their father. Alfred is said to have been the more likely to become a professional artist, but it is in fact almost impossible to tell their drawings apart. Both exhibited at the Academy. Alfred showed eight works between 1847 and 1853, the year of his accidental death by drowning. In the same number of years, Lionel showed rather more, thirteen works between 1849 and 1855. It is said that the two brothers were inseparable and usually painted together, and that Lionel lost much of his ambition as an artist after his brother's tragic death. Both were talented, and both tried their best to draw and paint like their father. The extent to which they succeeded is sometimes quite disconcerting.

ABBREVIATIONS

Farington Diary	Unless otherwise stated, quotations from the Diary of Joseph Farington RA are taken from the typescript deposited at the British Museum.
JCC I[...VI]	*John Constable's Correspondence*, ed. R.B. Beckett I. *The Family at East Bergholt*, 1962. II. *Early Friends and Maria Bicknell, Mrs Constable*, 1964. III. *The Correspondence with C.R. Leslie*, 1965. IV. *Patrons, Dealers and Fellow Artists*, 1966. V. *Various Friends, with Charles Boner and the Artist's Children*, 1967. VI. *The Fishers*, 1968.
JCD	*John Constable's Discourses*, ed. R.B. Beckett, 1970.
JC:FDC	*John Constable: Further Documents and Correspondence*, 1975. Part I. *Documents*, ed. Leslie Parris and Conal Shields. Part II. *Correspondence*, ed. Ian Fleming-Williams.
MS.JCC[...etc.]	Indicates a fresh transcript from the original manuscript of the document published in the Correspondence.
Leslie, 1951	C.R. Leslie, *Memoirs of the Life of John Constable, Esq. R.A.*, 2nd, revised, edition of 1845; ed. Jonathan Mayne, 1951.
R. [followed by a number – e.g. R.262]	Graham Reynolds, *Victoria and Albert Museum, Catalogue of the Constable Collection*, 2nd edition, 1973. The number refers to the relevant catalogue entry.

ACKNOWLEDGEMENTS

I would like to express my gratitude to the owners and trustees of the drawings and paintings illustrated for their generosity in allowing them to be reproduced in this book. I am most grateful to the Westerham Press for their interest in the production of this book and for the care they have taken with the reproductions. I wish particularly to thank Leslie Parris and Iain Bain of the Tate Gallery for the help and encouragement during the writing and preparation of the work.

CONSTABLE LANDSCAPE WATERCOLOURS & DRAWINGS

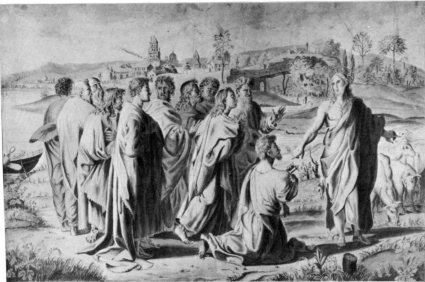

Fig. 1

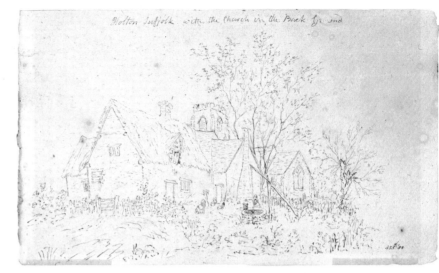

Fig. 2

Copy of an engraving by Nicholas Dorigny after Raphael's cartoon: 'Christ's Charge to Peter' Fig.1
Pen and wash, $19\frac{1}{4} \times 29\frac{3}{8}$ in (48.9×74.6 cm)
Inscr. 'John Constable del 1795'
Colchester, The Colchester and Essex Museum

This copy of one of Nicholas Dorigny's engravings of the Raphael Cartoons is the earliest known signed and dated drawing by Constable. Two further copies of the Dorigny engravings were in a family sale in 1892. In this year, 1795, Constable's mother obtained for him an introduction to the distinguished amateur artist, collector and connoisseur, Sir George Beaumont, who was staying with his own mother in Dedham on one of his annual visits. Sir George liked to carry around with him, in a special mahogany travelling case, his favourite painting by Claude, the exquisite little 'Hagar and the Angel' which is now in the National Gallery; this he showed to his visitor. Constable never forgot it. The Baronet was apparently pleased with the Dorigny copies, and when Constable came to London in 1799 he interested himself in the young man's career and allowed him to copy the paintings in his collection at his house in Grosvenor Square.[1]

A Cottage at Holton Fig.2
Pen and ink, $7\frac{1}{8} \times 11\frac{3}{4}$ in (18.1×29.9 cm)
Inscr. 'Holton Suffolk with the church in the Back Ground', and under the gable of the dormer window, 'J.C.1796'. From a dismembered sketchbook of fourteen pages.
London, Victoria and Albert Museum (R10)

In the summer of 1796 Constable stayed with an uncle at Edmonton, Essex, and there met J.T. Smith (1766–1833) who had attached himself to a circle of antiquarians and well-to-do connoisseurs.[1] Smith had been practising as a drawing master at Edmonton, but his father ran a print shop in St. Martin's Lane, and he was just about to set up in London as an engraver, in which craft he was already a skilled practitioner. The first of Constable's professional artist friends, Smith became the dominating influence during his development over the next few years. In 1796 Smith was issuing proposals for a book to be published the following year: *Remarks on Rural Scenery; With twenty etchings of Cottages, from Nature; and some observations and precepts relative to the pictoresque*. From Constable's letters it appears that Smith was still collecting examples of broken-down and otherwise picturesque cottages for the book, and it is likely that the sketch of Holton (Fig.2) was made by Constable in the hope that Smith might use it for one of his illustrations. 'I have in my walks,' he wrote on 27 October, 'pick'd up several cottages and peradventure I may have been fortunate enough to hit upon one, or two, that might please. If you think it is likely that I have, let me

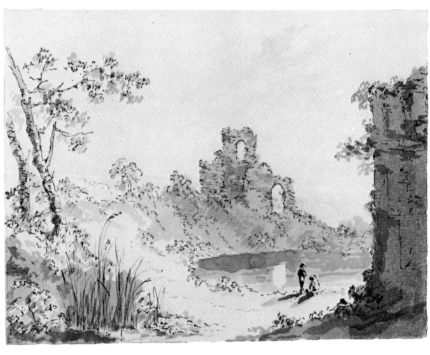

Fig. 3

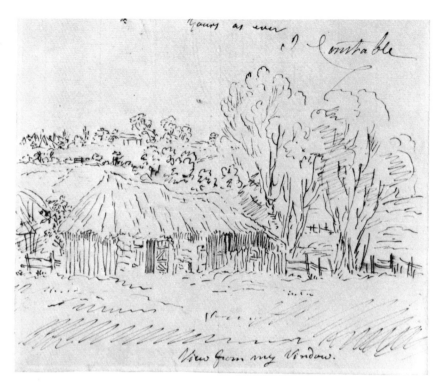

Fig. 4

know and I'll send you my sketchbook and make a drawing of any you like if there should not be enough to work from.'[2] Drawings of cottages were, in fact, sent by Constable to Smith, who apparently found some of them suitable for etching. None, however, appeared in his book.

Holton St. Mary, where Constable drew his cottage, is a small village just across the main London–Ipswich road from East Bergholt where Constable lived. At Holton Hall lived the Cooks, a family of farmers considered by the Constables to be 'true friends of all our family.'[3]

Landscape with a Ruin by a Lake Fig.3
Pen and black ink, grey wash, blue watercolour in the sky, $5\frac{3}{8} \times 7\frac{3}{16}$ in (13.7 × 18.2 cm)
Private collection

The undated drawing (Fig.3), plainly of an invented scene, could belong either to 1796 or to the next year; Constable does not seem to have used the pen in this manner, with such tense little scribbled touches, after 1797.

View from Golding Constable's House Fig.4
Pen and ink
Lower half of a letter to J.T. Smith; inscr. along bottom, 'View from my window'
From the collection of Mr and Mrs Paul Mellon

The letter, of which Fig.4 shows the lower half of the single sheet, was written early in 1797 to be enclosed with a perspective drawing Constable had been asked to return. The view he sketched was part of the panoramic sweep of countryside that he could see to the eastwards from his room at the back of the family home at East Bergholt. The house in which Constable was born had been built by his father. Completed in 1774, it stood in the middle of the village, with gateways on either hand, set back from the main street by the curve of the short drive, a square, three-storied, red-brick, comfortable-looking mansion. Behind, were Mrs Constable's flower-garden and the vegetable garden and then, beyond, the forty or so rolling acres that the Constables farmed. Not long after Constable made this drawing of their dilapidated old barn, his father built a fine new one, with double doors, an opening big enough for a loaded harvest waggon, and a threshing floor. This is to be seen, with the old one still in use behind it, in one of the two paintings that Constable later made of the wide vista that presented itself to him at that upstairs window (see Fig.109).

15

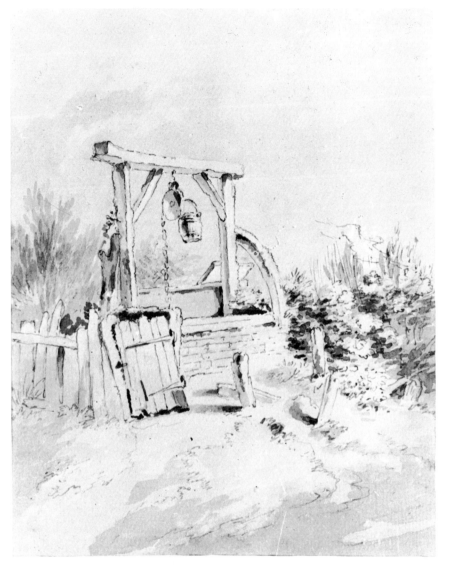

Fig. 5

Copy of a Drawing by J.T. Smith: Well on the Road to Ipswich Fig.5
Pen and wash, $7\frac{1}{2} \times 6\frac{7}{8}$ in (19.0 × 17.5 cm)
Inscr. 'Well on the road from E.B. to Ipswich done in a gig by J.T.S. & this is my copy from it'.
London, Courtauld Institute of Art (Witt Collection)

Little Wenham Church Fig.6
Pen and watercolour $5\frac{1}{2} \times 7$ in (14.0 × 17.8 cm)
Coll. Harold A.E. Day Esq.

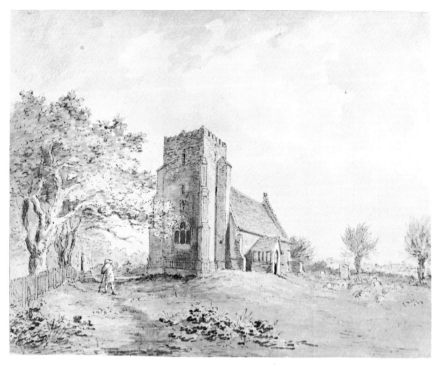

Fig. 6

Throughout this period Constable was working for his father in their corn and coal business, his elder brother, Golding, being unable to join the firm and Abram, the younger brother, as yet too young. As a drawing master, Smith must have had some experience of dealing with a pupil seized with romantic notions of becoming an artist. In Constable's case he seems to have handled the affair with some tact, persuading him to attend to business, and reassuring his family when he came up to London to see him. So successful was Smith, in fact, that in the autumn of 1798 he was invited to stay under the parental roof, at Bergholt. We know little of this visit; only that Constable introduced Smith to some of his friends and that (as we learn from an inscription, Fig.5) they stopped the gig when driving in to Ipswich so that Smith could draw a picturesque well-head.

The only drawing Constable is known to have dated this year (1798) is a tinted pen and wash study which recently came to light of a tomb in Little Wenham Church.[1] His watercolour of the church itself (Fig.6) is similar in style to the copy of J.T. Smith's well-head, as are several other of his drawings of about this time. Wenham is not far off the Ipswich road, well within range of Bergholt by gig, and certainly worth a visit for a visitor with antiquarian interests.

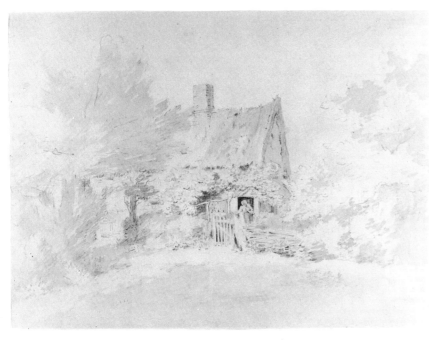

Fig. 7

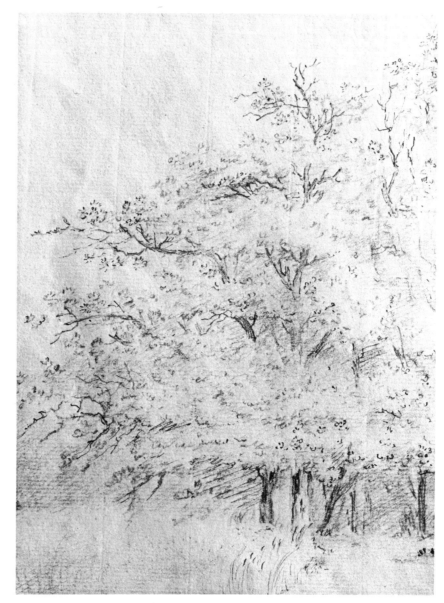

Fig. 8

A Cottage among Trees Fig.7
Pencil and grey wash, $9\frac{1}{2} \times 13$ in (24.1 × 33.0 cm)
Inscr. verso 'Letitia Proby 23rd. Sept: 1799'
From the collection of Mr and Mrs Paul Mellon

A Copse (detail) Fig.8
Pencil, pen and brown ink, $8\frac{7}{8} \times 12\frac{13}{16}$ in (22.5 × 32.5 cm)
Private collection

It is not known why Letitia Proby's name should appear on the back of the drawing of the cottage (Fig.6), but it is quite possible that she was the Miss Proby, daughter of the rector of neighbouring Stratford St. Mary, who was a friend of Mrs Elizabeth Cobbold, wife of a prosperous Ipswich brewer and one of Constable's earlier mentors. In February Constable left Bergholt for London, his father having agreed to let him study art. Armed with a letter of introduction from Mrs Priscilla Wakefield, whom he had met at Mrs Cob-

bold's, he presented himself at 35 Charlotte Street, the home of Joseph Farington, R.A. Farington helped him to gain admission to the Royal Academy Schools, and for the next few years Constable worked there as a student. Henceforth, the greater part of each year was spent in London.

The drawing of the copse, with some two dozen other examples of Constable's early work (see also Fig.3), comes from a portfolio of drawings that his sister Mary preserved and left to her nephew, The Revd Daniel Whalley.

17

1800

Helmingham Dell Pl.1
Pencil and grey wash, $20\frac{1}{2} \times 25\frac{1}{2}$ in (52.1×64.8 cm)
Inscr. '23 July 1800 Afternoon'
The Clonterbrook Trustees

Dedham Church and Vale, Suffolk Fig.9
Pen and ink and watercolour, $13\frac{5}{8} \times 20\frac{3}{4}$ in (34.6×52.7 cm)
Manchester, Whitworth Art Gallery, University of Manchester

Giffords Hall, Suffolk Fig.10
Pen and ink and watercolour, $11\frac{1}{4} \times 16\frac{13}{16}$ in (28.6×42.6 cm)
Private collection

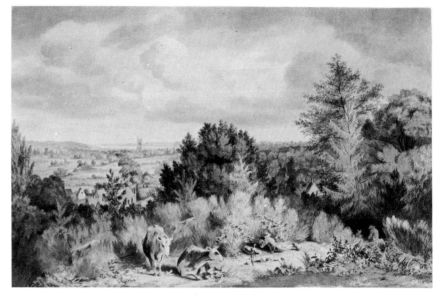

Fig. 9

'I am quite alone amongst the oaks and solitude of Helmingham Park', Constable wrote on 25 July to John Dunthorne, his painting crony at East Bergholt, 'There are abundance of fine trees of all sorts; though the place upon the whole affords good objects rather than fine scenery; but I can hardly judge yet what I may have to show you. I have made one or two drawings that may be usefull.'[1] In this drawing (Pl.1), the only known dated drawing of this year, we see Constable working before nature with a new assurance. For the past year he had been submitting himself to the rigours of academic discipline in the life-class of the Royal Academy Schools. In the shady water-course that wound its way through the park he appears to have found subjects to which his academic training enabled him to respond–the forms of the tree-trunks and the heavy branches bearing a likeness to human musculature. It is interesting to note how closely Constable's pencil-line resembles that of Henry Fuseli in the studies from life the Swiss artist was making at this time in the Academy Schools.[2]

In later life Constable painted at least three versions of 'The Dell', as he called it, all apparently based on this Helmingham study of 1800 (see Fig.110). Though a stone bridge has replaced the wooden one which Constable drew, the dell has not greatly altered since his day. The twisted tree to the right of the drawing can still be seen – stouter, but unmistakably the same oak.

The Whitworth drawing (Fig.9) is one of four views of the Stour valley which were given as a wedding-present by Constable in 1800 to Lucy Hurlock, the daughter of a local clergyman. The other three are in the Victoria and Albert Museum. All four remained with her descendants until 1934.

The drawing of Giffords Hall (Fig.10), to which only an approximate date of 1800 can be given, is Constable's earliest known country house portrait. Later, he was to paint a number of such views. The Hall is hardly more than five miles from Bergholt. An earlier building on the site, *c.*1200, was the work of one Richard Constable, possibly an ancestor.

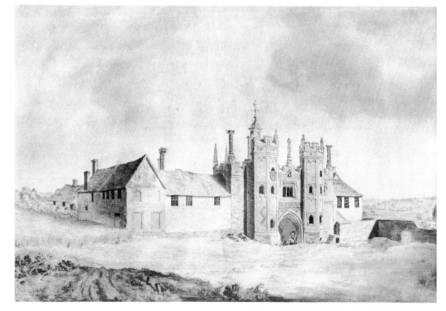

Fig. 1

18

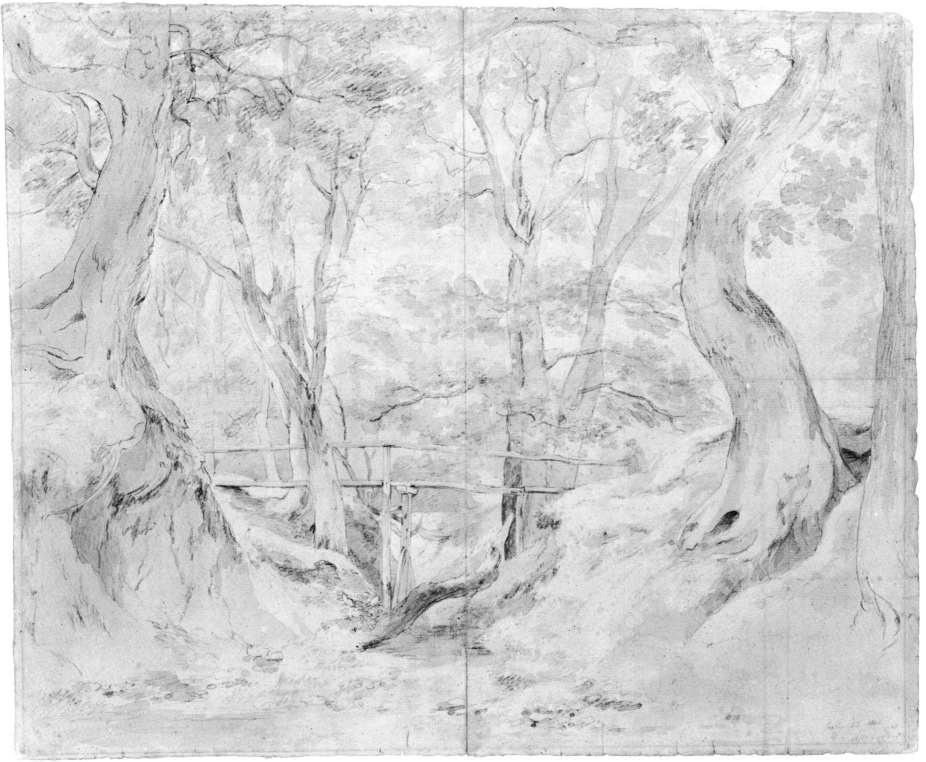

Pl. I

1801 and 1802

The Thames, with Eton College and Chapel Pl.2
Pencil and watercolour, $7\frac{1}{8} \times 14\frac{1}{4}$ in (18.1×36.1 cm)
London, Victoria and Albert Museum (R35)

View of Derwent Dale, Derbyshire Fig.11
Pencil and grey wash, $6\frac{5}{8} \times 10\frac{3}{8}$ in (16.8×26.3 cm)
Inscr. (in later hand over erased inscr.) 'Derwent Dale August 8 [18?]'
Manchester, Whitworth Art Gallery, University of Manchester

Chatsworth Park Fig.12
Pencil and brown wash, $6\frac{3}{4} \times 10\frac{1}{8}$ in (17.1×25.7 cm)
Inscr. 'Chatsworth Park Augst 17'
London, Victoria and Albert Museum (R24)

1801

Four months of this year – July to November – were spent by Constable with his sister's parents-in-law, the Whalleys, who lived at Great Fenton, Stoke-on-Trent, Staffordshire.[1] So far, the only drawings that have been identified from this period are those he made – about a score – during a two-and-a-half week's tour of Derbyshire with Daniel Whalley, one of his host's sons. The subjects he chose to record were of a conventional nature; the techniques he adopted no different from those currently employed by the general run of picturesque topographers. More than once we find him drawing in a manner closely resembling that of Sir George Beaumont (see Fig.104).

1802

Constable had met the second of his important early patrons, Dr Fisher, when the latter came to visit Langham, one of his parishes, in 1798. At this time a Canon of Windsor (later, of course, he became Bishop of Salisbury), Fisher seems to have taken an immediate liking to Constable. In May 1802, hoping thereby to further Constable's career, he arranged for him to be interviewed for a post as drawing master at the Military College by its Governor, General Harcourt. The interview was to be at Windsor, so the Canon took his protégé to stay with him at his residence in the Castle. Presumably to demonstrate his abilities as a draughtsman, Constable made four drawings during his stay: two of the Castle and two of views from the Canon's lodgings. The first pair were only tinted drawings, but the other two, one looking upstream, the other down (Pl.2), were almost certainly painted direct from the subject. Many years later, Archdeacon Fisher, the Canon's nephew and by then Constable's closest friend, was staying in the 'Canon's Row' at the Castle. In the letter he wrote to Constable he drew the view from his lodgings. It is the same view looking upstream that Constable had painted – the pair to Pl.2.[1]

20

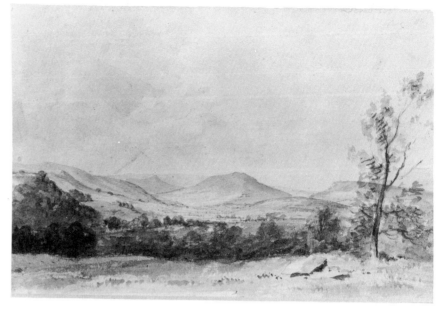

Fig. 11

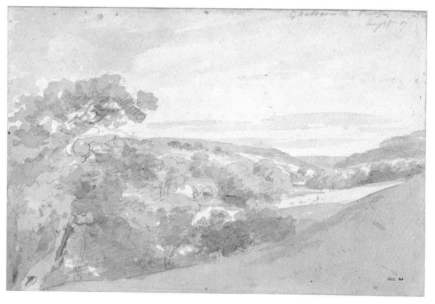

Fig. 12

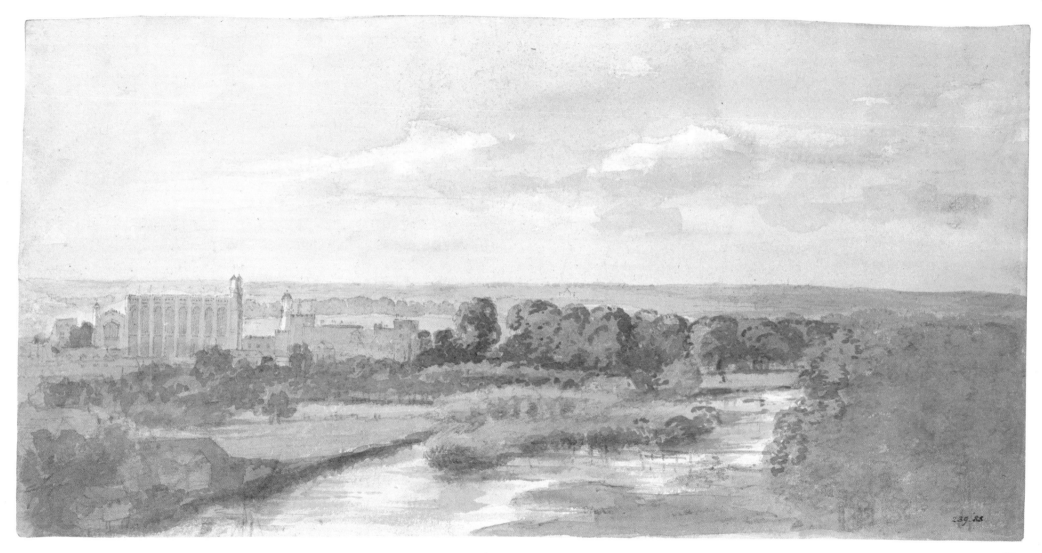

Pl. 2

1803 and 1804

A View at Hursley, Hampshire Pl.3
Black chalk and watercolour, $4\frac{3}{16} \times 14\frac{11}{16}$ in (10.6 × 37.4 cm)
Inscr. verso 'Hursley Hants 1804'
London, Victoria and Albert Museum (R53)

Chalk Church Fig.13
Pencil, squared up for transfer, $7\frac{1}{2} \times 9\frac{3}{4}$ in (19.1 × 24.8 cm)
Inscr. verso 'Nr Gravesend Chalk Kent April 18. noon 1803'
Private collection

Warehouses and Shipping on the Orwell at Ipswich Fig.14
Pencil and watercolour, $9\frac{5}{8} \times 13$ in (24.5 × 33.0 cm)
Inscr. verso '5 Oct–1803 Ipswich'
London, Victoria and Albert Museum (R52)

Fig.

1803

In the late spring of this year Constable spent nearly a month aboard an East Indiaman, the *Coutts*, outward bound from London on the first leg of her long voyage. He went ashore while the ship was at Gravesend and walked to Rochester, where he hired a boat and sketched the men-of-war assembled in the Medway, making drawings of the freshly painted *Victory*, 'the flower of the flock' as he called her. A number of these sketches have survived. Less familiar are those he made of the local architecture, drawings such as 'Chalk Church' (Fig.13). After squaring this up, he made a pen and wash study from it which he signed and dated, 1803.[1]

Michael Rosenthal's recent recognition of a drawing by the Ipswich artist George Frost as being a companion to the view down the Orwell (Fig.14) established the fact that Constable and Frost were working together at least by this date. When the drawings are compared (Fig.14 and Fig.106) it will be seen that the nearest boat was drawn by the artists at slightly different times: the boatman in Frost's view had made fast and left the scene by the time Constable came to draw his craft.

Fig.

1804

Dated works of this year are very rare and I only know of one other drawing which bears a stylistic resemblance to the view on the opposite page (Pl.3). This is a watercolour of the house in Epsom owned by the Gubbins,[1] relatives of the artist's mother, with whom he is known to have stayed in 1806 (see Pl.7) and 1809. It is not known why Constable was at Hursley in 1804. If he was staying at Hursley Park, then his host would have been Sir William Heathcote, a cousin of another Heathcote, Sir Gilbert of Normanton, whose wife in later years became one of Constable's patrons.

22

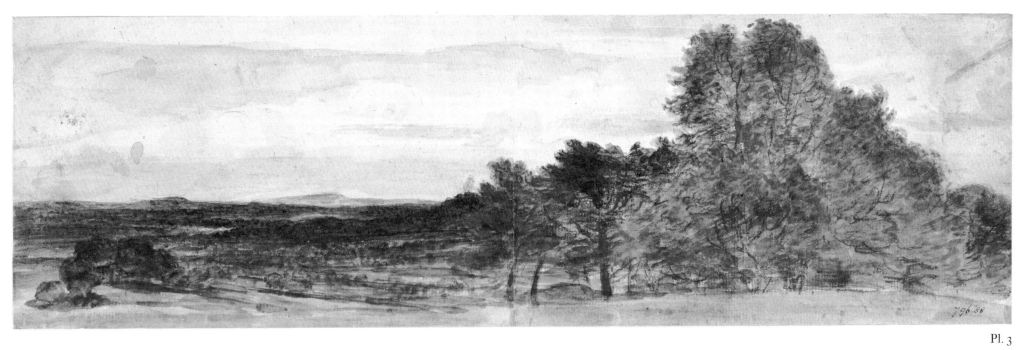

Pl. 3

23

c.1805

A Wooded Landscape Pl.4
Black chalk, $13\frac{1}{4} \times 19\frac{3}{4}$ in (33.7×50.2 cm)
From the collection of Mr and Mrs Paul Mellon

Trees in a Meadow Fig.15
Pencil and watercolour, $11\frac{3}{8} \times 9\frac{5}{8}$ in (29.0×24.5 cm)
From the collection of Mr and Mrs Paul Mellon

Because they both came from the same part of Suffolk, on more than one occasion Constable was asked for information about Thomas Gainsborough. He very greatly admired the other's work. In the summer of 1799, when staying with the Cobbolds, he had seen in the country around Ipswich 'Gainsborough in every hedge and hollow tree',[1] and even towards the end of his life, the thought of a painting by Gainsborough could still move him to tears. Another admirer was Constable's friend George Frost, a clerk in an Ipswich coaching office, who owned a large number of Gainsborough's early drawings. In his spare time an enthusiastic and prolific draughtsman, Frost's own style was modelled closely on that of the older master; so closely, in fact, that in some instances it was not until our own day that scholars have been able to distinguish the one hand from the other. Constable also owned drawings by Gainsborough – there were a dozen or so in his collection at his death – and as an inveterate copier of the work of other artists, it is extremely likely that he too copied from Gainsborough, especially in these early years. But though there exist drawings in the manner of Gainsborough which could be examples of Constable working in this vein, and though a few of these may well prove to be by him, at present there is not one such sheet that can incontrovertibly be accepted as his. The position will undoubtedly be clearer when we have learned to distinguish between Constable and Frost. All too often drawings have been given to Constable when without any shadow of doubt they were by Frost – sometimes only because they were considered 'too good for Frost'.

Neither of the two drawings on these pages (Pl.4 and Fig.15) is inscribed or dated, and their position in the chronology must therefore remain conjectural. In both there is to be seen for the first time a feature that characterises a number of Constable's watercolours and drawings in 1805 and 1806: a strong sculptural emphasis, a concentration on three-dimensional form and massing, coupled with a marked tendency to simplify trees and bushes into ovoid and globular forms. In Pl.14 this can be observed, germinating as it were, among the trees on the hill to the right and in the more distant ones. In Fig.15 the four small trees to the right of centre have been subjected to this treatment and left quite uncompromisingly rounded.

24

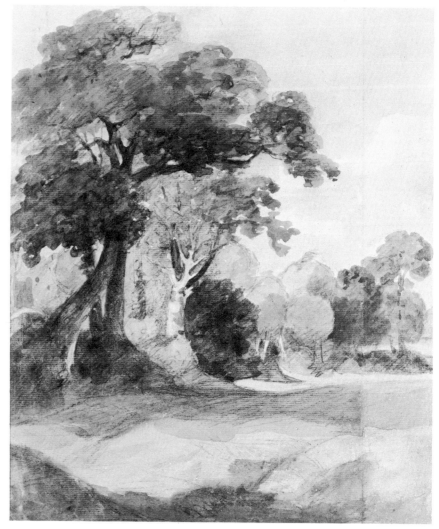

Fig.

Pl. 4

1805

The Stour Valley Pl.5
Pencil and watercolour, $6\frac{11}{16} \times 10\frac{13}{16}$ in (17.0 × 27.4 cm)
Inscr. verso 'Novr. 4. 1805 – Noon very fine day. the Hon ... [or 'Hou' ..?]'
Private collection

Track through a Wood Fig.16
Watercolour, $9\frac{3}{8} \times 12$ in (23.8 × 30.5 cm)
Private collection

View of Dedham [?] Fig.17
Pencil and watercolour, $7\frac{7}{16} \times 12\frac{1}{8}$ in (18.9 × 30.8 cm)
London, The Trustees of the British Museum (1910–2–12–238)

Hardly anything is known of Constable's affairs and even less of how he was spending his time during the period 1804–5, but there is evidence which suggests that he was finding things by no means easy. In 1804 he said that he could see no point in exhibiting,[1] and in that year no work of his hung in the Academy, the only year between 1802 and 1837 when this was the case. During that summer he painted portraits of farmers and their families for two and three guineas a time, and worked on landscapes in the afternoons. In 1805 he had two landscapes ready for the Academy; only one, a 'Moonlight', was hung – presumably the other was not accepted. In the summer of this year he received a commission to paint an altarpiece 'for a country church',[2] probably for the picture that now hangs in the church at Brantham, not far from Bergholt. This could have been a turning-point, for in November of this year (1805), after almost two years' of silence, we suddenly have three dated watercolours and, what is more, a number of others which seem to group themselves naturally around them. Several are of views that he has made familiar: Dedham Vale from the top of Fen Lane, the route he had taken every day on his way to school at Dedham; the footbridge over the Stour a little further on the same route; the outlook to the west from the fields below his home (Pl.6). Others are of unidentified places, woody tracks (Fig.16) and cultivated woodland. Stylistically, however, all are related. In almost all, the pencilling plays a subordinate role only. In all, the washes are painted on with a fairly full brush – the colour sometimes over a grey underpainting. Occasionally, foliage will be loosely outlined with the brush. A characteristic mannerism, confined almost entirely to these drawings, is the delineation of the stems and branches of the smaller trees with a succession of straight strokes in a darker tone. In all, the colour is muted: dull purples, warm greys, olive greens, russet yellows and browns predominate, with the skies often yellow rising to blue. Throughout, the mood is calm and perhaps faintly pensive.

26

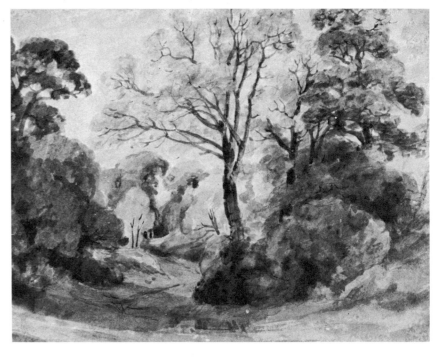

Fig.

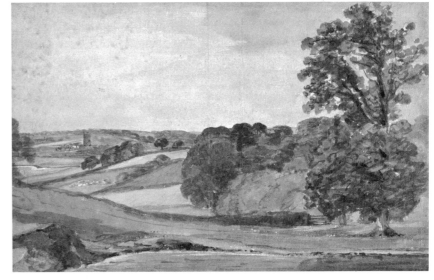

Fig.

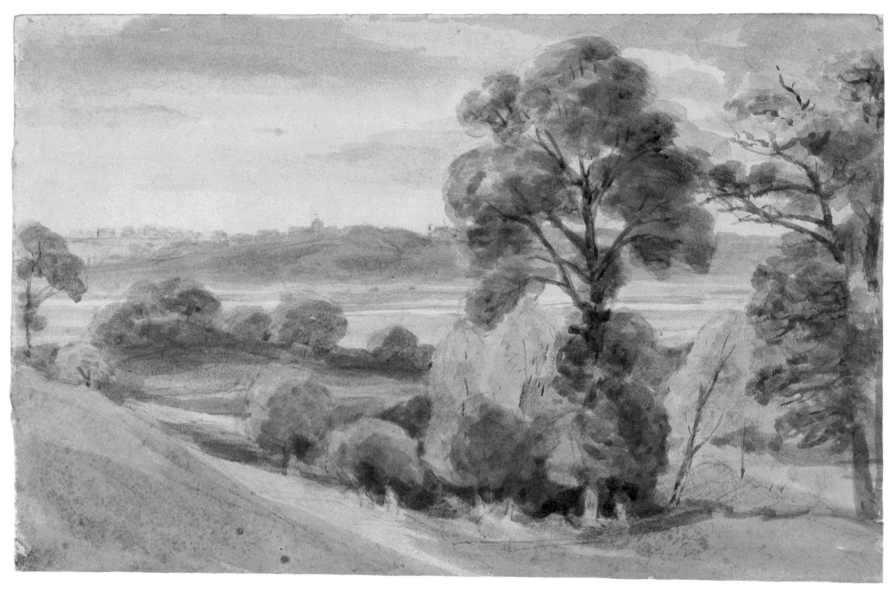

Pl. 5

Fig.

Fig. 18

A Corner of a Park Fig.18
Pencil and watercolour, $4\frac{1}{4} \times 7\frac{1}{16}$ in (10.9 × 18.0 cm) repr. actual size
28 *Paris, Musée du Louvre* (RF.8698, p.38)

Dedham Vale from near East Bergholt Pl.6
Pencil and watercolour, $7\frac{1}{8} \times 11\frac{3}{4}$ in (20.0 × 32.4 cm)
Dublin, National Gallery of Ireland

East Bergholt Church: View from the East Fig.19
Pencil and watercolour, $5\frac{1}{8} \times 7$ in (13.0 × 17.8 cm)
Inscr. verso 'June 1806'
London, Victoria and Albert Museum (R67)

For the number and variety of drawings Constable produced, as well as for the speed of his development as a draughtsman, the year 1806 is unique. Nearly fifty dated drawings of this year are known, and well over a hundred more can with reasonable certainty be so dated. There are sketchbooks filled with figure drawings, mainly of attractive young women; sketches of landscape subjects in Suffolk, Middlesex, Surrey and the Lake District; and drawings in pencil, chalk, pen and ink, and watercolour, variously combined. In some, the influence of other artists is to be seen quite plainly, but in many he is to be found working beyond the bounds of conventional practice. Judging by the scarcity of drawings in the years immediately following, the outpouring appears to have left him exhausted.

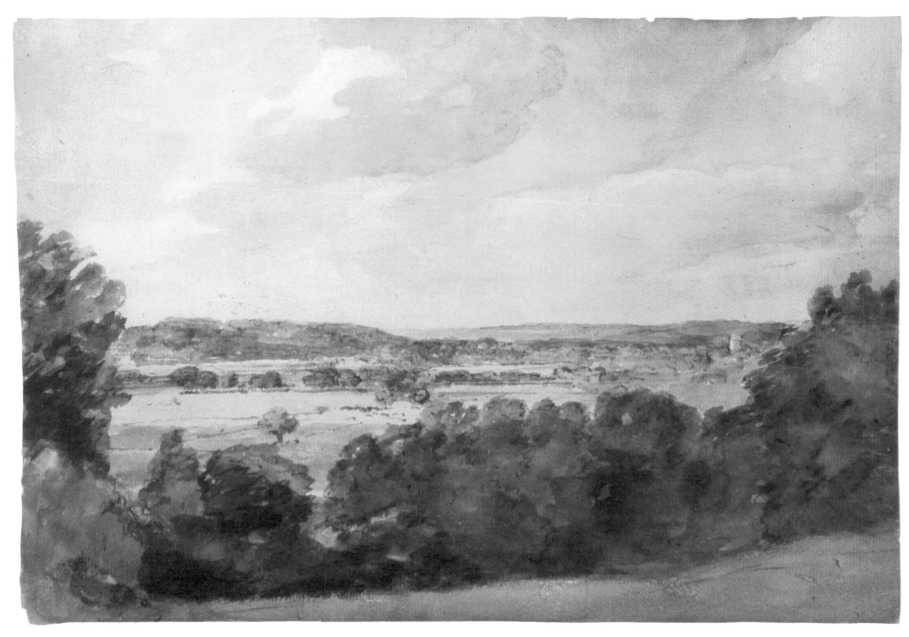

Pl. 6

29

1806

View from Epsom Pl.7
Watercolour, $6\frac{1}{8} \times 9\frac{1}{2}$ in (15.6 × 24.1 cm) repr. actual size
Inscr. 'Epsom. Augst. 6th 1806'; verso 'this is done with my 3 colors & Bister'
Private collection

In the Grounds of Markfield House Fig.20
Pencil, $3\frac{3}{8} \times 4$ in (8.5 × 10.1 cm) repr. actual size
Paris, Musée du Louvre (RF.6082)

Near Hackney Fig.21
Pencil, $4\frac{3}{4} \times 7$ in (12.0 × 17.8 cm)
Inscr. verso 'Thursday 10 July Hackney. 1806'
Paris, Musée du Louvre (RF.8700, p.6)

The earliest dated drawing of this year is the self-portrait (Fig.B, p.9) inscribed 'March 1806' which Constable drew with the help of two mirrors. Next we have a group of watercolours of the Bergholt area done in June, of which at least three are of the church (Fig.19). To the same month belong a number of sketches of the Cobbold daughters (four of whom were between the ages of 19 and 23) all drawn with swift, appreciative strokes of the pencil. In July, we find him in a new area, in Tottenham, Middlesex, staying with a family called Hobson at their house, Markfield. At present not much is known of this family, but their household too appears to have contained a sufficient number of young women to keep Constable happily occupied with his sketchbook and pencil. In the high-waisted fashion of the time, they are to be seen, as he recorded them, sewing, reading, at their ease before open windows, posing arm-in-arm, and occasionally strolling in the grounds beneath parasols with the house in the background (Fig.20). Later in the year, as we shall see, we have Constable far away from such delights, but among the several dozen drawings of this household at Tottenham there are remarkably few landscapes proper. The watercolour of the park (Fig.18) may have been done at Markfield, but otherwise the only landscape sketch undoubtedly of this time is the view inscribed 'Hackney' (Fig.21).

By the first week of August Constable had moved on to stay with relatives, a maternal aunt and her husband (a well-to-do surveyor) who lived at Epsom. Here, on the 6th, he made the watercolour on the opposite page (Pl.7). Sir George Beaumont is known to have advised Constable to study Girtin's watercolours for their 'great breadth and truth'.[1] In earlier drawings, the view of Eton (Pl.2) for example, it is possible to trace the influence of Girtin, and some of the watercolours of Bergholt church done this June are similar in the handling of the washes to works such as the Girtin of the Tithe Barn at Abbotsbury.[2] After this view of Epsom we shall not again see Constable working so closely to Girtin's manner.

30

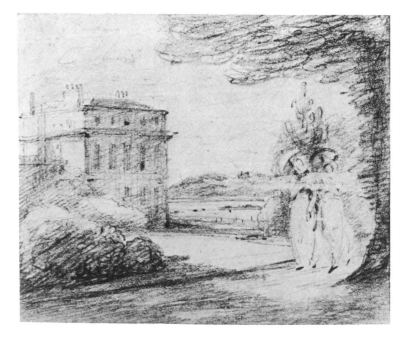

Fig. 20

Fig. 2

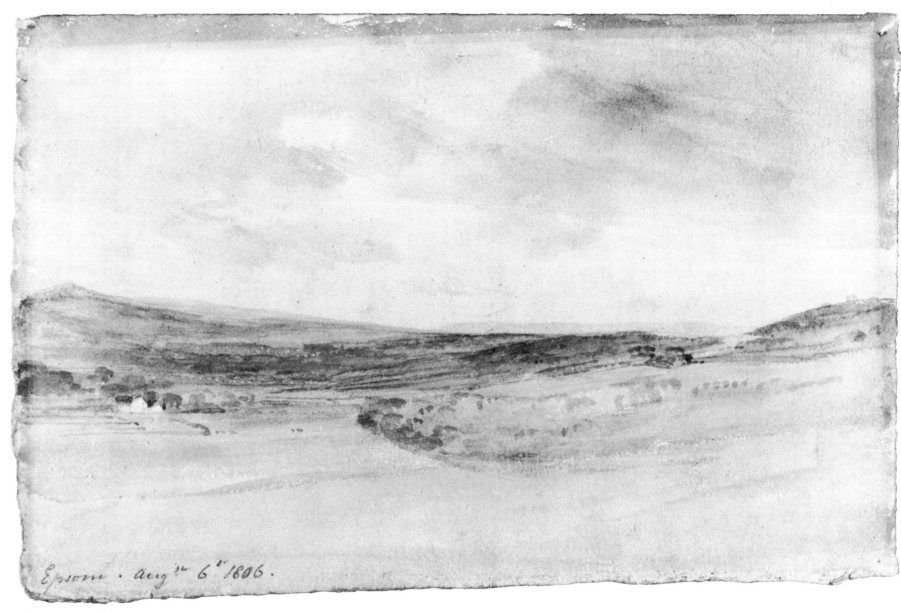

Epsom . Aug.st 6.th 1806 .

Pl. 7

1806

Borrowdale, Morning Pl.8
Pencil, 13 × 18⅜ in (33.0 × 46.6 cm)
Inscr. verso 'Bord – dale – morning/['Bordera' crossed out]/[words crossed out]/Border Gale marning/morning'
Leeds City Art Galleries

A Hamlet in a Lakeland Valley Fig.22
Pencil, squared up for transfer, 16 3/16 × 13⅝ in (41.6 × 34.6 cm)
Coll. Sir John and Lady Witt

Encouraged and possibly aided financially by his uncle, David Watts, who had recently lived for a time on the shores of Lake Windermere, in the autumn of this year Constable travelled north to make a sketching tour of the Lakes, the last journey he was to take for such a purpose. His first drawings in the area, of Kendal, are dated 1 September; his last, of Langdale, 19 October. For the first couple of weeks or so he stayed with friends near Ambleside and with a family called Harden at the head of Windermere; then he moved off deeper into the hills with a companion, the son of the portraitist Daniel Gardner. At least three of the ensuing weeks were spent in Borrowdale, most of the time alone, as his companion soon tired of looking on while he sketched. On 15 October he rejoined the Hardens and apparently stayed with them until he left the district a few days later.

A full count has not yet been taken of the drawings he made during the seven weeks of the tour, but the total already known runs well into the seventies, and the examples illustrated in these pages can give only a very limited idea of the whole group. The drawings shown here (two out of a number that is steadily increasing as new ones come to light) have been chosen to show three characteristics of his work with the pencil at this time: the flowing, rippling line; the directional shading (in the bigger drawing, more steeply angled as his arm stretched across the paper); and finally, a further stage in the development of the feature noted earlier (Pl.4 and Fig.15), the rounded sculptural forms. In some of the pencil sketches this last is even more pronounced. In Christchurch Mansion, Ipswich, there is a drawing of wooded slopes (probably done in the Lakes) so composed of these globular forms that they are even to be seen lurking in a bank of grass in the foreground.

Traces of squaring up for transfer visible in Fig.22, are also to be found in other sketches made on the tour: for example, a particularly fine drawing in the Lockett collection. This last drawing has an additional unusual feature, two figures – a man seated beside a road along which a woman is approaching.

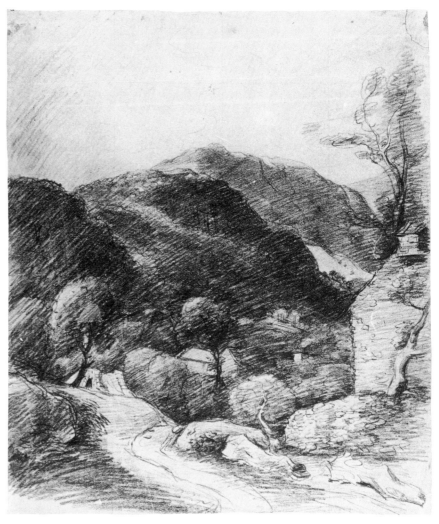

Fig.

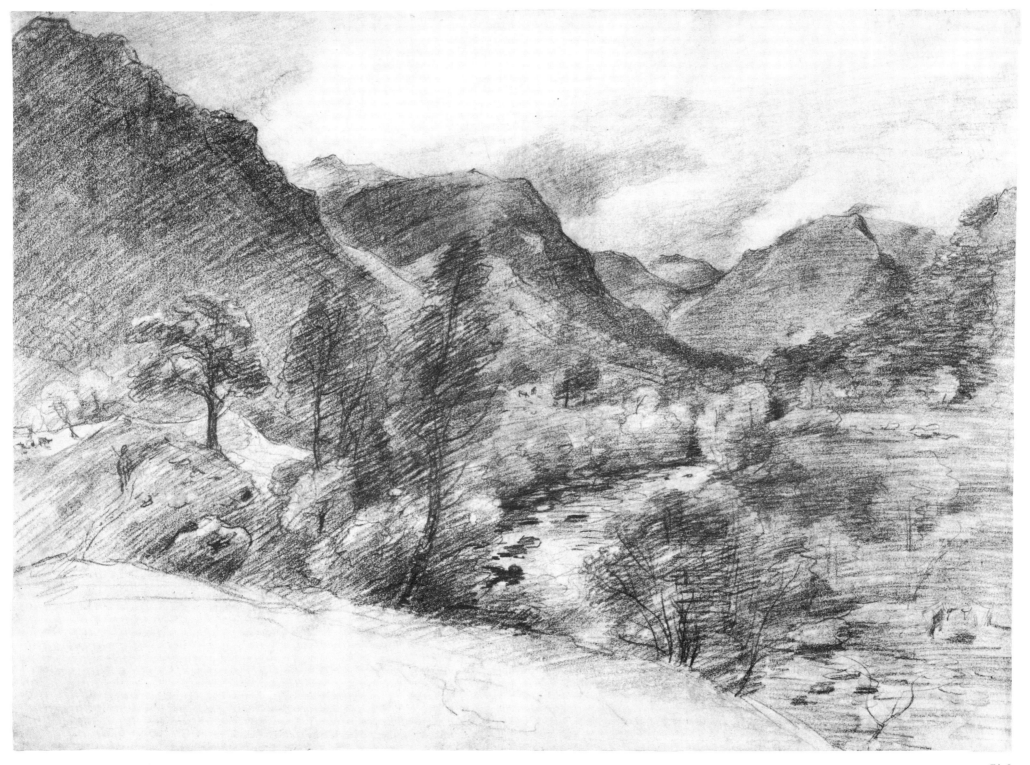

Pl. 8

Saddleback and Part of Skiddaw Pl.9
Pencil and watercolour, $3 \times 11\frac{5}{8}$ in (7.6 × 29.5 cm)
Inscr. in another hand on mount copied from now missing part of drawing
'Saddle back and part of Skeddaw'; inscr. continues in artist's hand on verso
of drawing '21 Sept. 1806 Stormy Day–noon'
London, Victoria and Albert Museum (R72)

View in Borrowdale Fig.23
Pencil and watercolour, $7\frac{1}{2} \times 10\frac{3}{4}$ in (19.1 × 27.4 cm)
London, Victoria and Albert Museum (R89)

Vale of Newlands Fig.24
Pencil and grey wash, $6\frac{1}{8} \times 9\frac{7}{16}$ in (15.5 × 23.9 cm)
Inscr. verso 'Sunday 22 Sepr–1806–Vale of Newlands very stormy
afternoon–Sunday.'
Cambridge, Fitzwilliam Museum

Constable is reported by Leslie as having said that the solitude of mountains
oppressed his spirits. Leslie goes on to say that the artist's nature was
peculiarly social and 'could not feel satisfied with scenery, however grand
in itself, that did not abound in human associations.[3] The truth of this last
observation should not lead us to underestimate the importance of the weeks
Constable spent in the Lakes, or to overlook the significant fact that he
voluntarily chose to remain alone in one of the more remote parts, Borrow-
dale, for nearly three weeks of his tour. It is also important to remember that
for the next two and a half years he was to exhibit only Lake District subjects.
Later, he is to be found exhorting his future wife to take a holiday in Wales
where she would find 'the change, the air, and the sublime scenery' such a
blessing,[4] and, not long after, commiserating with her when the trip was
cancelled: '. . . how much would you have been charmed with the affecting
and sublime scenery of a mountainous country.'[5] He would hardly have
written thus if the hills had only 'oppressed his spirits'.

As we learn from the inscriptions and from many of the drawings them-
selves, Constable was not specially favoured by the weather during his tour.
It is only occasionally, in drawings such as the view of Saddleback (Pl.9), that
he was able to record a passing shaft of sunlight, and it is probable that
several of the days unrecorded by drawings were in fact spent indoors waiting
for the weather to clear.

Much of the original colour has gone from the Lakeland watercolours.
'Saddleback' was chosen as it appears to have lost rather less of its colour than
most. It was in these drawings of 1806 that Constable first began to find ex-
pression for the power that was latent within him.

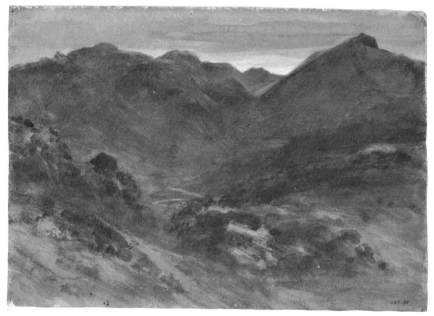

Fig. 23

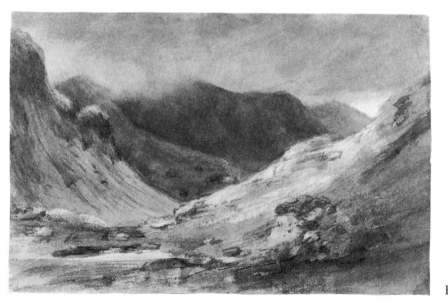

Fig. 24

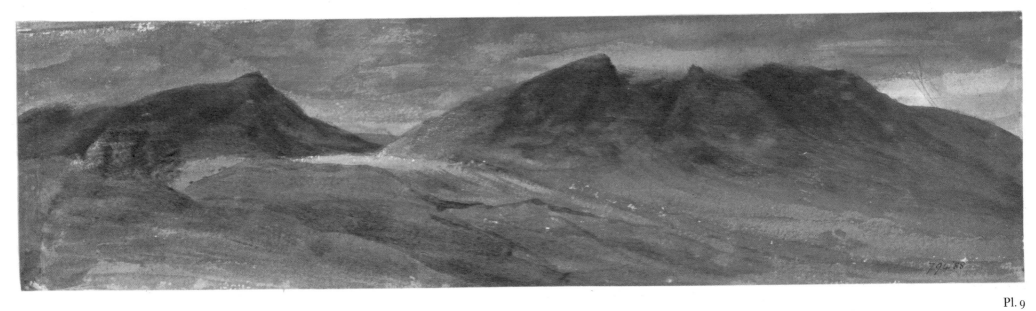

Pl. 9

East Bergholt Church Pl.10
Watercolour, $15\frac{5}{8} \times 23\frac{5}{8}$ in (39.7×60.0 cm)
Inscr. 'John Constable feb[y].1811.' and on a decorative label verso: 'A South
East View of East Bergholt Church in the County of Suffolk. a Drawing by
J. Constable Esq[r]. and presented in testimony of Respect to the Rev[d],
Durand Rhudde. D.D the Rector Feb[ry], 25 1811.'
Port Sunlight, Lady Lever Art Gallery

Copy of 'Jacob's Vision' by Salvator Rosa Fig.25
Pencil, $3\frac{1}{2} \times 6$ in (8.9×15.2 cm)
Inscr. 'Devonshire House–Oct[r].11.1811–'.
Private collection

We are told that Constable and Maria Bicknell first became acquainted in
1800, when, as a child of twelve, she came to stay with her grandfather, Dr
Rhudde, the rector of East Bergholt.[1] From a letter Constable wrote later we
learn that he declared his love for her in the summer of 1809, during one of
her subsequent visits to the Rectory. Mrs Constable, the artist's mother,
appears to have approved of her son's choice and, while he was ignorant of
the attachment, Dr Rhudde seems to have had no objection to his grand-
daughter seeing something of the Constables. To gain special favour for her
son Mrs Constable sent him a watercolour he had once given her of the
church, with a request that he would 'draw its true Likeness–and have it
Neatly framed and Glazed–as a Present from you to Dr Rhudde–it is what
He so much wishes for–'.[2] Next month Constable sent the original back to
her with a newly painted copy. In her letter of acknowledgement Mrs
Constable told him that after John Dunthorne had 'neatly letterd a small
Tablet–which I put on the Back–which explained all–& saved words',[3] she
had presented the gift to the Rector, who had said it was most beautiful. Dr
Rhudde wrote to thank the artist for the picture 'not merely as a Specimen of
Professional Merit, but as a Testimony of your Regard', enclosing a Bank
note for the purchase 'of some little article by which you may be reminded of
me, when I am no more.'[4] The watercolour on the opposite page (Pl.10) is the
copy given to the Rector. The label lettered by John Dunthorne is still to be
seen on the back, where Mrs Constable pasted it; her own watercolour, the
original, has not yet come to light.

The picture from which Constable made his pencil copy (Fig.25), Sal-
vator's painting of Jacob with his vision of the angels, is still in the Devon-
shire collection. When lecturing on landscape in 1836, Constable spoke dis-
paragingly of Rosa, the 'favourite with novel writers, particularly the ladies',
talked of his meanness of conception in history painting, and appears to have
agreed with Fuseli that the Neapolitan was a great genius only in landscape.[5]

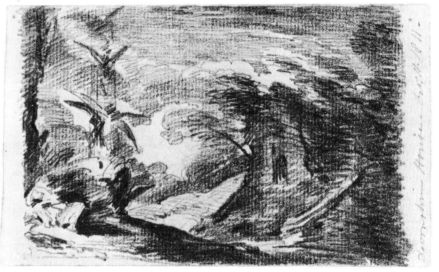

Fig.

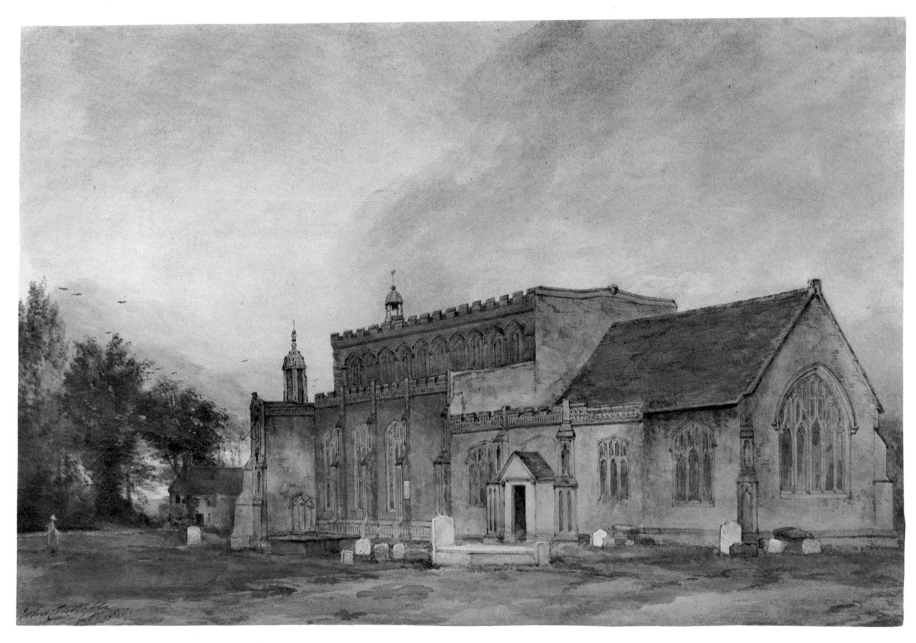

Pl. 10

1811

Salisbury Cathedral from Old Sarum Pl.11
Black and white chalk, grey paper, $7\frac{1}{2} \times 11\frac{3}{4}$ in (19.0×29.8 cm)
Oldham, Art Galleries and Museums

Salisbury from Old Sarum Fig.26
Black and white chalk, grey paper, $7\frac{1}{2} \times 11\frac{3}{4}$ in (19.0×29.8 cm)
Inscr. 'Sept. 14th, 1811'
Oldham, Art Galleries and Museums

After his Lakeland trip of 1806 we do not again find Constable on tour in search of material. Henceforth he seems to have been content to work wherever friendship or family ties happened to take him. It was for friendship's sake that he first went to stay at Salisbury, just as it was for the sake of a friendship formed on that visit that he was later to return a number of times to Wiltshire. His host was his old friend Dr Fisher, one-time Rector of Langham and Canon of Windsor, but now Bishop of Salisbury, and in residence at the Palace on the south side of the Close. Fisher and his wife had maintained their interest in their protégé since the attempt to help him with his career in 1802, and he had dined with them on a number of occasions at their London house. He had in fact been invited to Salisbury the year before, but it was not until the September of this year, 1811, that he was free to accept.

It is not known when he first met the Bishop's nephew, John Fisher, who became his closest friend, but it was almost certainly during this three weeks' stay that they first came to know each other well. Their friendship, which meant more to Constable than any other, lasted until Fisher's death in 1832 at the age of forty-four.

Over the last two years or so, Constable had been quietly making sensational advances in the oil-sketches he had been painting out in the open, capturing in them a brilliance of tonality far beyond anything he had yet achieved with the pencil or in watercolour. His choice of black and white chalk on grey paper for the larger drawings he made in Wiltshire this autumn (a medium hitherto almost entirely reserved for work in the life class at the Academy) may have derived from a desire to find a way of rendering this brilliance graphically. The sketches he brought back from his stay at Salisbury were much praised by Thomas Stothard, R.A., one of the older Academicians who took an interest in him. Stothard suggested that he should paint a picture 'of a respectable size' from one of the sketches–a general view of Sarum–and it seems that Constable took his advice; one of his exhibits at the Academy the following year was titled 'Salisbury: Morning', a picture that has so far evaded identification.

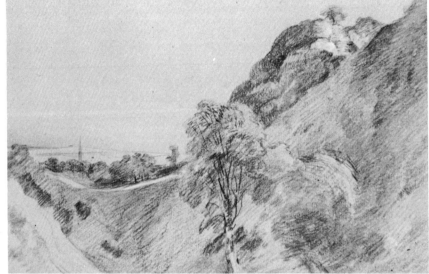

Fig

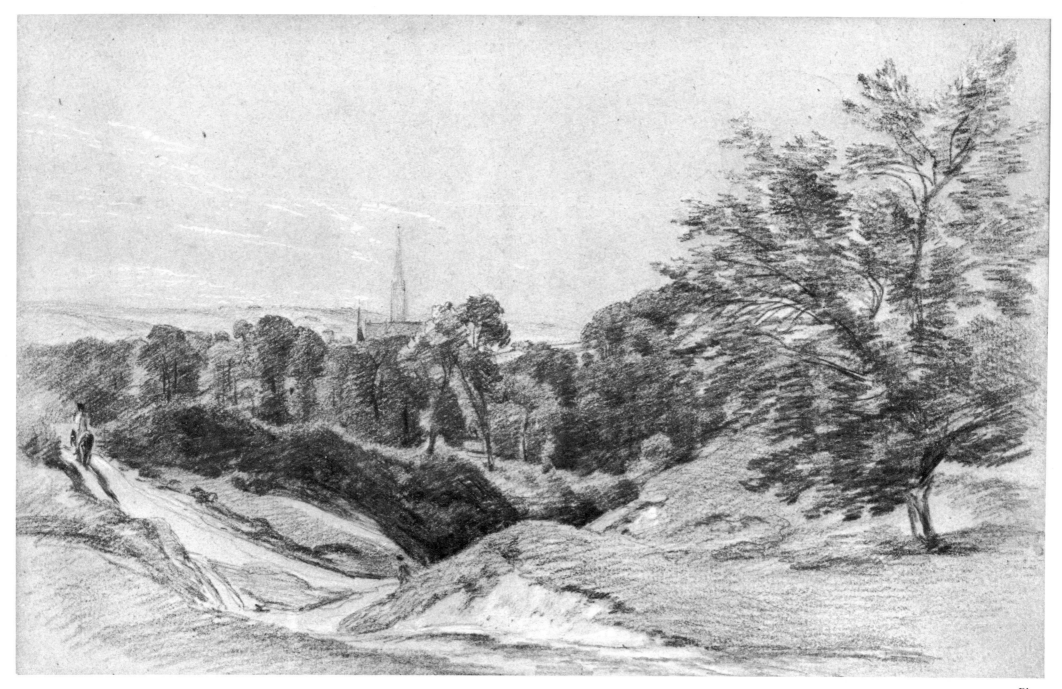

Pl. 11

1811

Salisbury Cathedral: Exterior View of the East End Pl.12a
Pencil, $5\frac{7}{8} \times 3\frac{1}{2}$ in (14.9 × 8.9 cm) repr. actual size
London, Victoria and Albert Museum (R108)

Salisbury Cathedral: Exterior from the South-East Pl.12b
Pencil, $5\frac{1}{4} \times 3\frac{1}{2}$ in (13.3 × 8.9 cm) repr. actual size
Inscr. '1811'; verso 'Sep 30 1811'
London, Victoria and Albert Museum (R106)

Worcester Cathedral Fig.27
Pencil, $3\frac{7}{16} \times 5\frac{11}{16}$ in (8.7 × 14.5 cm)
Private collection

Constable was in Worcester on only two occasions: in October 1835, when he gave three lectures on Landscape to the Worcestershire Institution; and in December of the year with which we are concerned, 1811, when he was passing through on one of the most dramatic journeys of his life.

Maria Bicknell lived with her parents in London in Spring Gardens, just by the Horse Guards, an address convenient for her father's work as solicitor to Admiralty and to the Prince Regent. For a while Constable was allowed to call there, but in the spring Maria left London to stay with her half-sister, Mrs Skey, who lived in comfortable circumstances at Spring Grove, just outside Bewdley, Worcestershire. By October, when Constable got back from Salisbury, there was still no sign of her returning. Finding this isolation unbearable, on 23 October he wrote to her, the first of the many letters he was to send during their long courtship. She answered, and in his reply he told her how he had been suffering in her absence. Gradually, as they exchanged letters, his spirits began to return. A short visit to Suffolk in December set him up still further, so that when he wrote to her on the 12th he was in a buoyant mood. 'I am so well', he told her, 'that I seem equal to a winters campaign . . . To one who is so much alone as I am I know the struggle will be great – but I look with confidence to the happiness of Your correspondence to support me in it.'[6] In more than one of her letters Maria had politely beseeched Constable to desist, to think no more of her and to 'leave off a correspondence that is not calculated to make us think less of each other'.[7] Each time, he had pressed forward more eagerly, as though he sensed she meant it less every time she said it. But in reply to this letter of the 12th, he received a bombshell, a letter in which she said quite firmly that she could not continue a correspondence wholly disapproved of by her father, and begged that he would cease to think of her. His uncle, David Watts, who knew of his troubles, had been urging him to stand up for himself, 'though you are miserable yet You are a *Man*.'[8] Thus encouraged, he now acted as a man, and took coach immediately for Worcester and Spring Grove.

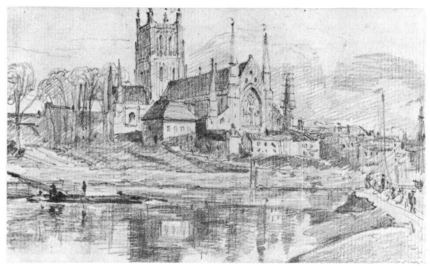

Fig.

Hardly more than forty-eight hours were spent at Mrs Skey's, but this, apparently was enough; the correspondence continued after his return, and before long he was 'my dear John' in her letters. In the first letter he wrote after getting back (24 December) he talks of his short stay and of waiting in Worcester for the coach on the return journey, though he does not mention the drawing of the Cathedral that he must have done while he was by the river. 'I could not but regret that the fine weather on sunday should not have happened a day or two sooner – that we might have had a walk to the banks of the severn – for in addition to the fineness of the morning the frost had made it dry under foot I was at Worcester two or three hours before the Mail set off – which gave me an opportunity of seeing the Cathedral and most of the Town & I had a very beautiful walk down the river –'.[9]

Pl. 12a

Pl. 12b

41

1812

Flatford Lock Pl.13
Pencil, $10\frac{1}{2} \times 17\frac{1}{4}$ in (26.7×43.8 cm)
Private collection

Coombe Wood Fig.28
Pencil, $3\frac{3}{8} \times 5\frac{1}{16}$ in (8.6×12.8 cm)
Inscr. 'Coombe Wood June 5th. 1812'
From the collection of Mr and Mrs Paul Mellon

Richmond Hill Fig.29
Pencil, $3\frac{5}{8} \times 6\frac{1}{8}$ in (9.2×15.5 cm)
Birmingham, City Museum and Art Gallery

'Yesterday I took a long walk with Mr Stothard', Constable wrote to Maria Bicknell on 6 June 1812, 'I left my door about 6 of the morning–we breakfasted at putney–went over Wimbledon Common–& passed three hours at least in Coomb Wood–(Stothard is a butterfly catcher) where we dined by a Spring–then to Richmond by the park–and enjoyed the view–and home by the River–all this on foot and I do not feel tired now though I was a little in the morning'.[1] For some time, we are told, Constable had been Stothard's chosen companion on his long walks out into the country. Some twenty years older than Constable, Stothard had built up his reputation very largely as an illustrator and designer–estimates vary only as to how many thousands of drawings he sent to the publisher–and he is little known as a landscape draughtsman, but in fact it may have been from watching him at work during these country rambles that Constable learned some of his final lessons in the handling of the pencil. Leslie tells us that he had seen 'a beautiful pencil drawing of a shady lane, which Constable made during their excursion to Coombe Wood, while his companion, who was introduced into it, was engaged with his butterfly nets.'[2] This drawing is not known, but the little sketch in the Mellon collection (Fig.28) was certainly drawn on that day, and the pencil study of Richmond Hill (Fig.29) may well have been done when they stopped to enjoy the view.

The drawing of the lock gates at Flatford was used by Constable as a study for the picture he exhibited at the Academy of 1813, a picture he called 'Landscape: Boys fishing' (see Fig.111). In Florence (Fondazione Horne), there is another drawing connected with the picture, a sketch of the group of trees to be seen in the painting further along the towpath to the left. The drawing of the lock and the view of Dedham overleaf (Pl.14) have much in common; in both we find the same delicate yet decisive statements, the same soft, flowing shading. A rather unusual, heavy paper was used for both of the studies for 'Boys fishing'. The Copenhagen Dedham view appears to have been drawn on a similar paper.

Fig.

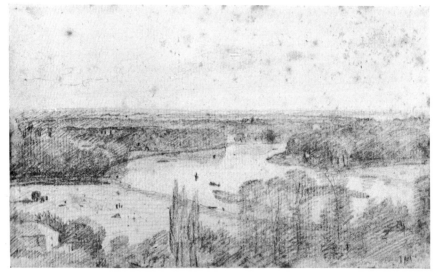

Fig.

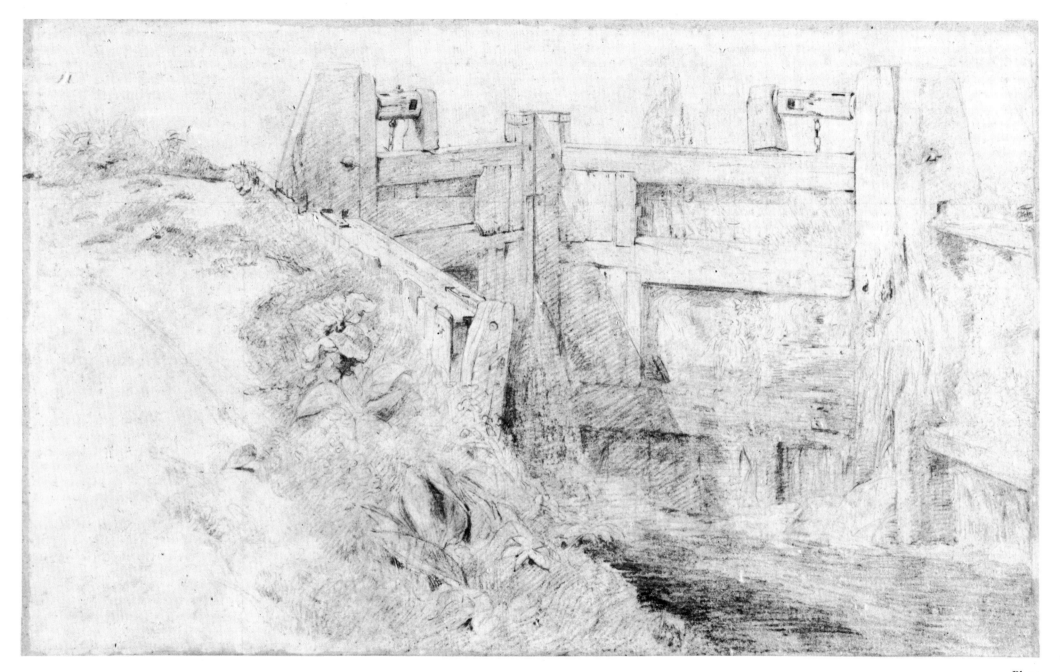

Pl. 13

Dedham from Langham Pl.14
Pencil, $12\frac{5}{8} \times 26\frac{1}{4}$ in (32.1×66.7 cm)
*Copenhagen, Department of Prints and Drawings, The Royal Museum
of Fine Arts*

Willy Lott's House Fig.30
Pencil, $7\frac{7}{8} \times 11\frac{13}{16}$ in (20×30 cm) watermarked 1807
London, Courtauld Institute of Art (Witt Collection)

In 1811 Constable had exhibited at the Academy one of his most ambitious pictures yet, 'Dedham Vale: Morning', a panoramic view of the valley looking westwards from the Bergholt-Flatford road. In 1812, the year now in question, he had shown a painting which may also have been a general view, a picture to which he gave a similar title, 'Salisbury: Morning'. The beautiful Copenhagen drawing (Pl.14), another panorama, is of a view comparable to the exhibited 'Dedham Vale' only looking towards the east, almost exactly in the opposite direction. Was he intending to follow up the two extensive views of this and the previous year with a third, with a 'Dedham: Noon', or 'Afternoon', or 'Evening'? No painting on a large scale of this subject is known to exist, but there are three oil sketches of the view, all remarkably alike. One of these (in the Ashmolean Museum, Oxford) is dated, 13 July 1812. Stylistically, 1812 is a plausible date for the drawing, for much of the pencil-work is very like the handling in 'Richmond Hill' and 'Flatford Lock' (Fig.29; Pl.13). The mood of the drawing is also consistent with what we know of the artist's own state of mind during the early part of this summer. He had arrived in Suffolk on 19 June. 'Nothing can exceed the beautifull appearance of the Country at this time', he had written to Maria soon after his arrival, 'its freshness – its amenity – the very breeze that passes the window is delightfull it has the voice of Nature.'[1] Four weeks later, he wrote: 'I have been living a hermit-like life though always with my pencils in my hand . . . How much real delight have I had with the study of Landscape this summer either I am myself much improved in *"the Art of seeing Nature"* (which Sir Joshua calls painting) or Nature has unveiled her beauties to me with a less fastidious hand – perhaps there may be something of both so we will divide these fine compliments between us –'.[2] To whichever year 'Dedham from Langham' belongs, the waggons to be seen carting hay just over the brow of the hill leave us in little doubt as to the season in which it was drawn.

A firm date does not readily come to mind for the important drawing of Willy Lott's House (Fig.30); for parts of it seem to have been drawn in 1812 while other passages resemble work done in the autumn of 1813. Perhaps a

Fig.

solution lies in the apparent contradiction. The study is drawn on three sheets stuck together – the third is only a thin strip along the right-hand edge. It is conceivable that Constable drew part of the house and the taller trees on the first sheet, say, in 1812, and then, a year or so later, attached the second (and third) sheet and extended the drawing to the left, while at the same time overworking parts of the old one.

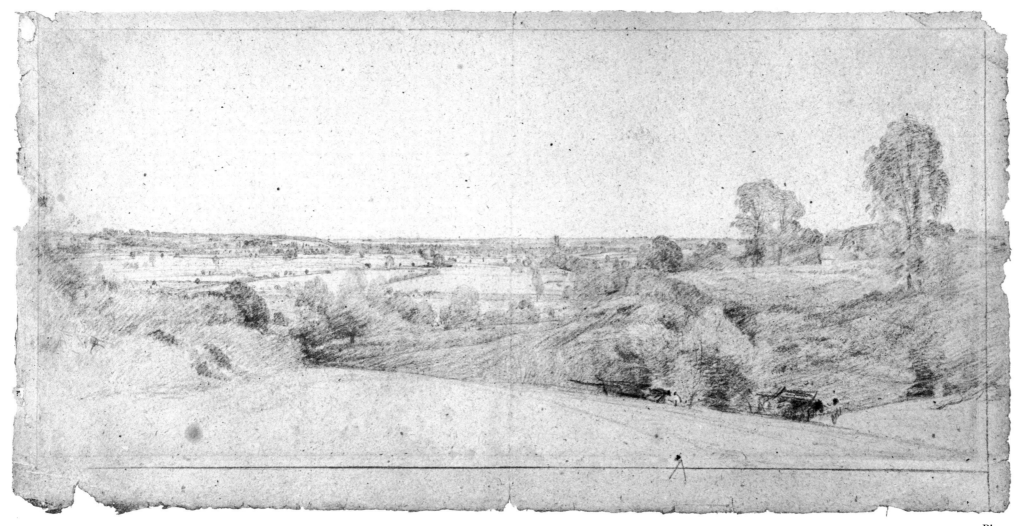

Pl. 14

Sketchbook
Pencil, $3\frac{1}{2} \times 4\frac{3}{4}$ in (8.9 × 12.0 cm)
London, Victoria and Albert Museum (R121)

The survival of this sketchbook intact is particularly fortunate as it enables us to watch Constable at work during a critical period in his development, the period June to October 1813 when he reached maturity as a draughtsman. The seventy-two pages of drawings it contains (often three or four to a page) apparently represent his entire output that summer with the pencil. Though the pages were not used consecutively like a diary, thirty-seven of the sketches are dated and we know that he regarded the little book as a kind of journal. It is as such, as a complete record of every object, view or event that he noted with his pencil during those weeks that it is of such value and interest. The pages shown here have been chosen to illustrate certain changes of method and of vision which occurred during that short time.

P.14 'The Barn at Flatford' (Fig.31) Inscr. 'July 10.1813'
The first dated drawing. The building stood between the Mill and the foot-bridge, upstream. It is to be seen again on p.27 of the sketchbook.

P.16 'A View over Rising Ground' (Fig.32), detail.
With its outlining, rounded forms and infilling of shading, this view is clearly one of the earlier drawings in the book.

P.21 'Cornfield at East Bergholt' (Pl.15a) Inscr. '13 July.1813'
This is taken from a viewpoint to the west of the village looking towards Langham. As yet, little change in style is to be seen: rounded forms are still outlined; the shading is mainly a series of flat 'washes'. The sketch records a bumper harvest.

P.34 'Two[?] Views of Golding Constable's House' (Pl.15b) The first, above. inscr. '19 July 1813 House in which I was born x'. The second, below, is dated 21 July.
These are the two key dated drawings. Outlining and shading has been replaced or overlaid by a complex system of tones and textures.

P.37 'Golding Constable's House' (Pl.15c) Inscr. '23'
This is Constable's home as seen from a track that ran south past some cottages across the road. With little or no outlining, the whole is seen as a tonal scheme. Now the pencil is being used as if it were a brush; Constable now draws as he paints.

P.12 'Dedham Vale' (Pl.15d) Inscr. '25 July – noon – Suffolk'
Tonal shading is here used to suggest colour and light. In the Academy of 1814 Constable exhibited 'Landscape: Ploughing scene in Suffolk'. Much of this picture was probably painted from Pl.15d. Elsewhere in the sketchbook

Fig. 31

Fig. 32

are studies of the ploughman with his team which are to be seen in the picture (see Fig.112).

P.63 'Cottages and outbuildings' Inscr. 'Sepr.1 1813'
'View towards Dedham'[?] inscr. 'Monday[?] Evng. Sepr.5.1813' (Pl.15e).
Already Constable's new way of drawing has become fluent and adaptable – nothing in the Suffolk scene is now beyond his powers.

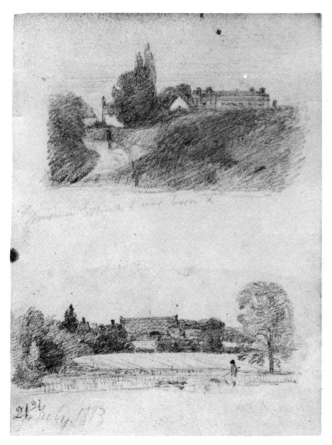

Feering Church and Parsonage Pl.16
Pencil and watercolour, 10½ × 14¼ in (26.7 × 36.2 cm)
Manchester, Whitworth Art Gallery, University of Manchester

Southend Fig.33
Pencil and watercolour, 3³⁄₁₆ × 4¼ in (8.1 × 10.7 cm) repr. actual size
Inscr. 'Southend–evg–23d June 1814'
London, Victoria and Albert Museum (R124)

Hadleigh Castle near Southend Fig. 34
Pencil, 3³⁄₁₆ × 4³⁄₈ in (8.1 × 11.1 cm) repr. actual size
London, Victoria and Albert Museum (R127)

In 1814 the vicar of Feering, in mid-Essex, was the Revd W.W. Driffield, an old friend of Constable's father. At one time a resident of East Bergholt, he had cause to remember Constable as an infant, for he had been called out late one night to baptize him when there were fears that he was not going to live. Since then he had taken an interest in Constable's career and recently had watched over the progress of a portrait he had been painting for friends of his, the Rebows at Wivenhoe, an estate not many miles from Feering. Constable had promised Driffield a drawing of his church and vicarage, and in June he spent nearly a fortnight with the old parson. During that time he accompanied Driffield on a visit to another of his parishes, Southchurch, near Shoeburyness. Constable described their visit in a letter to Maria. 'While Mr D. was engaged at his parish I walked upon the beach at South End. I was always delighted with the melancholy grandeur of a sea shore. At Hadleigh there is a ruin of a castle which from its situation is a really fine place – it commands a view of the Kent hills, the Nore and North Foreland & looking many miles to sea.' 'I have filled as usual', he continued, 'a little book of hasty memorandums of the places which I saw which you will see.'[1]

The little sketchbook he mentions has been dismembered and hardly a dozen of its pages have been identified. Six of the sketches it contained, however, are in the Victoria and Albert Museum; two of these are illustrated here (Figs.33 & 34). Perhaps it was a memory of Hadleigh's 'melancholy grandeur' that caused Constable to choose his slight pencil note of the cleft tower (Fig.113) as the subject of his first important painting after the death of his wife in November 1828.

Besides the fine view opposite, there is known a highly finished pencil drawing of the parsonage from close to. From his letter, it seems more likely that it was for the receipt of the pencil drawing that Driffield wrote to thank Constable in October of the following year.

Fig. 33

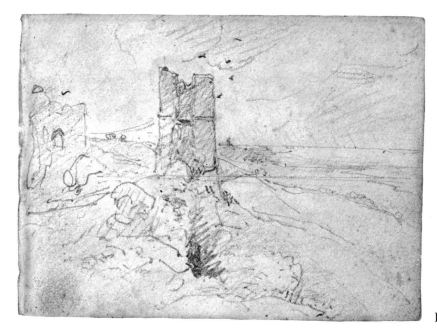

Fig. 34

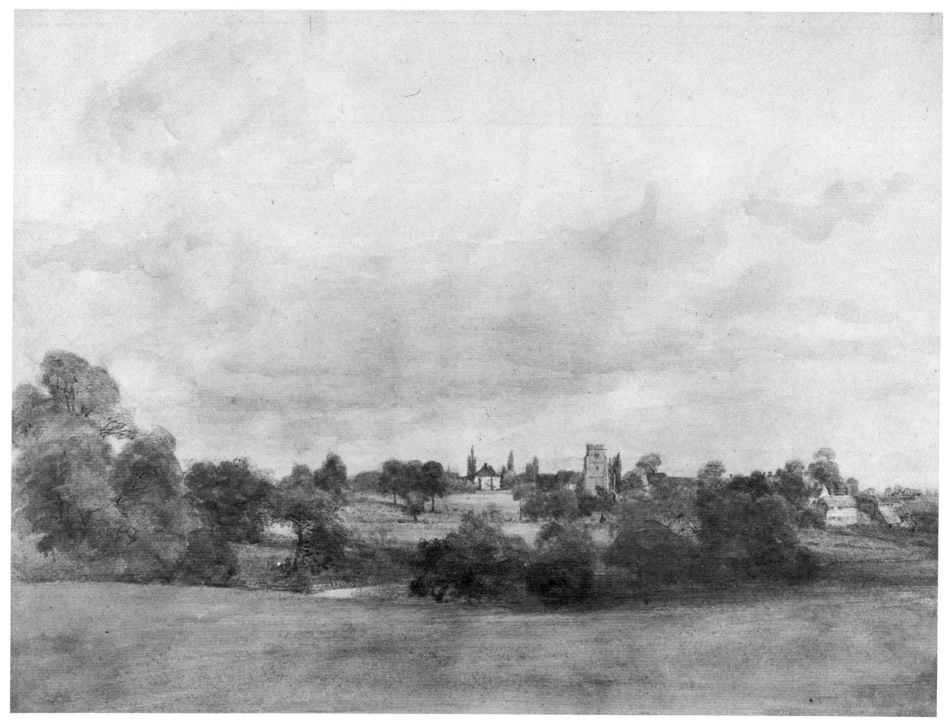

Pl. 16

49

1814

Sketchbook
Pencil, $3\frac{3}{16} \times 4\frac{1}{4}$ in (8.1×10.8 cm) repr. actual size
London, Victoria and Albert Museum (R132)

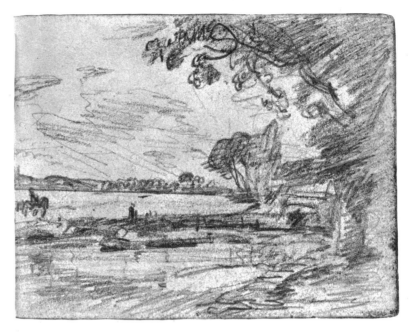

Fig. 35

For more than three months in 1814, from the end of July to the beginning of November, Constable was able to work at his home in Suffolk almost without interruption. '. . . it is many years', he told Maria in October, 'since I have pursued my studies so uninterruptedly and so calmly—or worked with so much steadiness & confidence.'[2] The second of his sketchbooks to have survived intact belongs to this period. In character its contents differ vastly from those of the book he used the previous summer. Many of the views drawn then were seen as compositions, but only one of them was afterwards painted on a large scale ('The Valley Farm') and it is possible that this was drawn in the book at a later date. In the 1814 sketchbook, on the other hand, we find material for no less than five of his major oils, two of which were 'six footers'– 'The White Horse' and the 'View on the Stour' (see Figs. 114 & 115).

P.62 Study for 'Stour Valley and Dedham village' (Pl.17a) Inscr. '26 Sepr morning $\frac{1}{2}$ 8 o'cl[?]', see Fig.116
P.81 The same (Pl.17b) Inscr. '9th octr'
Both of these sketches were drawn for a picture then in hand, a commissioned work, a wedding gift for the daughter of Peter Godfrey, of Old Hall, East Bergholt. The sketchbook contains a number of other studies for this painting. It is seldom that Constable is to be found thus, collecting material for a work actually in progress.

P.52 Study for 'View on the Stour' (Pl.17c), see Fig.115
P.59 The same (Pl.17d)
These were drawn on the river bank at Flatford between the mill and the footbridge. The final work combines elements from both drawings. The stern of the boat to be seen in the drawing on Pl.17d is that of the barge depicted in another important painting of this October, the well-known 'Boatbuilding' (see Fig.117) exhibited at the Academy the following year.

Pp.25 & 51 (Figs.35 and 36)
Two of the three studies in the sketchbook taken from a viewpoint on the north bank of the Stour just below Flatford Lock, looking westwards in the direction of Dedham. No oil-sketch or painting is known of this subject, though, clearly, Constable was considering it as a composition.

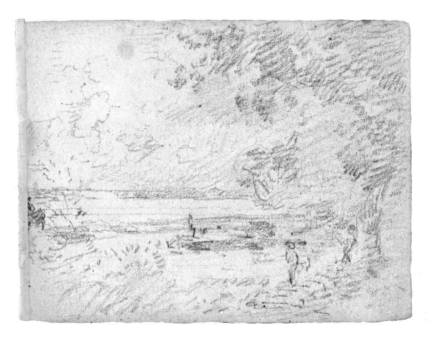

Fig. 36

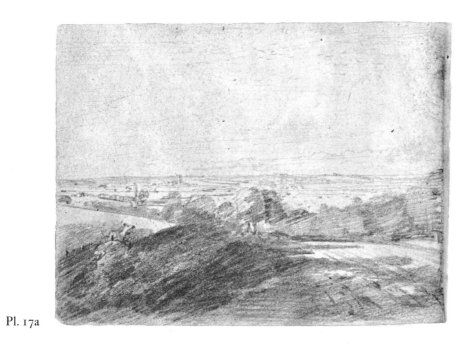

Pl. 17a

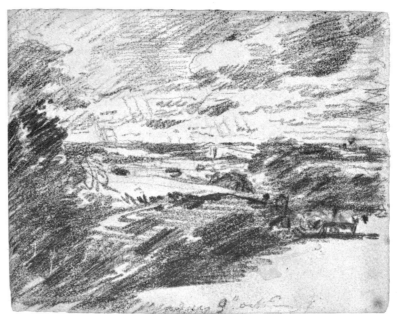

Pl. 17b

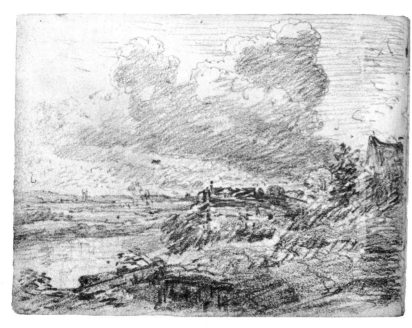

Pl. 17c

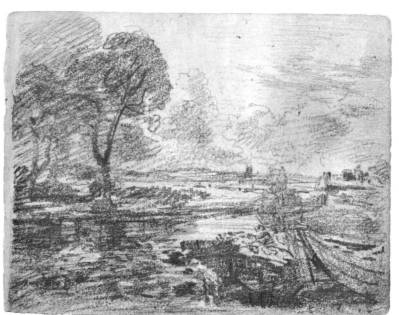

Pl. 17d

51

1814

View at East Bergholt over the Gardens of Golding Constable's House Pl.18
Pencil, $11\frac{7}{8} \times 17\frac{3}{4}$ in (30.2 × 44.9 cm)
London, Victoria and Albert Museum (R176)

Sketchbook, View from Upper Window of Golding Constable's House (p.38) Fig.37
Pencil, $3\frac{1}{8} \times 4\frac{1}{4}$ in (8.0 × 10.8 cm) repr. actual size
Inscr. '22d.Sepr.1814'
London, Victoria and Albert Museum (R132)

Both of the drawings illustrated here were done from one of the upstairs, eastward-facing windows at the back of East Bergholt House, the Constable family home. In the foreground is to be seen the flower-garden, of which Ann Constable, the artist's mother, was so fond, and the adjacent kitchen garden. Nothing now remains of the house (it was pulled down, it seems, in the 1840s), but the wall on the left still stands, as do the stables, out of the picture still further to the left. Beyond the wall we see one of Golding Constable's barns, and on the horizon, to right of centre, the windmill that he worked on the edge of Bergholt Heath. All the fields here in sight were farmed by him and it was the corn from this land, his own harvest, that was threshed in the barn. On the extreme right, half hidden among trees, can be seen the Rectory, where Maria Bicknell used to stay with her grandfather, Dr Rhudde. In two of Constable's letters to her we find him glancing out of the window at this view. 'From the window where I am now writing', he tells her in June, 1812, 'I see all those sweet fields where we have passed so many happy hours together – it is with a melancholy pleasure that I revisit those scenes that once saw us so happy – yet it is gratifying to me to think that the scenes of my boyish days should have witnessed by far the most affecting event of my life –'.[3] Then, on 18 September, only four days before making the drawing seen in Fig.37, we have him writing most movingly thus: 'I beleive we can do nothing worse than indulge in useless sensibility – but I can hardly tell you what I feel at the sight from the window where I am now writing of the feilds in which we have so often walked a beautifull calm Autumnal setting sun is glowing upon the Gardens of the Re[ctor]y and adjacent feilds – where some of the happiest hours of my life were passed – –'.[4]

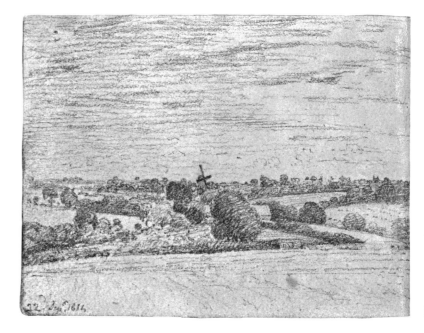

Fig. 37

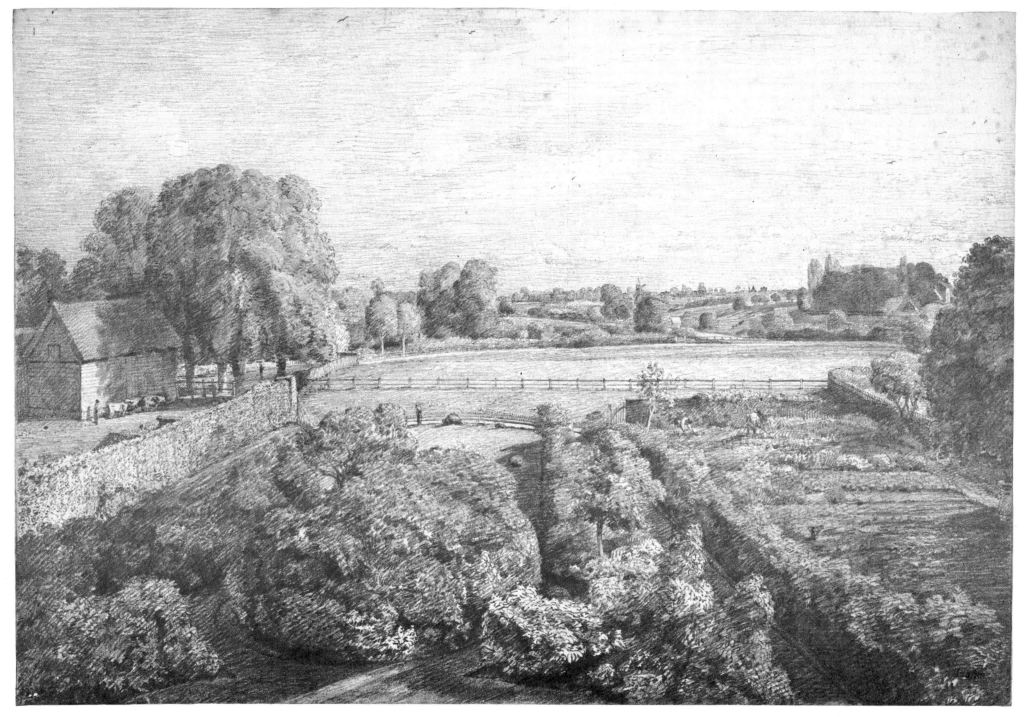

Pl. 18

53

A Lawn at East Bergholt Pl.19a
Pencil 4 × 3⅛ in (10.2 × 7.9 cm) repr. actual size
Inscr. '24 Augt 1815 – Lawn – E B.'
London, Victoria and Albert Museum (R143)

Cottage in a Cornfield Pl.19b
Pencil, 4 × 3⅛ in (10.2 × 7.9 cm) repr. actual size
Of the inscription, only 'E B' is now legible
London, Victoria and Albert Museum (R145)

East Bergholt: Looking towards Stoke-by-Nayland Fig.38
Pencil, 3⅛ × 4 in (7.9 × 10.2 cm) repr. actual size
Inscr. on mount in a later hand 'Aug.23 1815'
Coll. Sir John and Lady Witt

Fig. 38

For many years, until her death in 1811, there lived just across the road from the Constables at East Bergholt an elderly widow, Mrs Roberts. Her house, rather larger and built somewhat earlier than East Bergholt House, was then known as West Lodge. From the house, and from the lawns and parkland that sloped down to the watermeadows and the river, there were to be obtained uninterrupted views of the Stour valley: southwards across to Dedham, and round to the far west towards Stoke-by-Nayland. As a youth, Constable seems to have been quite a favourite of Mrs Roberts' and at least three of his early oil-sketches of sunset effects were painted from her grounds. Only a few months before she died he had painted an evening view from her lawn, and she had already told his mother that she always thought of him 'at the setting Sun – thro' her Trees'.[1] In all the drawings and paintings that can be identified with any certainty as having been taken from West Lodge, there is to be seen a distinctive tree standing in isolation, often almost against the sun and frequently with the tower of Stoke church near to it on the sky-line. In Pl.19a, the last of the dated views of the subject, we see the setting sun, the church tower and the tree brought together in close conjunction – as if in valediction.

The drawing of the cottage (Pl.19b) is undated, but as it comes from the same sketchbook as Pl.19a and two others of 1815 in the Victoria and Albert Museum, it has also been assigned to this year. It is closely related to the familiar oil-painting 'The Cottage in the Cornfield' in the same Museum (see Fig.118). In the 1813 sketchbook there are three drawings which appear to be of this cottage, one of the same elevation and two from the opposite side (pp.59, 25 and 44), the last with a rising moon, inscribed 'twylight'. These suggest that the cottage was not far from Flatford or Bergholt. It is probable that Constable made some use of the drawing when painting his picture of the cottage, but it is not necessarily a study for the picture in the sense that he had the picture in mind when he drew it.

The importance of Constable's studies of skies has been widely recognised and frequently discussed. While it appears to be true that he did not begin a systematic study of clouds much before 1821 (9 July 1819 is the earliest known date of a study of sky without landscape[2]) it is as well to remember that as a boy he was brought up in a household where each day's work had to be planned around the weather, and that there can hardly have been a time in his years as a painter when he had not regarded the sky as inseparably part of the landscape. In Fig.38 we have an earlier study in which the sky is a main feature. It will be noted that this and the sketch from the lawn at West Lodge were drawn on successive days, and that Stoke church tower is again to be seen on the horizon, this time almost hidden by rain.

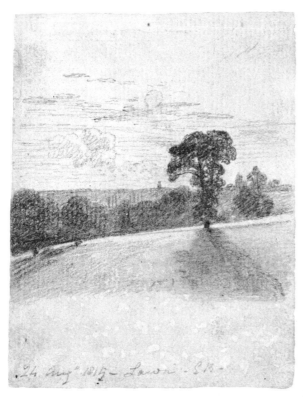

Pl. 19a

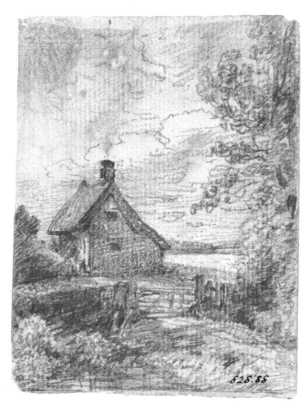

Pl. 19b

Weymouth Bay from the Downs Pl.20
Pencil, $6\frac{7}{8} \times 12\frac{1}{4}$ in (17.5 × 31.1 cm)
Inscr. 'Novr.5.1816.Weymouth'
Manchester, Whitworth Art Gallery, University of Manchester

Osmington Bay, with Portland Island in the Distance Fig.39
Pencil, $4\frac{1}{2} \times 7\frac{1}{8}$ in (11.5 × 18.1 cm)
Inscr. 'Novr. 7. 1816 – Osmington Bay'
London, Victoria and Albert Museum (R151)

Portland Island from Osmington Mills, 1975 Fig. 40

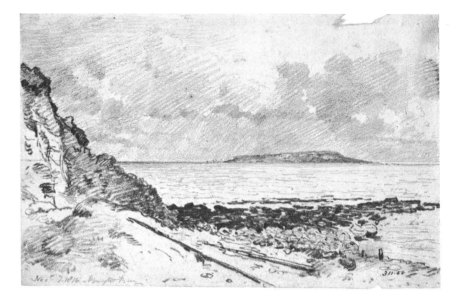

Fig. 39

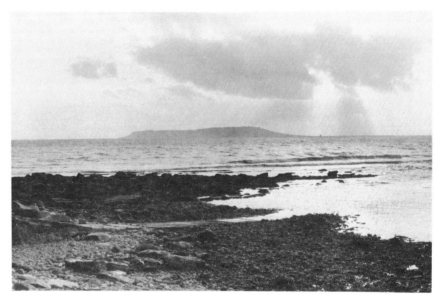

Fig. 40

On 2 October 1816, after their long engagement, Constable and Maria Bicknell were married in St. Martin's-in-the-Fields by the Revd John Fisher, the artist's closest friend. In the letter (27 August) in which he had offered to conduct the ceremony, Fisher had also invited Constable to spend at least part of his honeymoon with him and his wife at the vicarage at Osmington, Dorset. 'The country here is wonderfully wild & sublime & well worth a painters visit. My house commands a singularly beautiful view: & you may study from my very windows. You shall [have] a plate of meat set by the side of your easel without your sitting down to dinner: we never see company: & I have brushes paints & canvass in abundance. My wife is quiet & silent & sits & reads without disturbing a soul & Mrs Constable may follow her example. Of an evening we will sit over an autumnal fireside read a sensible book perhaps a Sermon, & after prayers get us to bed at peace with ourselves & all the world.'[1] This invitation the Constables were happy to accept, and six weeks of their honeymoon were spent with the Fishers at Osmington.

The village itself lies in a fold of the Downs that runs parallel with the line of the coast – in fact it was just out of sight behind the escarpment to the left from the spot where Constable made the drawing of 5 November (Pl.20). This is a view looking down from the heights above the village of Sutton Poyntz. The scene has changed little. When shown a photograph of the drawing, the farmer who works the land could recognise many of his own fields in the middle distance. There are several oil-sketches of the area – including the National Gallery's well-known 'Weymouth Bay'. At least three of these are of views from the little cove known as Osmington Mills, the nearest accessible beach to the vicarage. The sketch shown in Fig.39 was made on the beach looking south towards Portland. This, too has altered little. The cliff has eroded back, but the same line of rocks runs out to sea; boats and lobster pots still lie about on the shore. Just around the headland to be seen in the drawing, the stream that powered the mills (after which the place gets its name) falls in quite a dramatic fashion on to the beach. This was a favourite subject with other artists of the period. The picturesque fall must almost have been within earshot of Constable as he worked. Was his apparent indifference to such an obvious choice of a motif at all self-conscious?

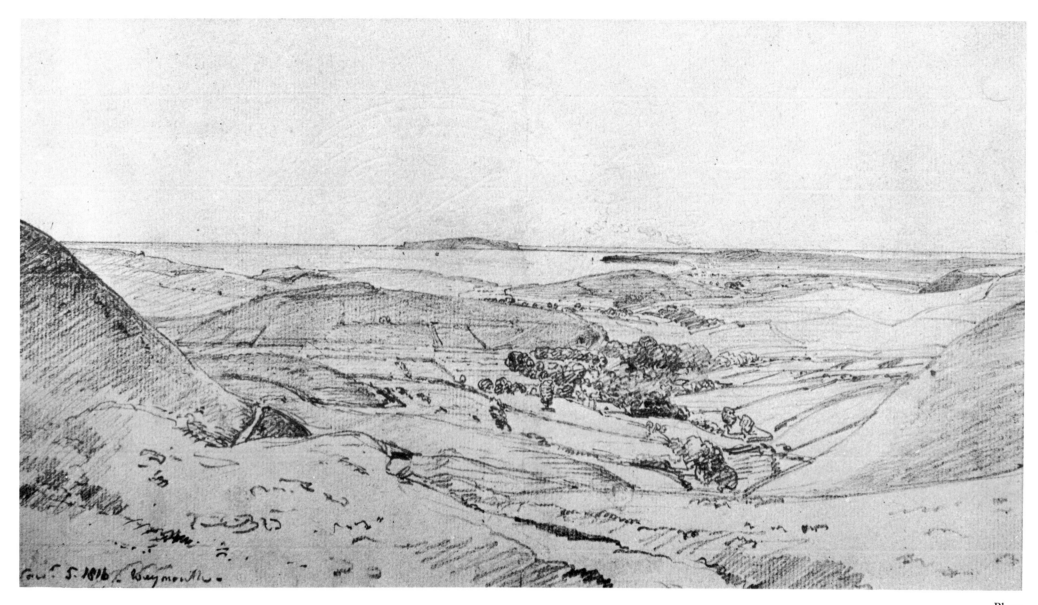

Aug.t 5. 1816. Weymouth.

Pl. 20

1817

East Bergholt Church Pl.21
Pencil, $12\frac{1}{2} \times 9\frac{3}{8}$ in (31.7×23.8 cm)
London, Courtauld Institute of Art (Spooner collection)

Mistley Fig.41
Pencil, $4\frac{3}{8} \times 7\frac{1}{8}$ in (11.1×18.1 cm)
Inscr. 'Augt 20.1817.Mistley'
Paris, Musée du Louvre (RF.32148)

Windmill at Colchester Fig.42
Pencil, $4\frac{1}{2} \times 7$ in (11.5×17.8 cm)
Inscr. 'Saturday Aug 9 1817'
The Executors of Lt. Col. J.H. Constable

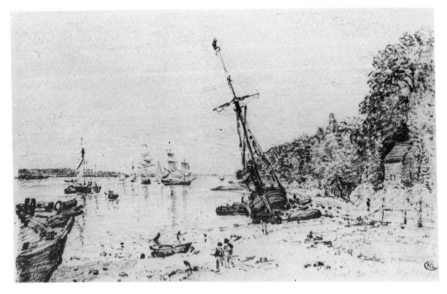

Fig.

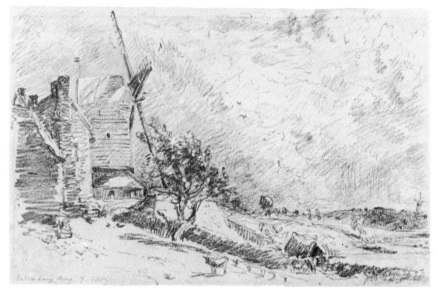

Fig.

In July 1817 Constable took his wife to stay at his old home in East Bergholt; she had not been back since the early days of their courtship. There were changes pending. With both parents now dead, there was talk of selling the house, of one brother and sister, Abram and Mary, returning to live at the Mill-house at Flatford, while the other two, Ann and Golding, moved to something smaller in the village–which is what eventually happened. All must have known that this was probably the last time that they would be together under that roof. With Maria pregnant Constable must have realised too that this would be the last long summer that he would be able to spend at Bergholt, the last of his Suffolk working holidays. He and Maria had now just about moved into their first proper London home, the house in Keppel Street, but it must have been quite a time before he ceased to think of Bergholt as 'home'. A revealing slip of the pen in a letter to Maria written six years later–'I have not heard from ~~home~~ E.B. . . .'[1]–shows that part of him at least still regarded his native village as his true home.

None of the many oil-sketches that he later told Farington he had done during this stay has been identified with any certainty, but there are a dozen or so dated drawings known and some of these are among the noblest of his works with the pencil, the 'Elms' overleaf, for instance (Pl.22). Comparable in quality is the remarkable study opposite of the uncompleted and by then part ruined west tower of Bergholt Church. No finer example can be wished for to illustrate Constable's understanding of structure and of the pattern of erosion than this last study; almost, he seems to have picked away at the crumbling masonry himself, so keenly have the outer shell of flint and the softer inner core of rubble been investigated.

The drawing of the Stour estuary shown in Fig.41 was taken from a viewpoint just downstream from Mistley, the little port where the Constables had their yard for the firm's vessel, the Balloon, to load and unload its cargoes. Another drawing (R181), also inscribed '20 . . .', shows the same vessel from downstream, with Mistley in the background, at high tide. We know nothing that would enable us to identify the little ship that played such an important part in the family business, but it is quite possible that it was the Balloon that Constable was drawing in these two sketches.

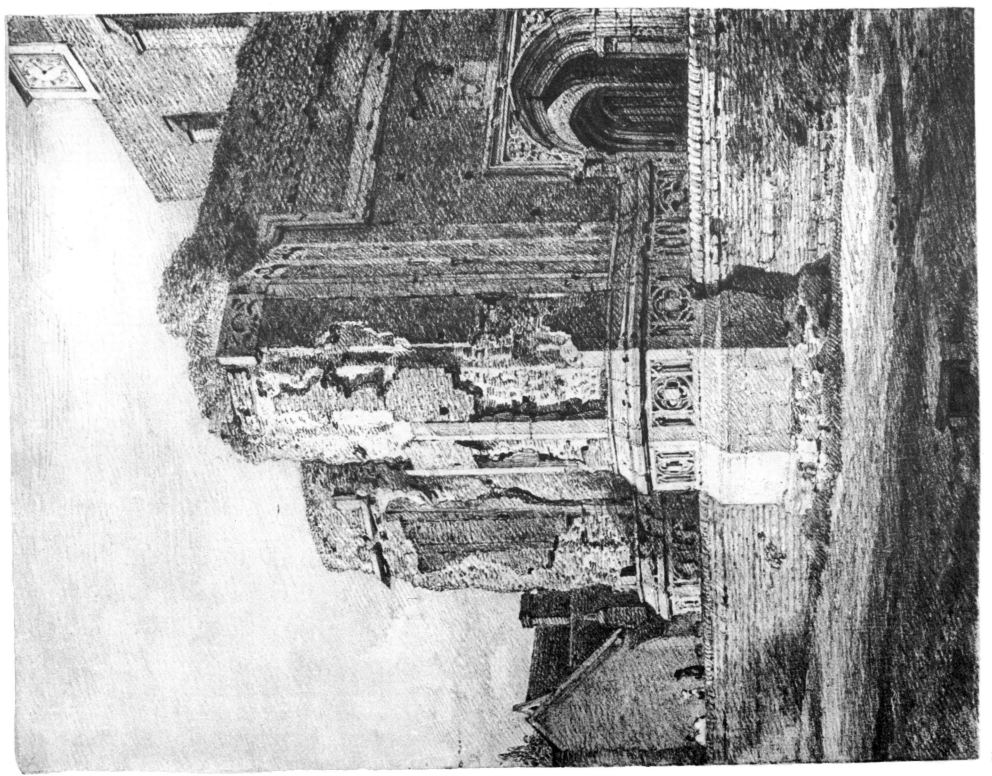

Pl. 21

Elm Trees in Old Hall Park, East Bergholt Pl.22
Detail, repr. actual size

Elm Trees in Old Hall Park, East Bergholt Fig.43
Pencil, grey wash, heightened with white, $23\frac{1}{4} \times 19\frac{1}{2}$ in (59.2 × 49.4 cm)
Inscr. 'Octr. 22d 1817 East Bergholt John Constable 1817'; verso 'This
noble Elm – stood in the Park of Peter Godfrey Esq – called "Old Hall" Park
at East Bergholt – Suffolk it was blown down April 1835. it broke even with
ground – it measured when standing upright [?] 10 × d having [?] formerly
[?] lost the large arm on the Right J.C. This drawing was made 1816. in the
Autumn.' Inscr. in a different hand 'The above is the Handwriting of John
Constable R.A. (who made the Drawing) – Purchased at the sale of his
Pictures and Drawings, at Fosters in – Pall Mall. 16 May 1838 – A. James.'
London, Victoria and Albert Museum (R162)

It is now generally accepted that the drawing illustrated on these two pages
was one of Constable's six exhibits in the Academy of 1818, the work listed in
the catalogue as 'No.483 Elms'. Number 446 in the same catalogue is
described as 'A Gothic Porch'; the study of East Bergholt Church shown on
the previous page (Pl.21) might well have been this exhibit in the 1818
Academy.

Old Hall was a manor with one of the larger holdings in the parish of East
Bergholt. Much of the land and property that the Constables worked, the
mill at Flatford for example, belonged to the owner of that estate. At the
beginning of the century this was a Mr John Reade, for whom in 1801
Constable had painted his first known country house portrait in oils, the
'View of Old Hall' (now in a private collection) which came to light in 1956.[2]
Reade died in 1804 and the house and land were then bought by Peter
Godfrey of Woodford who, on the death of Mrs Roberts of West Lodge, in
1811 acquired the manors of Old Hall and New Hall, both at East Bergholt.
The Godfreys are frequently mentioned in the Constable family correspon-
dence. Mrs Godfrey took a great interest in Constable's early career, buying
his paintings, commissioning portraits, and introducing him to future
patrons.

The heightening with white (whether chalk or opaque watercolour it is not
possible to say) may not be visible in our reproductions as Constable only
used it in the foreground – to soften the edges of some of the shadows, for
instance. The brownish grey wash is only to be found in the foreground,
also sparingly applied, to achieve textures unobtainable in pencil. In the
original it is noticeable that Constable used pencils of differing degrees of
hardness. The beautiful luminosity of the shadows owes much to his con-
trolled play with the harder and softer pencils.

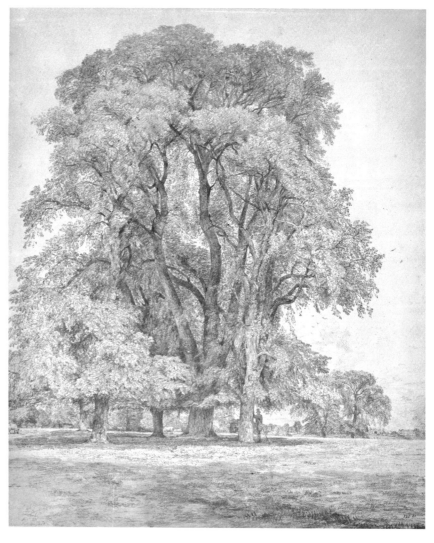

Fig. 43

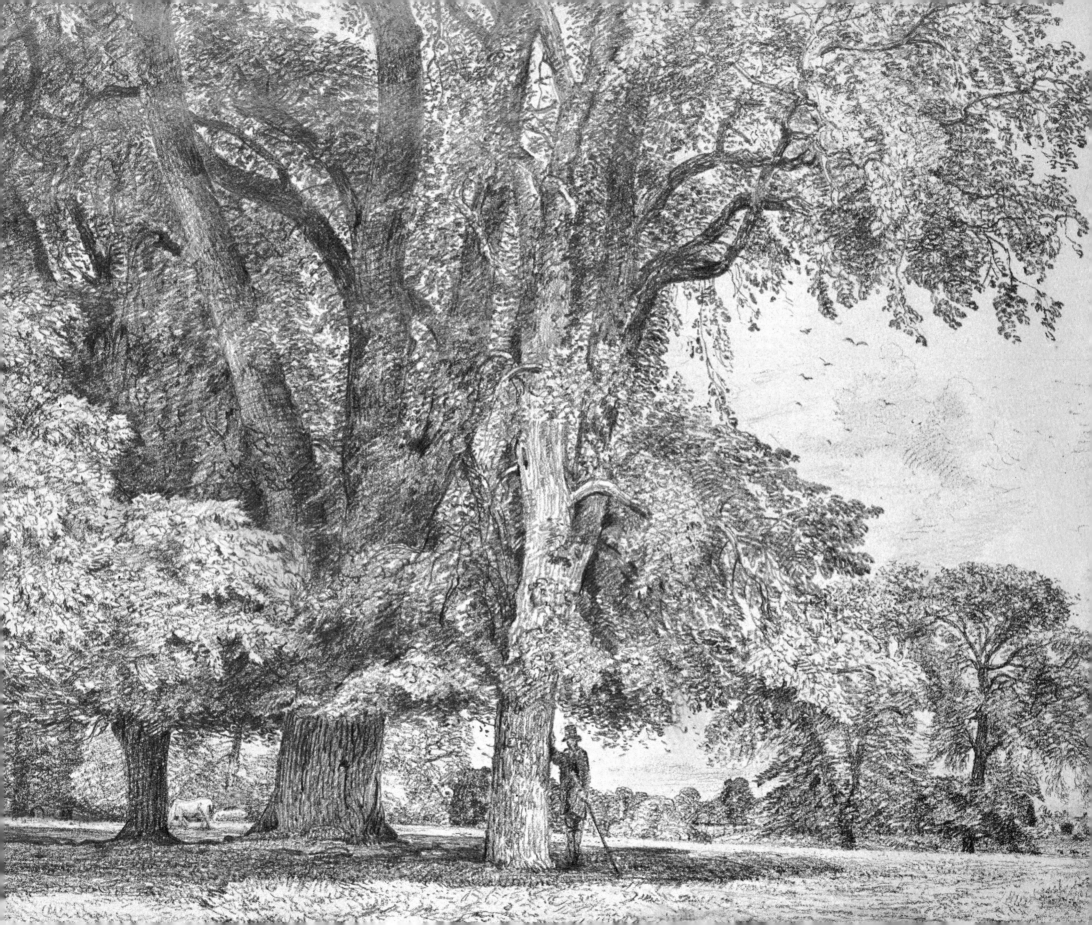

Bristol House, Putney Heath Pl.23a
Pencil, $3\frac{15}{16} \times 10\frac{1}{4}$ in (10.0 × 26.1 cm)
Inscr. 'Augt 13. 1818. Putney Heath'
Cambridge, Fitzwilliam Museum

A Windmill at Barnes Pl.23b
Pencil, $3\frac{7}{8} \times 5\frac{1}{4}$ in (9.9 × 13.3 cm)
Inscr. '8 Sepr Barnes'
Private collection

The Semaphore on Putney Heath Pl.23c
Pencil, $3\frac{15}{16} \times 5\frac{3}{16}$ in (10.0 × 13.1 cm)
Inscr. '8 Sepr 1818'
Cambridge, Fitzwilliam Museum

Golding Constable's House and East Bergholt Church Fig.44
Pencil, 4 × 5 in (10.2 × 12.7 cm)
Inscr. '27th. Octr. 1818'
The Executors of Lt. Col. J.H. Constable

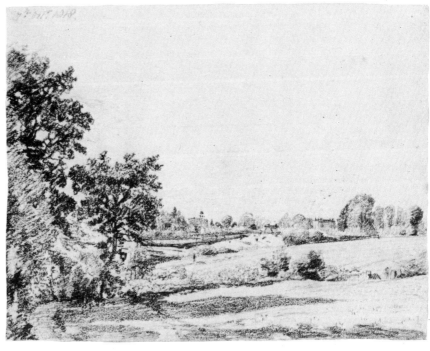

Fig. 4

In 1815 Constable's future father-in-law, Charles Bicknell, had taken a small house for his three daughters at Putney, near Roehampton. One of a terrace named after Bristol House (beside which the row had been built), the house was situated on the edge of the Heath, and after their marriage Constable's wife would return there from time to time to stay with her two sisters. During the summer of 1818 Constable was busy with portrait commissions, but when Maria was at 'Louisa Cottage'[1] with their baby son he would join her there for short holidays, and it must have been on two of these visits that he made the drawings opposite (Pls.23a, b & c). From the double-spread in his sketchbook (Pl.23a) Constable did three tinted drawings of the Bicknells' house, perhaps one for each of the sisters–his wife, Louisa and Catharine. One of the replicas, delicately executed in pen and watercolour and suitable for any young lady's album, is in the Victoria and Albert Museum (R165).

The central feature of Pl.23c, the semaphore, was one of a chain of eight that ran from from London to the Portsdown Hills, a communication system that enabled signals to be passed at high speed in clear weather between Admiralty and the Fleet at Portsmouth.[2] It will be noted that this drawing and the sketch of the windmill at Barnes, with their dissimilarly treated skies, were both drawn on the same day. On 8 September Constable also made a large pencil study of Fulham Church from across the river.[3]

The drawing of his old home, Fig.44, was done by Constable during a visit to East Bergholt in the autumn of that year to discuss family affairs, the sale of the house, Abram and Mary's move back to Flatford, and other like matters. Constable was always deeply moved when he returned to his native countryside; this visit he seems to have found especially poignant. 'I cannot enter this dear village', he wrote to Maria on the day of his arrival, 'without many regrets–the affecting sentiment of this roof containing now no more those who nourished my childhood & indulged my early years in almost every wish–the thoughts of these dear memories fill my eyes with tears while I am now writing–'.[4] His view of the house was taken from one of the more distant fields to be seen in Pl.18, the fields near the Rectory where he and Maria had walked together in the early days of their courtship.

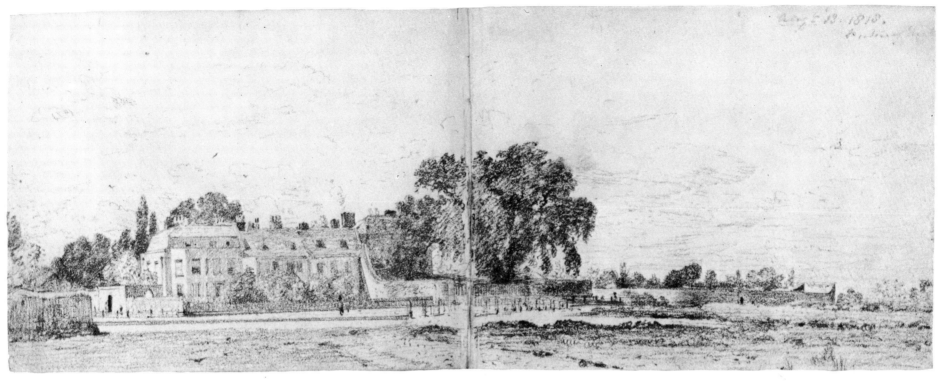

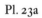

Pl. 23a

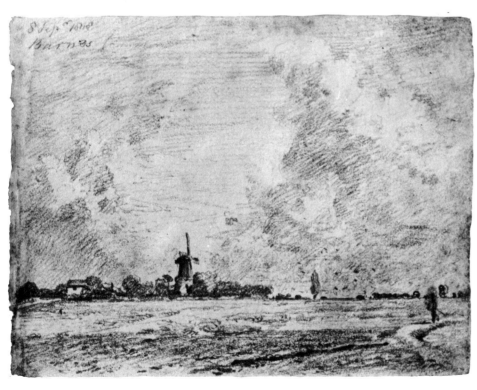

.23b

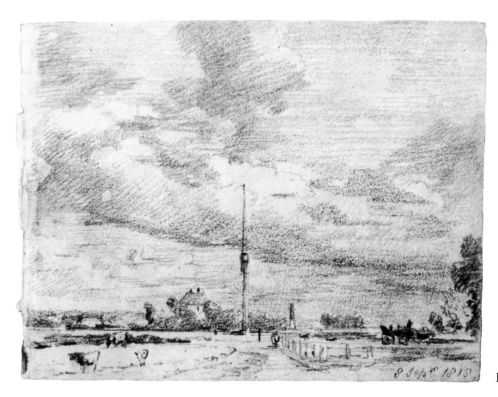

Pl. 23c

The Wheatfield, after Ruisdael Pl.24a
Pen and brown ink, 4×6 in (10.3×15.2 cm)
Inscr. as if signed by Ruisdael 'Ruysdael.fe:'. Inscr. verso 'J.C. fe: 1818'
London, Victoria and Albert Museum (R169)

The Wheatfield, Jacob van Ruisdael Pl.24b
Etching (3rd state), $3\frac{15}{16} \times 5\frac{13}{16}$ in (10.0×14.7 cm)
London, The Trustees of the British Museum (1839-3-9-24)

A Landscape with a Cornfield, after Ruisdael Pl.24c
Pencil, $3\frac{1}{2} \times 4\frac{3}{8}$ in (8.9×11.0 cm)
Inscr. verso 'V.W[?elde]–1 foot $4\frac{1}{2}$/l d° $7\frac{1}{4}$/hight of Hor[?se] 3 inches/
Ruysdeal [the next two measurements one above the other and bracketted]
1 foot 6/l d°. $9\frac{1}{2}$/British Gallery July 13.1819'
The Executors of Lt.Col. J.H. Constable

A Landscape with a Cornfield, Jacob van Ruisdael Pl.24d
Oil on canvas, 1ft 6in \times 1ft $9\frac{1}{2}$in (45.7×54.6 cm)
Thomas Agnew & Sons Ltd

As we have seen (Fig.1) the earliest known signed and dated drawing by Constable is a copy, a copy of an engraving after one of the Raphael Cartoons. Throughout his life we find him making copies: studied and meticulously executed near-facsimiles, as well as quickly-drawn memoranda of works seen at exhibitions; copies of paintings and drawings by the great masters of the past, but also of drawings by friends such as J.T. Smith and Sir George Beaumont. In one form or another he is known to have copied artists as diverse as Correggio, Rubens, Rembrandt, Cuyp, van de Velde, Reynolds, Alexander Cozens, Hoppner and Lawrence, but there were two artists whose work he never seems to have tired of studying and copying – Claude and Ruisdael.

The earliest reference to the copying of a Ruisdael is to be found in a letter of 1797 to Smith. In this, Constable says he has 'a great mind to copy one of Rysdale's etchings' and asks him to send him one which is not too scarce and expensive.[1] Probably his last 'Ruisdael' was painted in the autumn of 1832: a winter scene with windmills belonging to Sir Robert Peel, who only agreed to lend the picture if there was an addition or omission in the copy which would enable it to be distinguished from the original – a curious condition, though perhaps a tribute, if a somewhat backhanded one, to Constable's skill as a copyist. Ruisdael is one of the artists most often mentioned in the correspondence with Fisher. Notes sent round to Constable by hand are addressed 'Reysdale' and 'Ruysdale' House,[2] and one of the artist's most memorable descriptions of a painting by the Dutchman is to be found in a

letter to Fisher of 28 November 1826: 'I have seen an affecting picture this morning, by Ruisdael. It haunts my mind and clings to my heart – and has stood between me & you while I am now talking to you. It is a watermill, not unlike "*Perne's Mill*" [at Gillingham] – a man & boy are cutting rushes in the running stream (in the "*tail* water")–the whole so true clear & fresh–& as brisk as champagne–'.[3] In the sale of his paintings which was held the year after his death there were four copies after Ruisdael – one of them being Peel's 'Winter Scene'.

The drawings on the opposite page are good examples of two sorts of copy – the facsimile and the memorandum. In the first, the pen and ink drawing of the etching, it was plainly his intention to reproduce as closely as he could the character of Ruisdael's individual hand, in some passages line by line and touch by touch – in the topmost twigs of the nearest tree, for instance. But that this was not just a study of the technique and vision of another artist is equally plain, for if that had been his sole reason for making it we would not find an imitation of the unwiped edge of the plate around his drawing, and a 'Ruysdael.fe:' copied in the top right-hand corner. Was it, in fact, an elaborate leg-pull, one wonders, perhaps in reply to Fisher's 'Reysdale House', also of 1818?

Until quite recently, when Robert Hoozee noticed the resemblance to the Ruisdael painting, the drawing of the cornfield (Pl.24c) was always considered to be just a Suffolk view. Now, of course, with the help of the inscription on the back, all is made clear. Constable had been given a ticket by Farington for the reception on the evening of 28 June at the exhibition of Old Masters organised by the British Institution (the 'British Gallery').[4] He must have gone to the exhibition again on 13 July and not only sketched No.51 – 'Landscape, with Figures and Cattle Ruysdael and A,Vandevelde Earl of Mulgrave [owner]' – and noted its size on the back of the page, but also noted another [?A.] van de Velde, perhaps No.94, 'The Hayfield'.

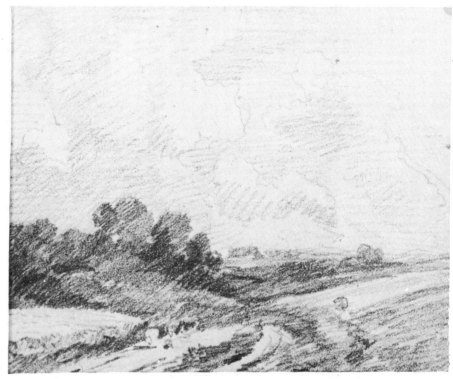

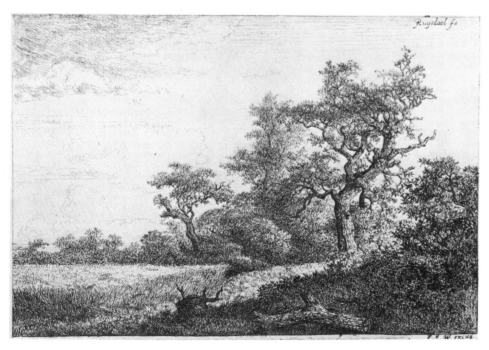

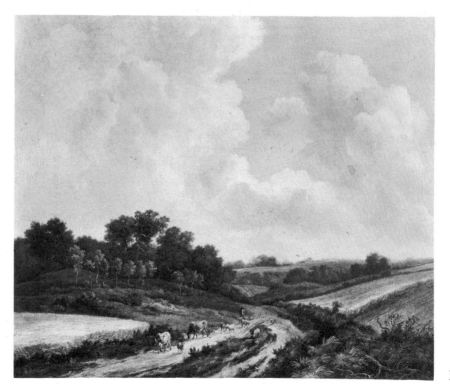

1819

Sketchbook
Various media, $2\frac{5}{8} \times 3\frac{5}{8}$ in (6.7 × 9.2 cm) repr. actual size
Inscr. inside of cover 'Hampstead – Sepr. 9th. 1819'
London, The Trustees of the British Museum (1972–6–17–15)

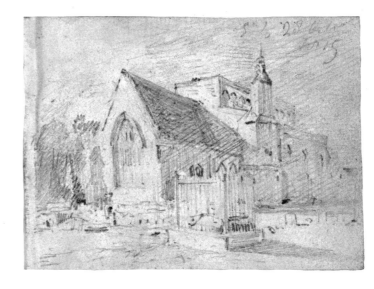

Fig. 45

The drawings in this little sketchbook were first identified as the work of Constable in 1972. They are of a variety of subjects: views at Hampstead and East Bergholt; men at work; animals, both out of doors and indoors; figure studies, including a woman feeding a child and a male model in a Life-class; trees, boats and childish scribbles – some of these defacing work by the artist. Constable does not seem to have used the book for much more than two months – a study of a cedar is inscribed Putney 10 Novr.1819 – but its discovery is nevertheless of some importance as there was relatively little dated work in any medium for 1819.

Shortly after the christening of their second child, Maria Louisa, on 20 August, Constable moved his wife and their young family to a cottage quite near the Heath at Hampstead which he had taken for the remainder of the season. The move had been undertaken for the sake of Maria's health, but in fact it provided Constable with an opportunity to work out of doors, an opportunity sorely needed now that they were London residents. This was the first of their seasonal migrations to Hampstead. Later, of course, they settled permanently there, in Well Walk.

'View from Hampstead looking towards Harrow' (Pl.25a) Pencil. Inscr. '10 Octr. 181[?9]
This must be one of the very first studies Constable made of the view westwards with the house known as the Salt Box and the familiar single isolated tree prominently in the middle distance. As the position of the sun (top left-hand corner) shows, it was approaching evening when Constable noted the scene.

'Hampstead, the Lower Pond' (Pl.25b) Pencil
On the inside margin of the opposite page, there are to be seen three accidental blots, the shapes of which mirror-image the irregular inner edge of this beautiful little drawing. It is noticeable that all the drawings in the book done in soft pencil have at some later time been washed with a fixative, possibly with diluted isinglass, a pure form of gelatin. In the case of this drawing, it appears that the book was shut before the fixative along the inner edge of the drawing had had time to dry and that these still wet areas had consequently stuck to the opposite sheet, so that when the pages were opened again the pencilling stuck to the blotted but now dry fixative, producing the mirror effect.

'A Quarry with Cart and Team of Horses' (Pl.25c) Pen and greyish-brown ink
Truly a little masterpiece; probably again Hampstead. It was not Constable's normal practice to carry a pen and ink drawing thus far. Did he take a bottle of ink out with him, or was the subject lightly drawn in pencil on the spot and then worked up at home?

'A Hampstead view' (Pl.25d) Pencil
Leslie tells us that Sir George Beaumont showed the young Constable the thirty or so watercolours he owned by Girtin, and advised him to study them 'as examples of great breadth and truth.' 'Their influence on him', Leslie continues, 'may be traced more or less through the whole course of his practice.'[1] This drawing could be an example of what Leslie had in mind.

'East Bergholt Church from the N.E.' (Fig.45) Pencil. Inscr. 'E B 28 Octr 1819'
Towards the end of October Constable left Maria in Hampstead with her sister, Catharine, and went to Bergholt to join his brothers and sisters in dividing up 'the spoil', as he called it, the china, silver, linen, etc., from the family home. On another page of the sketchbook he made a study of the tomb to be seen in the foreground here, the tomb of his parents. Normally he gave 'East Bergholt' as the address when writing from there. His letter of 24 October to Maria at Albion Cottage, Hampstead, is headed 'Poor Old Bergholt'.[2]

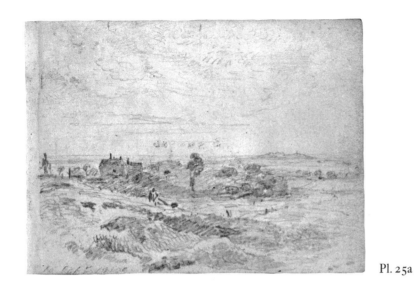

Pl. 25a

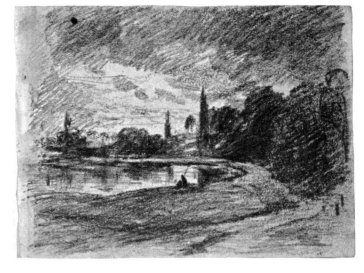

Pl. 25b

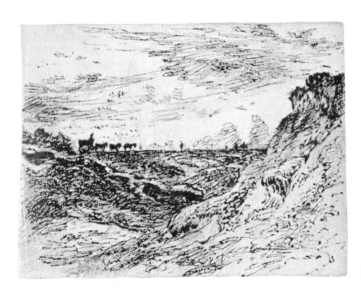

Pl. 25c

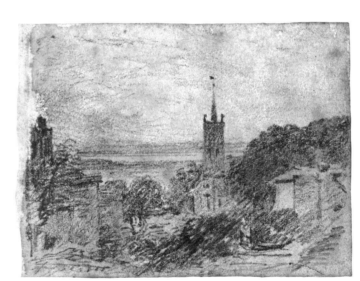

Pl. 25d

Waterloo Bridge from the West Pl.26
Pencil, $12 \times 16\frac{1}{8}$ in (30.6×41.0 cm) Detail, repr. actual size
London, Victoria and Albert Museum (R173)

The Thames Waterfront and Waterloo Bridge Fig.46
Pencil, $4\frac{5}{16} \times 7\frac{1}{16}$ in (11.0×18.0 cm)
Private collection

Waterloo Bridge from the Left Bank Fig.47
Pencil, $4\frac{3}{8} \times 7$ in (11.0×17.8 cm)
Rhode Island School of Design, Museum of Art, Anonymous Gift

Fig.

On 18 June 1817, the second anniversary of the battle of Waterloo, the Prince Regent embarked in the Royal Barge from Whitehall Stairs to perform the ceremony of naming the new bridge built to span the Thames. It is possible that Constable had witnessed the ceremony from the adjacent terrace of Somerset House, which of course at this time housed the Royal Academy. A few days later, the 27th, he added a postscript in a letter to his wife: 'I go to the Exhibition every day – Last evg I walked over the Waterloo Bridge–'.[1]

Constable first mentions a preparatory work for his great painting 'Waterloo Bridge from Whitehall Stairs' two years later in a letter to John Fisher: '. . . I have made a sketch of my scene on the Thames – which is very promising.'[2] Then, on 11 August, Farington noted in his diary: 'Constable called, & brought with him a painted sketch of his view of Waterloo bridge . . . I objected to his having made so much a "Birds eye view" and thereby lessening magnificence of the bridge & buildings. He sd. he would reconsider his sketch.'[3]

It is not known how or when the idea first came to Constable for a painting of this, for him, very unusual subject, but one of Turner's two big pictures in the Academy of that year, 1819, had been titled 'England, Richmond Hill, on the Prince Regent's Birthday', and it is possible that this may have prompted someone, his father-in-law for instance who was a solicitor to the Regent, to suggest that there might be something to be gained from attempting a work of a comparable nature.

The problem of finding a date for the drawings shown here is still open to solution, but the final painting and most of the other known studies for it are seen from a lower viewpoint, so it is likely that the big drawing (Pl.26) antedated the bird's eye view to which Farington objected. Fig.46 shows Constable working almost at water-level. From this he made an oil-sketch which now belongs to the Royal Academy. Fig. 47 is taken from a slightly higher vantage point. The oil-sketch in the Victoria and Albert Museum (R174) was probably based on this second drawing.

Fig.

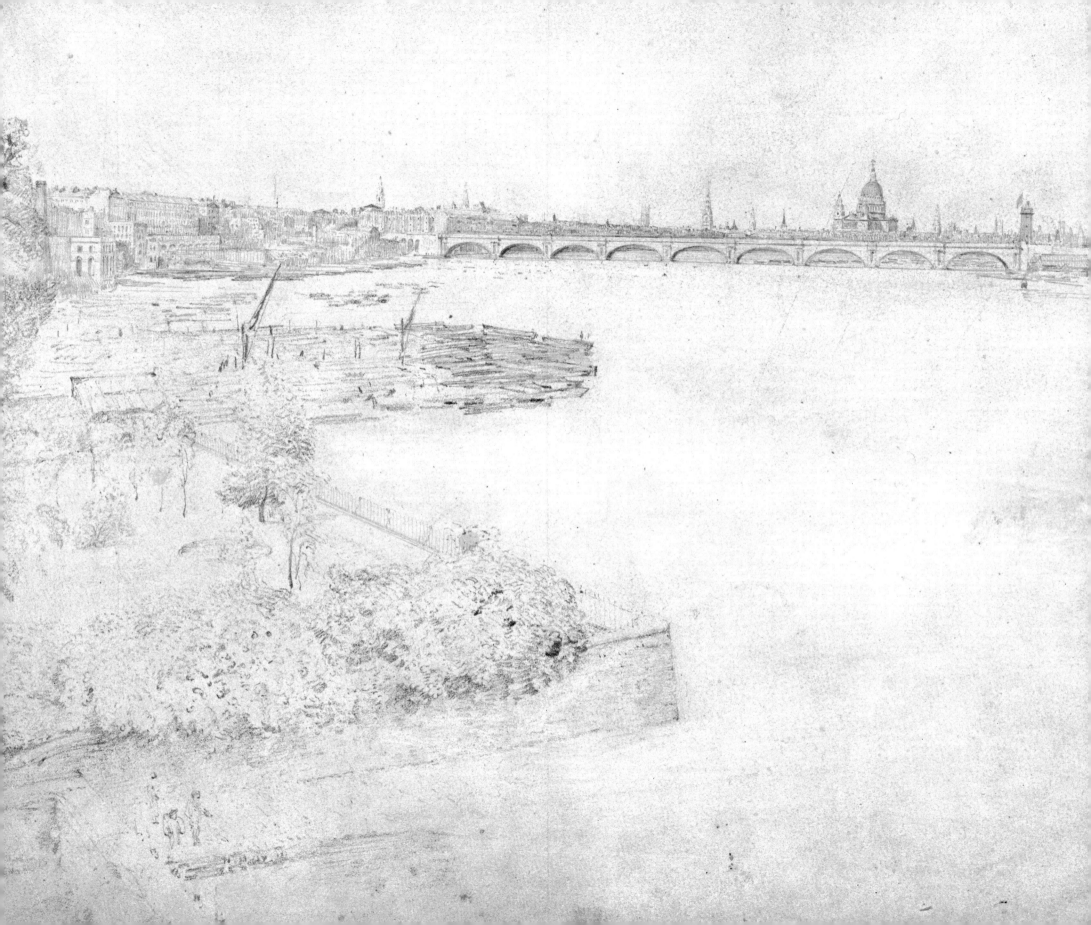

1820

Stonehenge Pl.27
Pencil, $4\frac{1}{2} \times 7\frac{3}{8}$ in (11.5×18.7 cm) repr. actual size
Inscr. '15 July 1820'
London, Victoria and Albert Museum (R186)

Salisbury Cathedral from the River Fig. 48
Pencil, $4\frac{1}{2} \times 7\frac{1}{4}$ in (11.4×18.4 cm)
Inscr. '18 July 1820'
Private collection

Salisbury Cathedral from Old Sarum Fig.49
Pencil, $6\frac{1}{4} \times 9\frac{1}{8}$ in (15.9×23.2 cm)
Private collection

Fig.

In the Academy of 1819 there had hung the first of Constable's six-foot canvases of the Stour, the picture now known as 'The White Horse' (see Fig.114). After enquiring its price on behalf of 'the gentleman who meditates the purchase', on 19 July 1819 John Fisher wrote to declare his own interest in the picture. His letter begins: 'As I have painting utensils here of every sort, you have only to put yourself into the Mail any day & come down hither. When your great picture is finished & you can spare it from the exhibitions I wish to become the purchaser.'[1] On the day Fisher wrote his letter, Constable's second child, Maria Louisa ('Minna'), was born and with his new responsibilities there was no longer any question of just putting himself into a coach for a jaunt into the country. However, a visit to Salisbury was eventually arranged for the whole family the following summer, and in July the Constables arrived at Leydenhall, the Fishers' house in the Close, for a two months' stay. During their time together Constable and Fisher went on a number of excursions; to Old Sarum, near at hand; to the New Forest; to Gillingham, of which parish Fisher had recently been made vicar; and to Stonehenge. There are drawings of all these places and oil-sketches as well as drawings of the Cathedral and its immediate environs. When writing after their return to thank the Fishers for all their kindnesses, Constable tells the Archdeacon that his Salisbury sketches 'are much liked – that in the palace grounds – the bridges – & your house from the meadows – the moat – &c.' He goes on to say that he was putting his 'Thames', i.e. his 'Waterloo' on a large canvas, and that it promised well.[2]

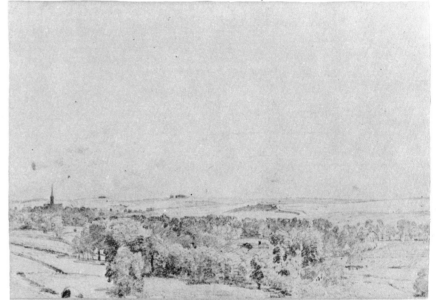

Fig.

Some fifteen years later, Constable turned to the drawing of Stonehenge (Pl.27), and from it painted one of his most impressive watercolours (Pl.50). In this sketch of 1820 there is no sign of the feature which dominates the watercolour, the over-arching rainbow, but in the watercolour Constable did make use of the great waggon that he had originally noted in the drawing as the vehicle passed slowly by in the background.

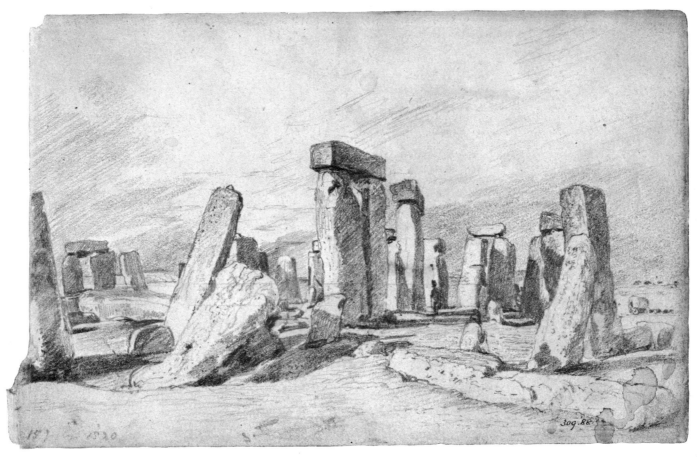

Pl. 27

1820

Malvern Hall Pl.28
Pencil, $4\frac{17}{32} \times 7\frac{3}{16}$ in (11.5 × 18.3 cm) repr. actual size
Inscr. 'Malverne Hall Sepr.10.1820'
The Executors of Lt. Col. J.H. Constable

Fir Trees at Hampstead Fig.50
Pencil, $9\frac{3}{16} \times 6\frac{1}{4}$ in (23.2 × 15.9 cm)
Inscr. 'Wedding day. Hampstead Octr.2.1820'
London, Victoria and Albert Museum (R203)

This sparkling drawing of Malvern Hall was made on the second of Constable's visits to the house near Solihull belonging to his patron, Henry Greswolde Lewis. The purpose of his previous visit, in 1809, had been to paint a portrait of Lewis' ward, the charming Mary Freer. Over the years which followed Constable was given tasks and commissions by Lewis for which he was not always best fitted: a miniature likeness of Mary Freer's eye on a shirt pin; a figure of a Norman warrior for a nine-foot panel to hang over the main stairs at Malvern; and a sign for an inn, the Mermaid, at nearby Knowle. In April 1819, when writing about the panel of his Norman ancestor, Lewis had asked Constable to Malvern again. 'I shall have great pleasure in your seeing it again, & meeting Lady Dysart this summer & taking your opinion, in forming the Landscape of the park by cutting glades & shearing timber & tree so as to give a forest scenery.'[3] Magdalena, Countess of Dysart, Lewis's sister, had been a patron of Constable's for even longer than her brother and one of the artist's reasons for the present visit may have been a commission from her to paint two views of the Hall, her old home. Neither of the two known paintings of this entrance front was taken from the same viewpoint as our drawing. It is surprising that the owner himself does not appear to have ordered a landscape from Constable, of Malvern or any other subject.

Soon after getting back from Salisbury, Constable had moved his family up to Hampstead again. The air was undoubtedly better there, but this time he was also concerned for their safety, the streets of London having been in an uproar since the start of the 'Queen's Trial', the House of Lord's enquiry into the conduct of Queen Caroline–'the Royal Strumpet', as Constable called her.[4]

It has been suggested that Leslie was referring to the tree study shown here (Fig.50) in the following anecdote about William Blake. 'The amiable but eccentric Blake, looking through one of Constable's sketch books, said of a beautiful drawing of an avenue of fir trees on Hampstead Heath, "Why, this is not drawing, but *inspiration*;" and he replied, "I never knew it before; I meant it for drawing."'[5] It is known that Constable and Blake met once at least, for they feature together (in company with John Varley) in the entry in John Linnell's diary for 12 September 1818.

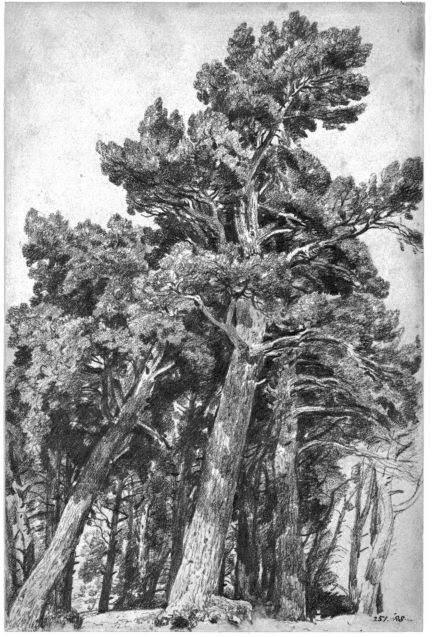

Fig.

72

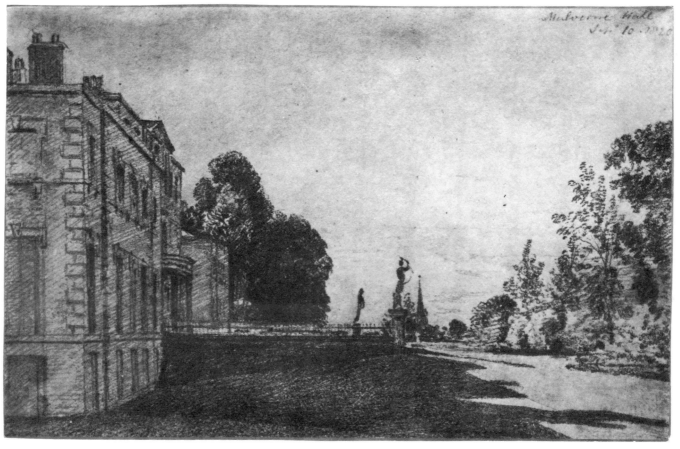

Pl. 28

73

1821

A Lock near Newbury Pl.29
Pencil, $6\frac{1}{2} \times 9\frac{7}{8}$ in (16.5×25.1 cm) repr. actual size
Inscr. 'Lock near Newbury [June] 5 1821'
Private collection

A Water-mill at Newbury Fig.51
Pencil and grey wash, $6\frac{3}{4} \times 10\frac{1}{4}$ in (17.2×26.1 cm)
Inscr. 'Newbury Berks June 4. 1821'
London, Victoria and Albert Museum (R211)

A Sunken Barge at Reading Fig.52
Pencil, $6\frac{3}{4} \times 10\frac{1}{8}$ in (17.2×25.7 cm)
Inscr. 'Reading June 6. 1821'
Private collection

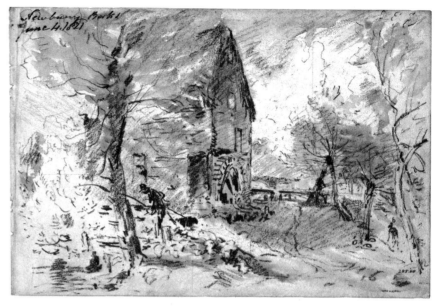

Fig.

All three drawings shown here were done when Constable accompanied John Fisher on one of the latter's Visitations of Berkshire in his official capacity as Archdeacon. Fisher had broached the idea in a letter of 6 March: 'The first week in June I go my Visitation. Will you accompany me free of expence. I shall take Oxford in my way.—'[1] In his reply Constable had not responded to the invitation as he had other things on his mind–the recent birth of his third child and the imminent sending-in-day at the Academy. But by the beginning of June life had sufficiently returned to normal for him to leave his family for a few days, and on the 4th he and Fisher were staying at *The Pelican* in Newbury. Both the quality of his drawings and the number of pages that he filled in his sketchbook (a slightly larger one than usual) suggest that Constable was in something of a holiday mood on this trip. When in unfamiliar surroundings most people like to be reminded of their own part of the country. Whether in Sussex, Dorset or in Berkshire, as at this time, Constable was always quick to note familiar things–windmills, locks, or ploughs–if only to record differences of design or situation. On this short tour they were never far from navigable water. All six of the dated drawings Constable made during the two days at Newbury were drawn on the banks of the Kennet or of the Kennet and Avon canal (see Pl.29 & Fig.51). On the third day they were at Reading, where Constable again managed to find his way down to the water-side (Fig.52). Their visit to Abingdon on the 7th was the occasion for three drawings, of which two were of the river. By the 8th Fisher had completed his rounds, and the two men were both free to enjoy themselves. They spent a night at Woodstock, where Constable obtained the visitors' view of Blenheim Palace over the tops of the trees from the Woodstock end of the great drive (R219). The 9th, their last day, was spent at Oxford, of which Constable only made one drawing, the view of the High Street now in the British Museum.

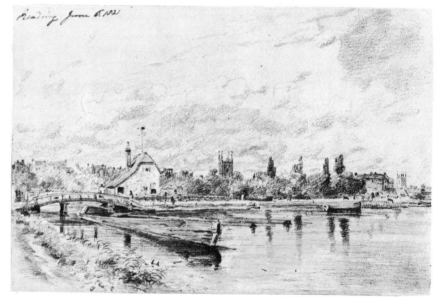

Fig.

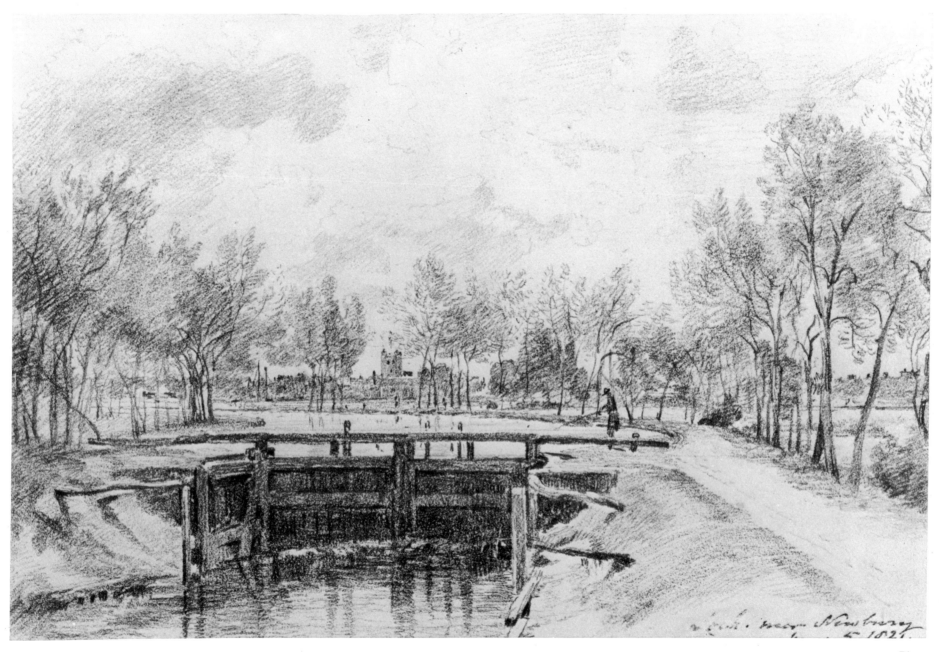

A Lock near Newbury 1821

Pl. 29

75

1821

Trees Against the Sky Pl.30
Pencil and watercolour, $6\frac{5}{8} \times 9\frac{15}{16}$ in (16.9 × 25.2 cm) repr. actual size
London, The Trustees of the British Museum (L.B.28b)

Winchester Cathedral: West Front Fig.53
Pencil and grey wash, $6\frac{1}{4} \times 9\frac{1}{4}$ in (15.9 × 23.5 cm)
London, Victoria and Albert Museum (R238)

This year Constable again moved his family up to Hampstead for the summer, taking for them a small house, No.2 Lower Terrace. Here he spent much of his time from the beginning of August to the end of October, having converted an old shed in the garden into a 'place of refuge'[2] where he could work on his smaller oil-sketches and paintings. This was the first of the two seasons at Hampstead when Constable's working hours in the open seem to have been devoted almost entirely to the study of the sky. Many of this year's oil-sketches of skies include roof-tops, obtruding parts of buildings and the tops of trees and bushes, and would appear to have been painted from the windows of No.2 or from the garden at the back. In one of these (R232) there is to be seen a line of washing pegged out, and against dark clouds two poplar trees and the upper storey of a house. A companion to our Pl.30, a watercolour in the Victoria and Albert Museum (R242), shows the same poplars and house but from a slightly different angle. This undated drawing and ours must surely have been done within a short space of time, so alike are they, both having the same underdrawing in soft pencil, the same rapidly dashed-in shading, and the same wet colour washes. It is doubtful, however, if Constable could have seen a view quite like Pl.30 from Lower Terrace.

Fisher was always hoping to have Constable to stay with him again. It may have been the following passage in his letter of 26 September which finally proved the irresistible lure: 'I was the other day fishing in the New Forest in a fine deep broad river, with mills, roaring back waters, withy beds, &c. I thought often of you during the day. I caught two pike, was up to the middle in watery meadows, ate my dinner under a willow, and was as happy as when I was "a careless boy."'[3] Constable rose to this with his famous '. . . sound of water escaping from Mill dams . . . Willows, Old rotten Banks, slimy posts, & brickwork. I love such things–'.[4] By the second week in November he was on his way to Salisbury. He had told Fisher how much he wanted to see Winchester; he was not disappointed. '…it is the most magnificent Cathedral I ever saw', he wrote to tell Maria, 'much more impressive but not so beautiful as Salisbury–and all about the town is much more for a painter than here.'[5]

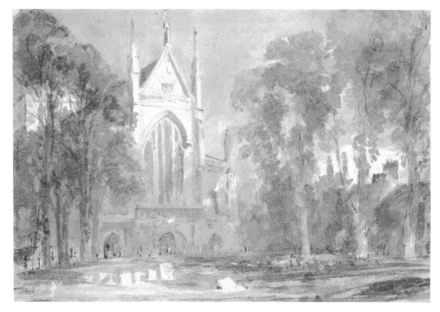

Fig.

76

Pl. 30

1823

Bentley Pl.31
Pencil, $6\frac{5}{8} \times 10$ in (16.8×25.4 cm) repr. actual size
Inscr. 'Bentley 21. April 1823'
London, The Trustees of the British Museum (L.B.9)

Boathouse at Flatford Fig.54
Pencil, $6\frac{11}{16} \times 10$ in (17.0×25.4 cm)
Inscr. 'E.B.April 20. 1823'
London, The Trustees of the British Museum (L.B.11a)

In contrast to the previous year, 1823 is rich in dated or datable drawings, some being of the highest quality. The year started badly for Constable, with the whole family ill, but by the end of February he reported to Fisher that he was back at work again. The drawings shown here record a visit, presumably a short one, to Suffolk. Nothing else is known of this trip, but it was at about this time that Constable obtained for his difficult elder brother, Golding, a position as warden of the Countess of Dysart's woods at Bentley, a few miles from Bergholt. The date of this appointment is uncertain, but the drawing of Bentley suggests that Constable was engaged on his brother's behalf in some way during this stay.

In the 1819 sketchbook we have seen an accidental effect resulting from excessive and hurried fixing. Another result of carelessly fixing a drawing can be observed in the view of Bentley. In this study it does not seem to have been the artist's intention to indicate tone of any sort in the sky, yet over the house there is a discernible patch of pencilling, a patch with some of its edges quite sharply defined. To the right of the single tree, and also in the hedge to the right of the gate, there are to be seen equally hard-edged patches, but in this case they are areas from which some of the graphite seems to be missing. The latter, the fainter areas, appear to be those the artist failed to set with fixative, and from which graphite has consequently rubbed off–probably while in contact with another sheet or drawing. The former, the apparent pencilling in the sky, shows the effect of such rubbing, the transfer of unfixed graphite from another drawing.

The little ferry-boat that was poled to and fro across the Stour just below Flatford Mill features in a number of Constable's sketches and paintings. With its ferry-man and his passenger it figures prominently in the foreground of 'The Valley Farm'. The same craft, or an identical one, is to be seen in 'The White Horse' (Fig.114), moored beside its tumble-down boathouse with Willy Lott's house just beyond. Here, in Fig.54 we see the boathouse and skiff again, but from a slightly different angle.

Fi

78

Bentley 21st April 1823

Pl. 31

79

An Ash Tree Pl.32a
Pencil, $10 \times 6\frac{5}{8}$ in $(25.4 \times 16.8\,\text{cm})$
Inscr. 'Hampstead June 21.1823 longest day. 9 o clock Evening.Ash'
London, The Trustees of the British Museum (L.B.13a)

Trees at Hampstead Pl.32b
Pencil, $7\frac{1}{4} \times 4\frac{5}{8}$ in $(11.7 \times 18.4\,\text{cm})$
Inscr. '[tear] nine evening–'; verso, in another hand 'Hampstead nine evening'
London, Victoria and Albert Museum (R205)

A Birch Tree Fig.55
Pencil, $9\frac{1}{8} \times 6\frac{3}{16}$ in $(23.2 \times 15.7\,\text{cm})$
London, The Trustees of the British Museum (L.B.13b)

For the season of 1823 Constable rented a house in Hampstead called Stamford Lodge. Commissions of one sort or another kept him busy until well on into the summer, and he seems to have had less time than in recent years for sketching out on the Heath. Of the three drawings illustrated here only one, the study of the ash tree, is dated, but the other two are undoubtedly of the same period. The birch is drawn on similar paper and the Victoria and Albert Museum drawing (also drawn at nine o'clock, it will be noticed) could almost be of the same ash from a viewpoint a little to the right.

Although Constable is to be found drawing many sorts of tree, it was the ash which attracted him most, and at times he seems to have experienced a quite extraordinary intensity of feeling at the sight of a particularly beautiful specimen. At the last of his lectures, it may be remembered that it was as the story of the mortal wounding of a lovely young woman that he told the sad tale of an ash killed by two long spikes being driven 'far into her side'.[1] Leslie writes of this love of his, 'I have seen him admire a fine tree with an ecstasy of delight like that with which he would catch up a beautiful child in his arms. The ash was his favourite, and all who are acquainted with his pictures cannot fail to have observed how frequently it is introduced as a near object, and how beautifully its distinguishing peculiarities are marked.'[2]

By comparison, the birch seems to have been observed with noticeably less feeling. This was a tree that had to wait, along with the cattle in the Glens, until the second half of the century for full recognition of its pictorial qualities.

Fig. 5

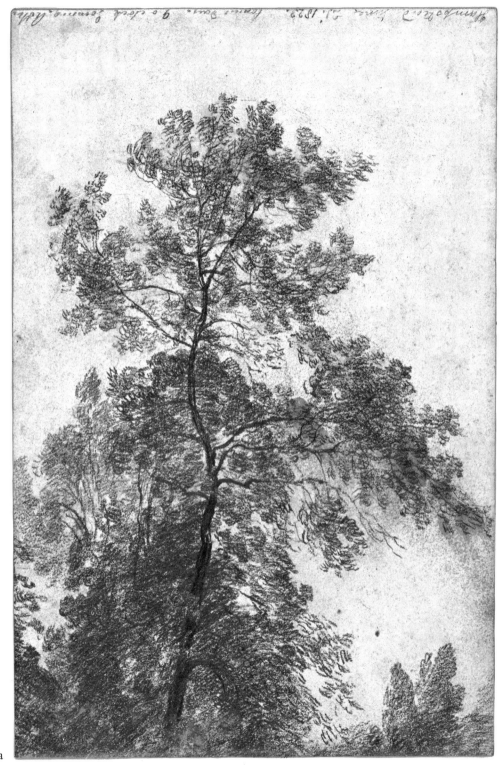

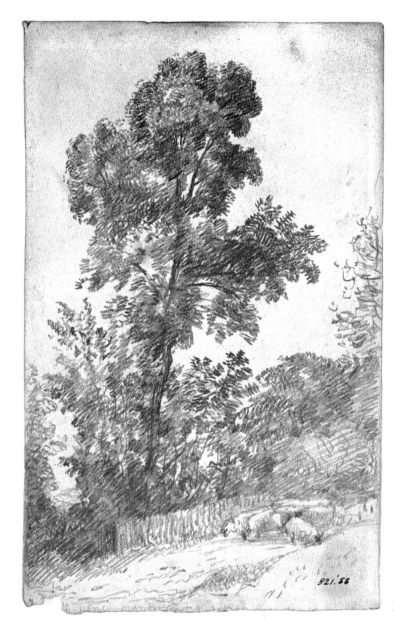

821.'58

1823

The Cenotaph to Sir Joshua Reynolds in the Grounds of Coleorton Hall Pl.33a
Pencil and grey wash, $10\frac{1}{4} \times 7\frac{1}{8}$ in $(26.0 \times 18.1$ cm$)$
Inscr. verso, Wordsworth's sonnet beginning: 'Ye Lime-trees rang'd before this Hallowed Urn…' etc., '…written by Mr.W.Wordsworth/ and engraven on the Urn.in the Garden/ Coleorton Hall.Novr.28.1823.'
London, Victoria and Albert Museum (R259)

A Stone Dedicated to Richard Wilson in the Grove of Coleorton Hall
Pl.33b
Pencil and grey wash, $10\frac{1}{4} \times 7\frac{1}{8}$ in $(26.0 \times 18.1$ cm$)$
Inscr. verso 'Stone in the Grove Coleorton Hall. Dedicated to the Memory of Richard Wilson. Novr.28.1823.'
London, Victoria and Albert Museum (R260)

Trees at Staunton Harold, Leicestershire Fig.56
Pencil, $7\frac{1}{8} \times 10\frac{1}{4}$ in $(18.1 \times 26.0$ cm$)$
Inscr. verso 'Leicestershire – the lane leading to Ferrars Hall – Ld Ferriers [?] house I was on horseback with Sir G.B. – who kindly held my horse when I made this sketch 1823 I think it was the finest ash I ever saw.'
London, Victoria and Albert Museum (R262)

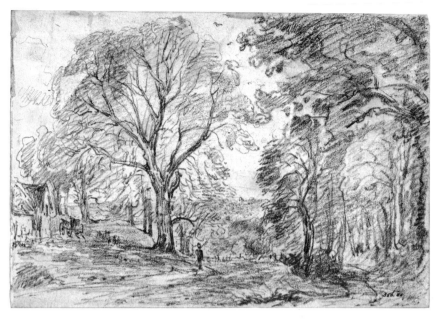

Fig. 56

Constable's letter to his wife telling her of his arrival at Coleorton, the Leicestershire home of his old friends, Sir George and Lady Beaumont, is dated 21 October 1823. 'O dear this is a lovely place indeed', he wrote, '…Such Grounds – such trees such distances – Rock and water – all as it were can be done from the various windows of the House: The Church stands in the Garden & all looks like fairy Land –'.[3] The two views taken in the grounds (Pls.33a & 33b) were drawn on the last day of his visit nearly six weeks later. Seldom was a visit of his into the country less productive in terms of outdoor sketches. Poorish weather was partly to blame for this, but the real reason was that Constable could not tear himself away from the pictures in the house – Rubens, Claude, Poussin, Rembrandt, Wilson, Cozens – and spent the greater part of his time in Sir George's painting room at the top of the house making faithful copies of two little Claudes. 'You would laugh to see my bed room', he wrote Maria, 'I have draged so many things into it. books portfolios – paints canvases – pictures &c. and I have slept with one of the Claudes every night'.[4]

After his enjoyment of the pictures, it was undoubtedly his host's and hostess's kindness and easiness of manner which afforded Constable the greatest pleasure during his stay at Coleorton. When they had first met, almost thirty years before, Constable and the Beaumonts were far apart in age and station, and it was only on this visit that the artist finally lost his feel-ing of reserve in their presence. The inscription which he afterwards added to the drawing of Staunton records, therefore, an action of Sir George's, simple enough in itself, but which for Constable meant a great deal.

'In the dark recesses of these gardens, and at the end of one of the walks', Constable wrote to John Fisher on 2 November, 'I saw an urn – & bust of Sir Joshua Reynolds – & under it some beautifull verses, by Wordsworth.'[5] The laying of the first stone of this memorial (Pl.33a) had been conducted ceremonially on 30 October 1812 by Sir George and his wife, with Farington and William Owen as witnesses. All in turn had tapped the stone with a mallet, Lady Beaumont saying, 'May nothing but *Time* destroy this Monument'.[6] So far, happily, her words have been efficacious. Constable sent his painting of this subject, 'The Cenotaph' (and not his 'Arundel Mill') to the Academy of 1836, the last of the exhibitions to be held in Somerset House, because, he said, he 'preferred to see Sir Joshua Reynolds's name and Sir George Beaumont's [a frequent exhibitor in the past] once more in the catalogue for the last time in the old house.'[7] As it turned out, 'The Cenotaph' was the last painting by Constable to be exhibited in his lifetime.

Elsewhere in the grounds at Coleorton there is still to be seen the great stone dedicated to Richard Wilson (Pl.33b), another of the artists of a previous generation whom Beaumont had known. This is inscribed 'Brought here 6 Jan 1818'. No more fitting memorial could have been found for one who delighted in painting objects just such as this in the foregrounds of his pictures.

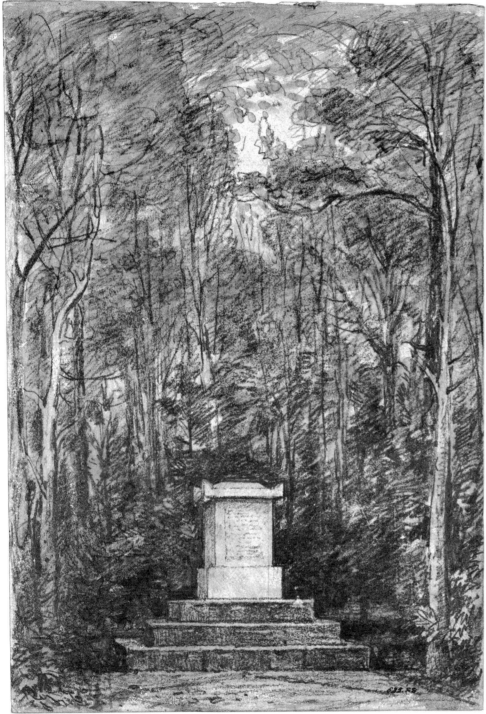

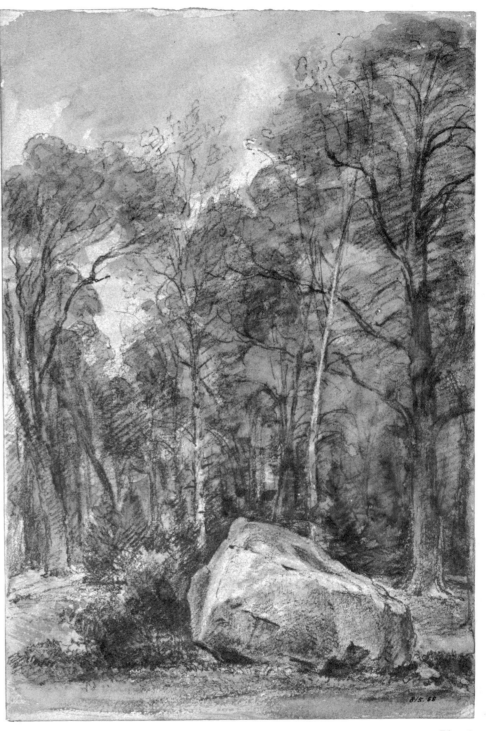

Pl. 33a

1824

Brighton Beach Pl.34
Pencil, pen and grey wash, $7\frac{1}{16} \times 12\frac{3}{4}$ in (18.0×32.4 cm)
London, The Trustees of the British Museum (1948–10–9–10)

Worthing Fig.57
Pencil, pen and grey wash, $7 \times 10\frac{1}{8}$ in (17.8×25.8 cm)
Inscr. 'Worthing 22 Sep 1824'
Private collection

Brighton Fig.58
Pen and grey wash, $7 \times 10\frac{1}{4}$ in (17.8×26.0 cm)
Inscr. '18. Oct. 1824 Noon'
Harvard, Fogg Art Museum

For some time now Constable must have been aware of the slow but steady deterioration in his wife's health. The aim of their migrations to Hampstead had been to provide her with an air that she could breathe more freely. In May this year, 1824, she was already finding the heat oppressive, so, after taking medical advice, they decided on a move to Brighton for the summer. Constable went down with her on the 13th for six days; joined them for the inside of a week in June; and then rejoined them in July for a working holiday which was finally extended well into October. At first he heartily disliked Brighton, 'Piccadilly by the sea-side' he called it, where 'Ladies dressed & *undressed*—gentlemen in morning gowns & slippers on, or without them altogether about *knee deep* in the breakers–footmen–children–nursery maids, dogs, boys, fishermen–*preventative service men* (with hangers & pistols), rotten fish & those hideous amphibious animals the old bathing women, whose language both in oaths & voice resembles men–all are mixed up together in endless & indecent confusion.'[1] But as the house they had taken was on the extreme western limits of the town, when he could spare the time from his work indoors he soon found plenty to interest him down on the beach and in the nearby fields.

The first of the oil-sketches he made at Brighton is dated 10 June;[2] the dated drawings come much later–a chalk and wash sketch of 1 September is the earliest so far seen.[3] Though of similar subjects, scenes on the beach, all the remaining dated drawings of this year are in pen (or the fine point of a brush) and wash, and are markedly alike in the handling of the medium. When he was back in London, towards the end of the year, Constable was asked by a French dealer to make twelve drawings from a Brighton sketch-book to be engraved for publication in Paris. Graham Reynolds has suggested that drawings such as the three illustrated here may have been done with this commission in mind;[4] the unusually deliberate and careful manner of execution is certainly consistent with the idea that they were for an engraver.

84

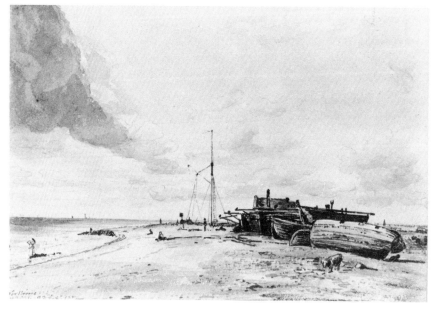

Fig.

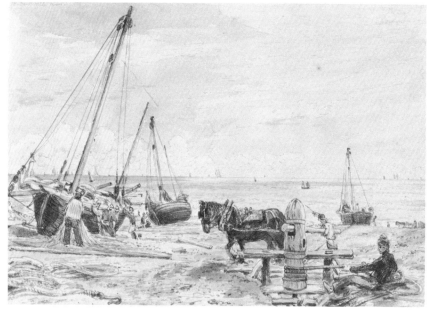

Fig. 5

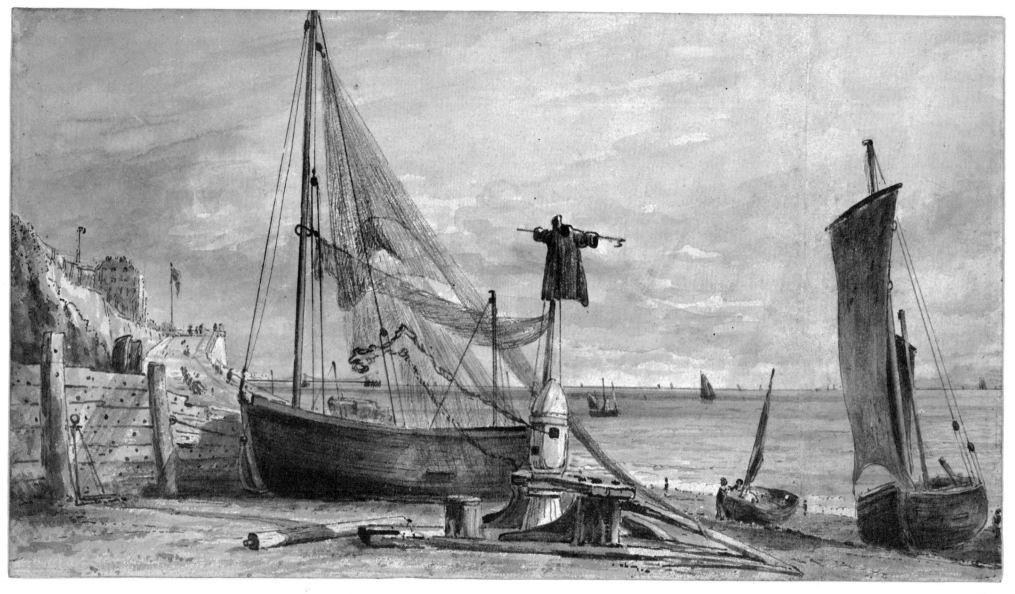

Pl. 34

'The Leaping Horse' was the last of the six-foot canvases that Constable painted of the commercial traffic on the Stour. It is the third large work for which there has survived a full-size oil 'sketch'. Various small related sketches for the other two ('The Hay Wain' and the 'View on the Stour') are known, but for neither, nor for any other work so far exhibited, do we have compositional studies like the two illustrated here. Constable seems to have had more difficulty than usual with the painting of the final picture, and few of his large paintings show more signs of having been altered and over-worked. He was anxious about the picture when it left his studio for the exhibition in April 1825, and when it came back from the Academy he continued to make changes in the composition. It is possible that the root cause of the trouble was the fact that at the start he had provided himself with alternative compositions, with the two versions of the subject, and that neither ever finally gained ascendency over the other. In the first edition of his *Life*, Leslie said that so carefully did Constable study his subject 'that he made in the first place, two large sketches, each on a six-foot canvass. One [he believed] was intended to be the picture, but was afterwards turned into a sketch, not an unusual occurrence with him.'[5] This passage was omitted by Leslie in his second edition two years later, perhaps, it has been suggested,[6] because he learnt that the statement was not well founded. It is true that the two large canvases, the final work and the Victoria and Albert Museum 'sketch', are obvious candidates for Leslie's 'two large sketches', but if these were the paintings he had in mind when writing that passage, what was there so incorrect about his statement that he had to delete it altogether? Could it have been that he was wrong only in that two sets of facts had been confused, that there were two sketches and there were two six-foot canvases, but that the two original sketches were drawings, not oils—in fact, the two compositions illustrated overleaf (Pls.35 & 36)?

It was Constable's practice to start work in the autumn on the picture he intended to make his principal exhibit at the Academy the following year. In 1824 he mentions having begun such a work in a letter to Fisher of 17 November. When writing a few days before, on the 13th, Fisher had said that he hoped Constable would diversify his subject this year as to time of day. 'Thompson you know', he added, 'wrote, not four Summers but *four Seasons*. People are tired of Mutton on top Mutton at bottom & Mutton at the side dishes, though of the best flavour & smallest size.'[7] 'I am planning a large picture', Constable had replied,' I regard all you say but I do not enter into that notion of varying ones plans to keep the Publick in good humour—subject and change of weather & effect will afford variety in landscape.'[8] Later in the same letter he tells Fisher of the Brighton sketchbook (see previous page) with which he says he is busy for a few days. In his next letter to Fisher, of 17 December, we hear more of the Brighton drawings which Samuel Reynolds was to engrave for publication in Paris, 'I work on these in the evenings', he tells the Archdeacon. At the very end, he mentions in passing

that he is putting a six-foot canvas in hand.[9] Within three weeks he is writing again, this time a hasty scrawl in the dark 'before a six foot canvas—which I have just launched with all my usual anxieties. It is a canal scene'.[10] It is very possible that this was the second of the big canvases but whether he had started on one or both of the large paintings by this time (5 January), for our study the significant fact revealed by this short narrative of events is that he was actively engaged in designing ('planning') the new work at least a month before making a start on a large scale. It is likely that the two British Museum studies (Pls.35 & 36) were done at this planning stage. We know that Constable was working on the Brighton drawings for Reynolds the engraver at this time, in the evenings, he says. Brown and grey wash, a medium he had only just turned to again, was used in both the drawings of Brighton shore (such as those illustrated, Pl.34; Figs.57 & 58) *and* the 'Leaping Horse' studies: additional evidence to support the notion that they were done concurrently. If it was on the execution of these Brighton drawings that he was engaged in the evenings, it makes the explosive character of the compositional studies all the more understandable. After an evening employed on careful outlining and the laying of flat controlled washes, it would be natural to find Constable relieving his pent-up feelings in just such a storm of creative work.

With the evidence at present available we cannot be certain as to which of the two studies for the 'Leaping Horse' Constable began first (Pls.35 & 36). But it is not just to distinguish one from the other that they are here called 'First' and 'Second' study; the titles reflect a considered opinion. As we have seen, it was Constable's habit to look through his sketchbooks when in search of an idea for a new painting. In the present case it seems a reasonable assumption to make that ideas began to generate for the new picture ('The Leaping Horse') when he picked up the study of the willow (Fig.61), a drawing with so many of the ingredients of the later sketches—the curious silhouette of the tree, the cattle, the river, the tower of Dedham (?) church. The right-hand side of our 'first' study for the picture has been taken almost directly from this drawing. In the final painting all that remains is the church tower, almost on the very edge of the canvas.

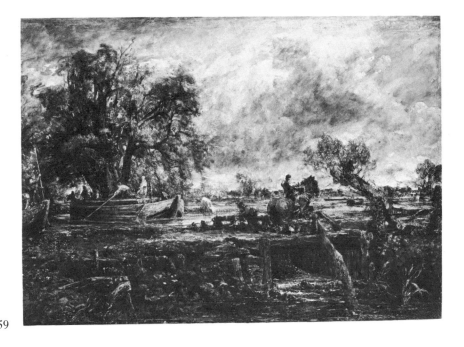
Fig. 59

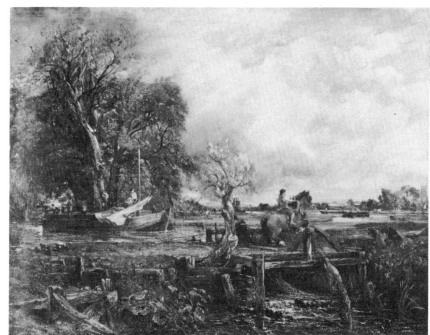
Fig. 60

Fig. 61

Study for 'The Leaping Horse' Fig.59
Oil on canvas, 51 × 74 in (129.4 × 188.0 cm)
London, Victoria and Albert Museum (R286)

The Leaping Horse Fig.60
Oil on canvas. 53½ × 71 in (135.9 × 180.3 cm)
London, Royal Academy of Arts

Study of a Willow Fig.61
Pencil, 3½ × 4½ in (8.9 × 11.4 cm)
London, Courtauld Institute of Art (*Witt collection*)

First Study for 'The Leaping Horse' Pl.35 (see overleaf)
Pencil, pen, ink and wash, 8 × 11⅞ in (20.3 × 30.2 cm)
London, The Trustees of the British Museum (L.B.10a)

Second Study for 'The Leaping Horse' Pl.36 (see overleaf)
Pencil, wash, 8 × 11⅞ in (20.3 × 30.2 cm)
London, The Trustees of the British Museum (L.B.10b)

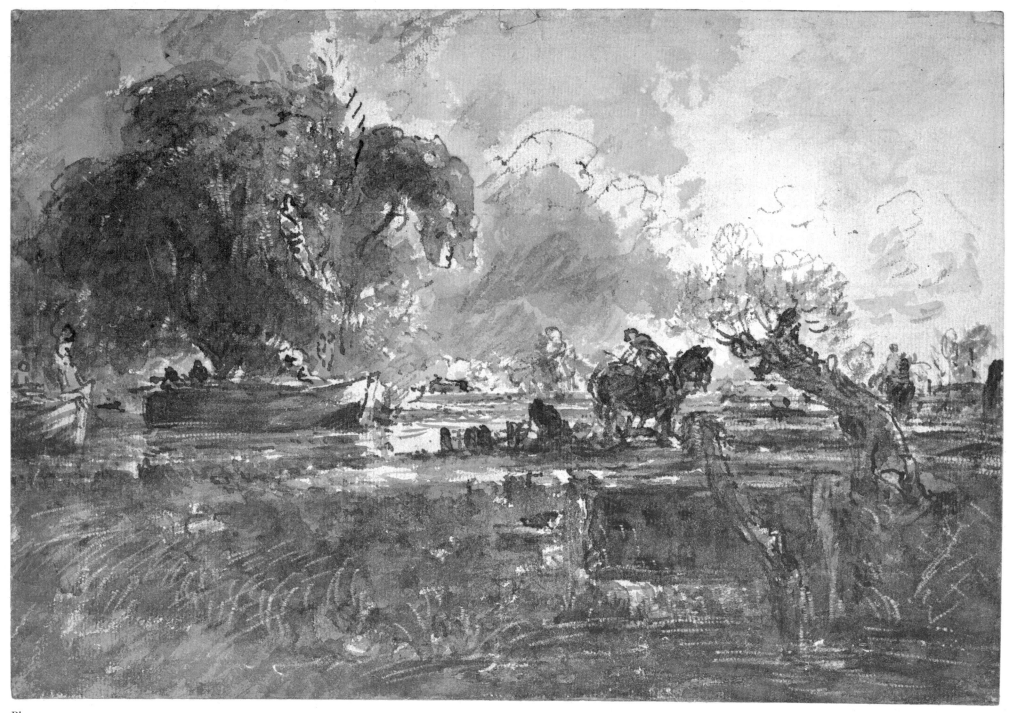

Pl. 35

Pl. 36

Landscape with Trees, after Claude Lorrain Pl.37
Pen and brown wash, $11\frac{5}{16} \times 7\frac{7}{8}$ in (28.8×20.0 cm) repr. actual size
Inscr. verso of mount 'copied from a drawing by Claude Lorraine/left to Sir
Thomas Lawrence/Hampstead July/1825', and in pen, Cpied by
J. Constable ARA – from a Drawing by (as/–it is said) Claude Lorraine,/
done at Hooke's Cottage,/Hempd, July/1825'
From the collection of Mr and Mrs Paul Mellon

**Claude Lorrain: The Campo Vaccino with the Entrance to the Villa
Farnese** Fig.62
Pen and brown wash, $5\frac{1}{16} \times 3\frac{11}{16}$ in (12.8×9.4 cm)
Reproduced by gracious permission of Her Majesty the Queen

**Copy of an Engraving by G. Lewis after Claude's Drawing of the
Campo Vaccino** Fig.63
Pen and brown wash, $4\frac{15}{16} \times 3\frac{9}{16}$ in (12.5×9 cm)
Paris, Musée du Louvre (RF06117)

Fig. 62 Fig. 63

Constable was nineteen years of age and untutored in the art of landscape when he first saw a painting by Claude–the little 'Hagar and the Angel' which Sir George Beaumont had brought with him when visiting Dedham. In the sale of Constable's work after his death, three copies in oils of Claude landscapes were catalogued–all three from paintings at one time in Beaumont's collection. We read a lot about these copies in the artist's letters and he has a great deal to say about Claude no matter to whom he is writing. 'I do not wonder at you being jealous of Claude', he writes to his wife from Coleorton when in the middle of his copying, 'if any thing could come between our love it is him . . . the Claudes *the Claudes* are all I can think about while I am here.'[1] (*We* do not wonder when we find her replying that she would advise him not to show her the copy on his return or she would throw it out of the window.) A couple of years before this there had apparently been a chance of the Academy borrowing one of Angerstein's great Claude sea-pieces. Constable told Fisher of this in a letter dated 4 August 1821, '. . . one of the most perfect pictures in the world–should that be the case, though I can ill afford it, I will make a copy, a facsimile–a "*study*" only will be of value but to myself–the other will be real property to my children and a great delight to you & me–the very doing of it will almost bring one in communication with Claude himself & with whose great spirit I may seem to hold commune.'[2]

The copies illustrated here show that Constable was as prepared to study the drawings of the French master as he was to make facsimiles of his oil-paintings. In view of Constable's only recorded opinion of Claude's drawings and an observation shortly to be made about one of his own, it is perhaps as well that this should be given due emphasis. The sole reference to the draw-

ings comes in a letter to Fisher of January 1824, and follows immediately upon Constable's description of a visit paid to his studio by the wealthy collector Richard Payne Knight who praised his paintings, saw him hard at work 'for my poor infants', bought nothing, and then 'that day gave "Sixteen Hundred Pounds", for some drawings or slight sketches by Claude.' 'I saw them', he continues, '–drawings–they looked just like papers used and otherwise mauled, & purloined from a Water Closet–but they were certainly old, & much rent, & dissolved, &c. but their meer charm was their age.'[3]

When photographs of Claude's 'Landscape, with Goatherd'[4] and Constable's copy of the painting are placed side by side, it is not easy at first to tell one from the other. No such trial can be made with his copy on the opposite page (Pl.37) as we do not know the present whereabouts of the original.[5] George Lewis, from whose engraving Constable made his copy of the Claude drawing of the Campo Vaccino,[6] has followed the original closely enough for it also to be difficult to tell which Constable had worked from–the drawing or the engraving. One detail, however, makes it reasonably certain that Constable copied the print. In the drawing, there are three figures in the middle distance, a single figure with a stick and then two more almost merging with the cattle beyond. Lewis does not distinguish clearly between figures and cattle, so, when Constable came to draw the herd in the distance, he quite naturally assumed that the group consisted of a single herdsman with his charges. He would not have made this error if he had had the original drawing before him.

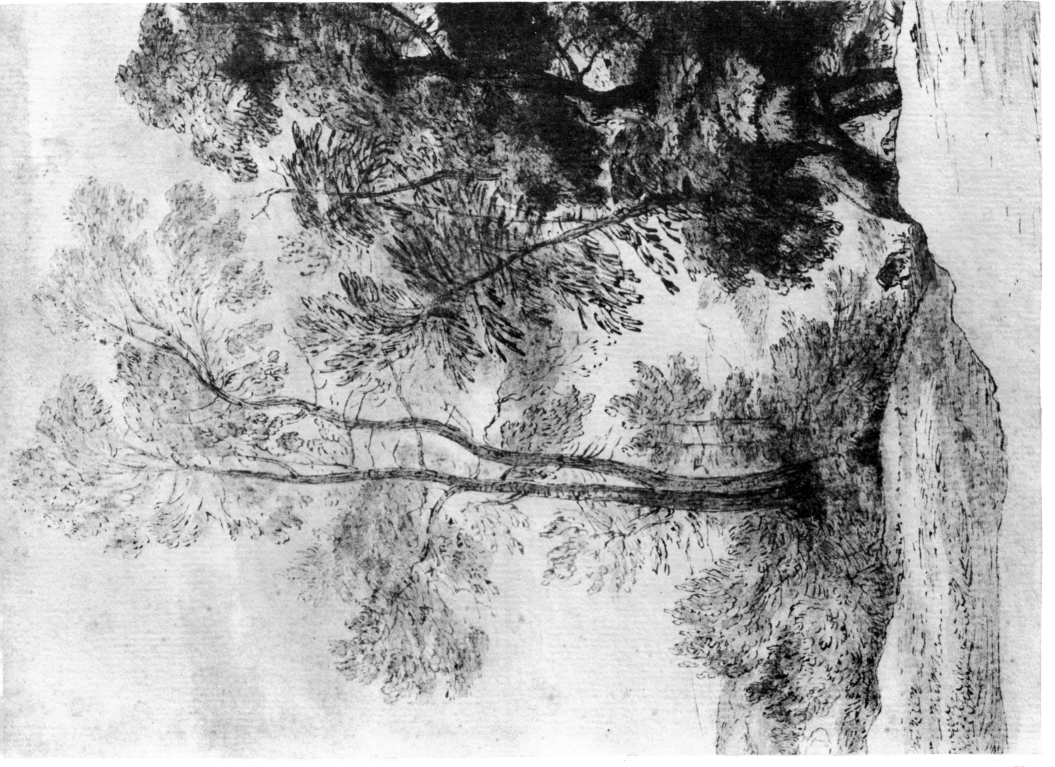

Pl. 37

1826

The Lock Pl.38
Pencil, pen and ink, brown wash, white heightening, $11\frac{15}{16} \times 14\frac{1}{2}$ in
(30.3×36.8 cm)
Cambridge, Fitzwilliam Museum

Flatford Lock Fig.64
Pencil, $8\frac{11}{16} \times 12\frac{13}{16}$ in (22.1×32.5 cm)
London, The Trustees of the British Museum (L.B.15)

A Boat Passing a Lock Fig.65
Oil on canvas, $40\frac{1}{2} \times 50$ in (102.9×127.0 cm)
London, Royal Academy of Arts

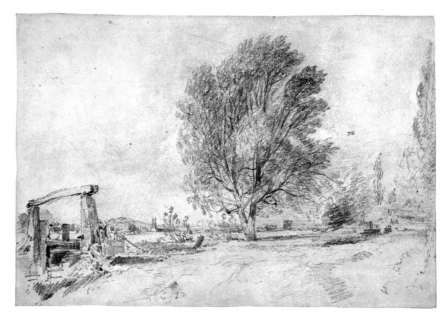

Fig. 6

In the Academy of 1824 Constable had exhibited 'A Boat Passing a Lock', a painting of the lock at Flatford. The picture was a success, and sold on the opening day. After completing a replica, Constable began a third painting of the subject to fulfil a commission he had received from James Carpenter, a Bond Street bookseller and picture-dealer with whom he was on friendly terms. In the new work, Constable made a number of changes. The painting of 1824 showed a 'navigator' cranking up the paddle to release the water in the lock for a barge that was waiting to proceed on its way downstream. In the new composition the figure was again at the capstan, but this time lowering the water for a boat below the lock that was on its way up-river. In his first painting of the subject, an upright composition, the upper half of the canvas was equally divided between sky and a massive group of trees; in the new one we find the main axis horizontal, the trees greatly reduced, and the design altogether more open and spare.

It is possible that this new spaciousness originated from his seeing the actual site again – and perhaps making the drawing of it, Fig.64 – while on a short visit to Flatford in April 1826, the year now in question. Later in the year we have him writing to Carpenter about a picture he is painting for him – in all likelihood 'The Lock'.[1] The sketch of the subject (Fig.64) shows the upper lock-gate with the first of the lintels or tie-beams under which the downstream traffic would pass when entering the lock. In the compositional drawing (Pl.38) Constable has gone back to the earlier viewpoint, but has not yet relinquished the idea of incorporating one of the lintels into his design. The ruled lines of the supporting posts and the carefully incorrect perspective of the lintel itself are puzzling features in this drawing, but more puzzling still is the style in which it is drawn. If Constable had intended it for a pastiche Flatford Lock in the style of a Payne Knight Claude drawing, he could hardly have been more successful; perhaps that was his intention.

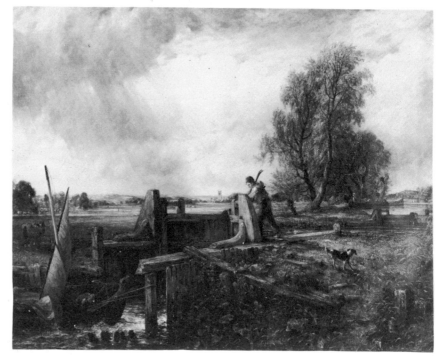

Fig. 6

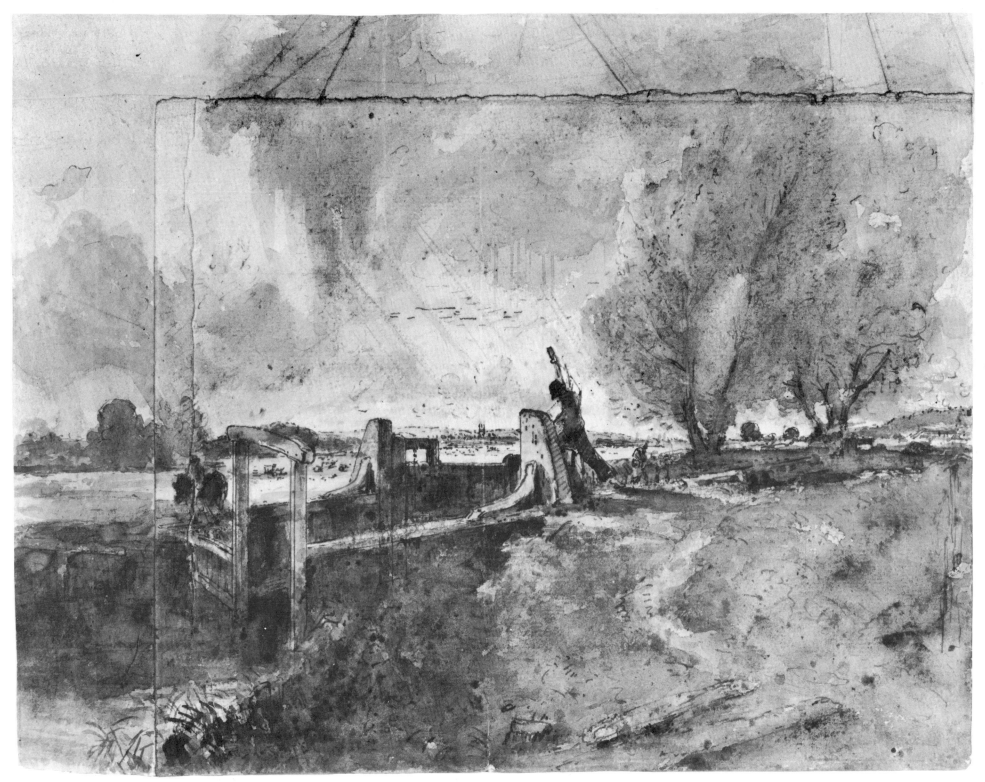

Pl. 38

Flatford, Dedham Vale Pl.39
Pencil, 8$\frac{11}{16}$ × 12$\frac{13}{16}$ in (22.1 × 32.5 cm)
Inscr. 'Flatford Octr 5 1827'
Dublin, National Gallery of Ireland

Two Children on a Barge at Flatford Fig.66
Pen and brown wash, 12$\frac{1}{4}$ × 8$\frac{1}{2}$ in (31.1 × 21.6 cm)
Private collection

In October 1827 Constable took his two eldest children, John Charles and
Minna, aged nine and eight, for a fortnight's holiday to stay with Abram and
Mary, his brother and sister, at Flatford. Although he had been back to
Suffolk a number of times on family business, it was nearly ten years since
he had had a holiday there, and for the children it was their first visit. Abram
had raised several objections when his brother had suggested that he should
bring the children down, the strongest being a fear for their safety, but their
behaviour was exemplary and it was not long before Constable was able to
tell his wife that all was well and that Abram and Mary were in no hurry to
part with them. John, he reported, was crazy about fishing, and Minna, he
said, looked a picture in her pelisse and blue sash.[1] The familiar subjects, the
lock, the barges, the footbridge and its cottage, the vistas across the meadows,
were all drawn yet again, but though his response to these scenes was as keen
as ever, it was doubtless partly to keep his eye on his young son as he fished
that the drawings were made so often on the river banks.

Pl.39 is a view of which we have already seen two drawings in the 1814
sketchbook (Pl.17c & d), the subject he had chosen for the fourth of his large
canvases – 'The View on the Stour' (Fig.115, exhibited R.A. 1822). Upstream
we see the well-known footbridge, in the far distance the tower of Dedham
church, and in the foreground the dock where barges were built. The happy
scene depicted in Fig.66 with John Charles apparently 'undergoing the
agony of a bite',[2] was observed from precisely the same spot, only looking
downstream. Another pen and ink drawing made on that trip (Victoria and
Albert Museum, R300) shows men at work unloading a barge (perhaps the
same one) similarly moored and also with a plank as a gangway. The drawing
in Pl.39 is characteristic of work done on the spot; the other (Fig.66) of a
scene drawn from memory.

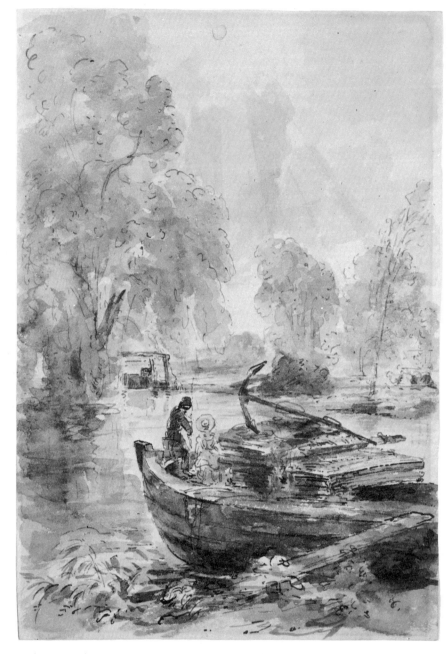

Fig. 6

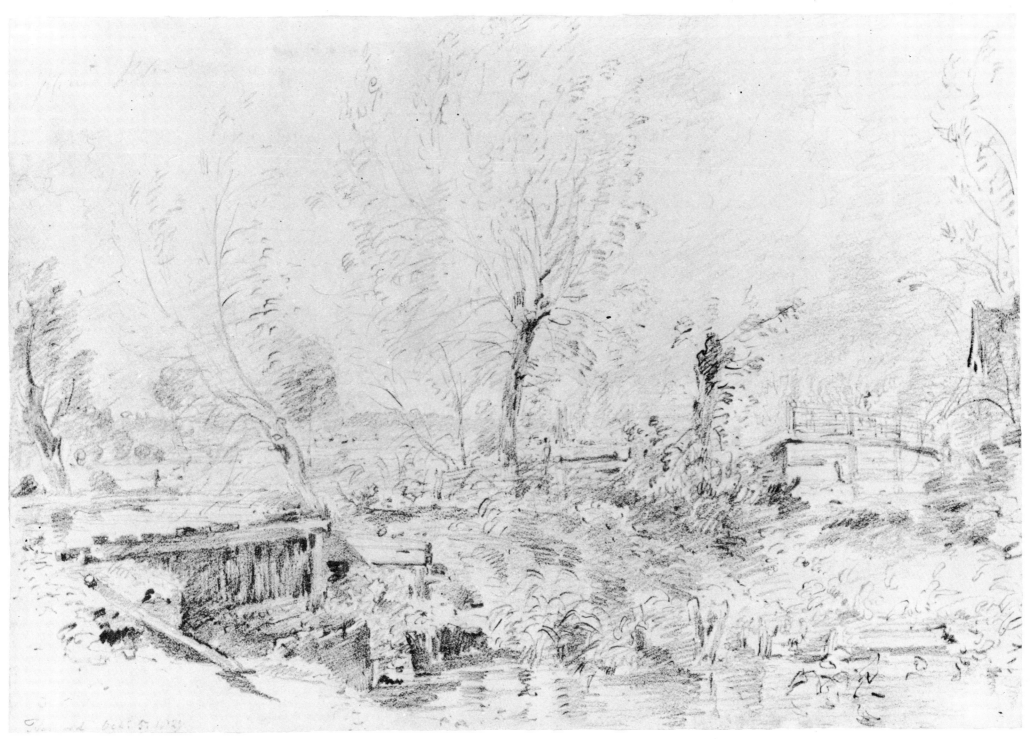

Pl. 39

1828

Coast Scene at Brighton Pl.40
Pencil, pen and ink, grey wash, $4\frac{1}{2} \times 7\frac{3}{8}$ in (11.5×18.6 cm) repr. actual size
Inscr. 'May 30 1828'
London, Victoria and Albert Museum (R305)

Coast Scene with Vessels at Brighton Fig.67
Pencil and grey wash, $4\frac{1}{2} \times 7\frac{1}{8}$ in (11.5×18.1 cm)
Inscr. 'May 30 1828'
London, Victoria and Albert Museum (R304)

A Beached Vessel Fig.68
Pencil, $4\frac{1}{2} \times 7$ in (11.5×17.8 cm)
Inscr. 'May 30 1828'
Coll. Harold A.E. Day

Fig. ‹

For Constable, 1828 was a year of bitter disappointment and of tragic loss. After the birth of their seventh child, Lionel, in January, his wife never fully recovered her strength. He suffered an humiliating defeat in February when he had been hoping for full honours at the Academy and, instead, William Etty was elected Academician by an overwhelming majority. He managed to keep working at his easel so as to complete his main work for the exhibition, the 'Dedham Vale' (now in Edinburgh), but after this his wife's steady decline and the care of his children, some of whom also fell ill in the spring, appear to have occupied him entirely, and it was only when he managed to get his wife to Brighton towards the end of May that we find him turning once again to his sketchbook.

None of the drawings that we know of this summer is anything more than a brief note in pen and wash drawn on the beach or near by. There seems to have been something unusual about the beached vessel to be seen lying on its side in the three drawings illustrated. Constable drew many such craft on this beach – some were apparently coal brigs and may therefore have had a particular interest for him – but around none did he record a gathering as large as the one we see here.

Maria was brought back to Hampstead at the end of July. In previous years she had benefitted from the sea air, but by now there was nothing to be gained from keeping her there. She lived on into the autumn and died on 23 November. We do not find Constable dating a drawing again until May of the following year.

Fig. ‹

Pl. 40

97

Old Sarum Pl.41
Pencil, $9\frac{1}{16} \times 13\frac{1}{16}$ in (23.0 × 33.2 cm)
Inscr. 'Evening July 20 1829'
Bath, Victoria Art Gallery

Salisbury Cathedral from the N.W. Fig.69
Pencil, $9\frac{3}{16} \times 12\frac{7}{8}$ in (23.3 × 32.7 cm)
Inscr. verso in later hand 'Salisbury 1829'
Cambridge, Fitzwilliam Museum

Archdeacon Fisher with his Dogs, Salisbury Fig.70
Pen and brown ink and watercolour, $3\frac{5}{8} \times 5$ in (9.2 × 12.7 cm)
Inscr. verso '22 July 1829 – Salisbury Fisher & his dogs'
London, Victoria and Albert Museum (R313)

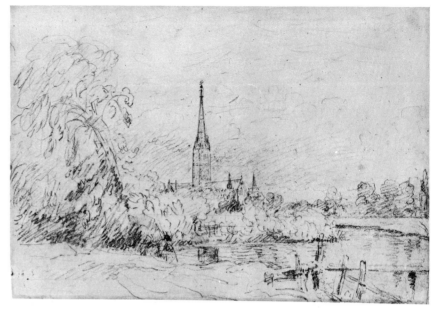

Fig. 6

Fisher proved Constable's main prop and stay in the difficult months that followed the death of his wife, and the two men saw more of each other in 1829 than during any year since the commencement of their friendship. In February and March, Fisher was in London; in July, Constable with his two elder children, John and Minna, spent three weeks with the Fishers at their house, Leydenhall, in Salisbury Close; and in November, Constable went down again to Salisbury to fetch Minna who had remained there all summer. Paintings such as the beautiful little oil in the Victoria and Albert Museum (R320) of the view from Leydenhall in a calm early morning light, and equally serene drawings like that of Old Sarum (Pl.41) are perhaps a measure of the success of the Fishers' efforts on his behalf.

It may have been during his November visit, a stay of some ten days or so, that Constable sketched the three views of the cathedral from the northwest (of which Fig.69 is one) from which he subsequently developed his next large picture, 'Salisbury Cathedral from the Meadows'. All three views are compositional in character, notes of possible thematic material rather than studies *in situ*. In both the other drawings, horses and carts are to be seen lightly sketched in – the germ of an essential element in the final composition, the wain and team of horses.[1] On the other hand there are certain things in the final painting which are only to be found in the drawing illustrated here – the proportion of the cathedral to the whole, the tree to the left and the line of trees in the distance to the right. In the Tate Gallery's oil-sketch of the subject, a man is just about to cross the footbridge in the right-hand corner, a dog at his heels. These are just visible in one of the other drawings. Was this Fisher with one of his dogs? In the final work only the dog remains, looking rather as though he had lost his bearings (and his flock) and wandered in from 'The Cornfield'.

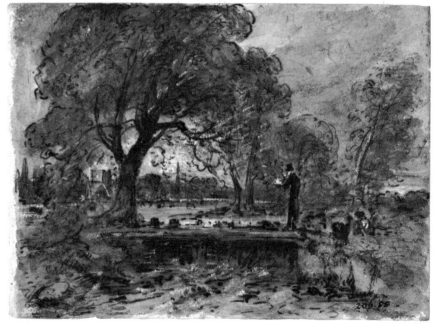

Fig. 7

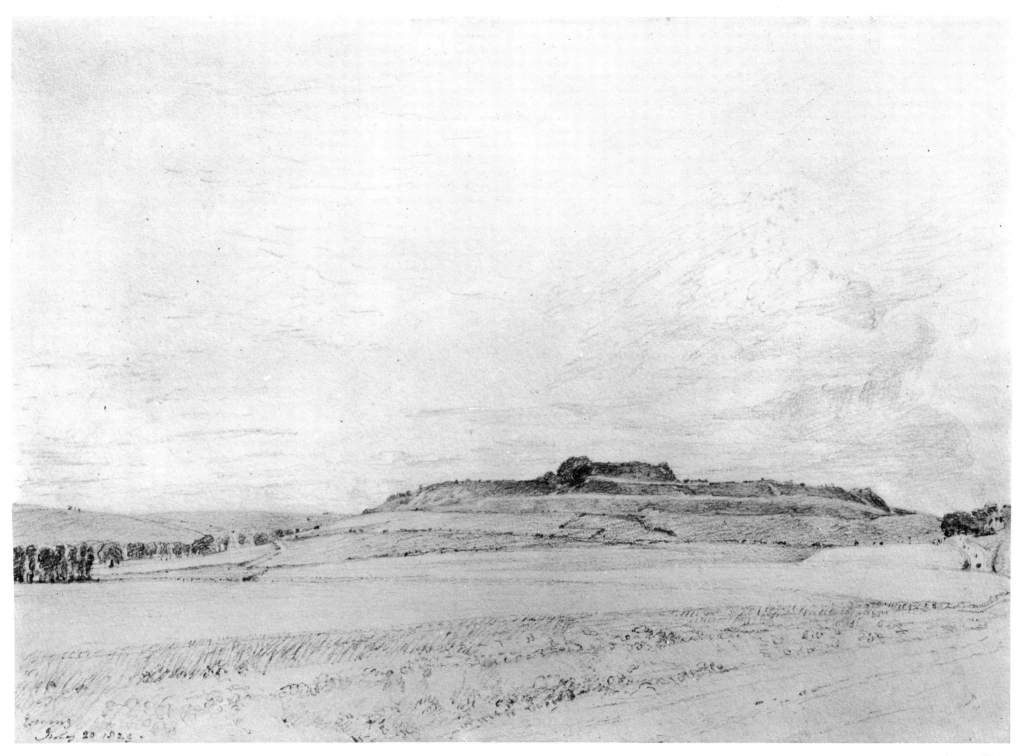

Evening
July 20 1828.

Pl. 41

<table>
<tr>
<td>

</td>
<td>

View from Hampstead, with a Double Rainbow Pl.42
Watercolour, $7\frac{3}{4} \times 12\frac{3}{4}$ in (19.7×32.4 cm)
Inscr. 'between 6.& 7.0'clock Evening June [?] 1831'
London, The Trustees of the British Museum (L.B.32b)

Study of Clouds Fig.71
Pencil and watercolour, $7\frac{1}{2} \times 9$ in (19.0×22.8 cm)
Inscr. verso 'about 11 – Noon – Sepr 15 1830. Wind – W'
London, Victoria and Albert Museum (R328)

London, from Hampstead Fig.72
Pencil and watercolour, $4\frac{1}{2} \times 7\frac{3}{8}$ in (11.3×18.8 cm)
London, The Trustees of the British Museum (L.B.31b)

</td>
<td>

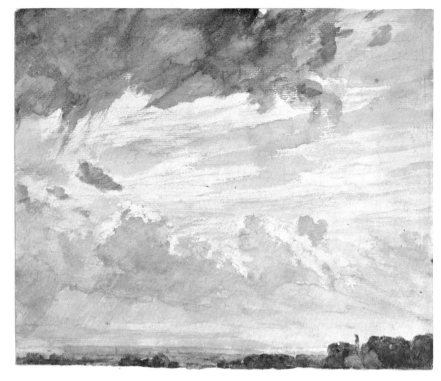

Fig.

</td>
</tr>
</table>

On 26 August 1827 Constable wrote to Fisher to ask him for a loan to help pay for the expenses incurred in moving to his new house, and permanent home, No.6 Well Walk, Hampstead. '*Help to establish me in this house!*' he wrote beseechingly, 'It is indeed everything we can wish. It is to my wife's heart's content . . . our little drawing room commands a view unequalled in Europe – from Westminster Abbey to Gravesend. The *dome* of *St Paul's* in the air, realizes Michael Angelo's idea on seeing that of the Pantheon – "I will build such a thing in the sky".'[1]

In the Constable family collection there is a small watercolour view of the City beyond a screen of trees which an inscription on the mount tells us was taken 'from Constable's window at Hampstead'. Stylistically, it belongs to the small group of watercolours of which Fig.72 is a representative example; topographically, it confirms what has been fairly generally supposed, that the dozen or so watercolours of London from Hampstead were all views from the windows at the back of No.6.

Towards the end of his *Life* Leslie expresses regret that he was unable to find any written observation on skies and clouds among his friend's papers, but remembers Constable pointing out to him one effect of the sun's rays which he thought few artists had noticed and which he had never seen in any picture except the 'Waterloo Bridge'. 'When the spectator stands with his back to the sun, the rays may be sometimes seen *converging* in perspective towards the opposite horizon.' 'Since he drew my attention to such effects,' he continues, 'I have noticed very early in the morning the lines of the rays diminishing in perspective through a rainbow.'[2] This unusual effect could also be observed towards the end of a day, as the watercolour opposite shows us. On the back of this are explanatory diagrams of the phenomenon in pencil, perhaps drawn by Constable for the benefit of his young sons. The following is an extract from an unpublished letter written by the youngest, Alfred, to his brother, Lionel, some years after his father's death: '. . . only

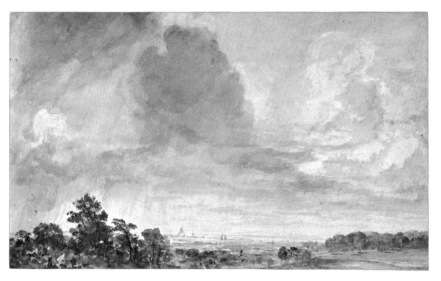

Fig.

think of you having seen the suns rays going off in Perspective how did it look I beleive it is very rare it is painted in the large picture of Waterloo Bridge'.[3]

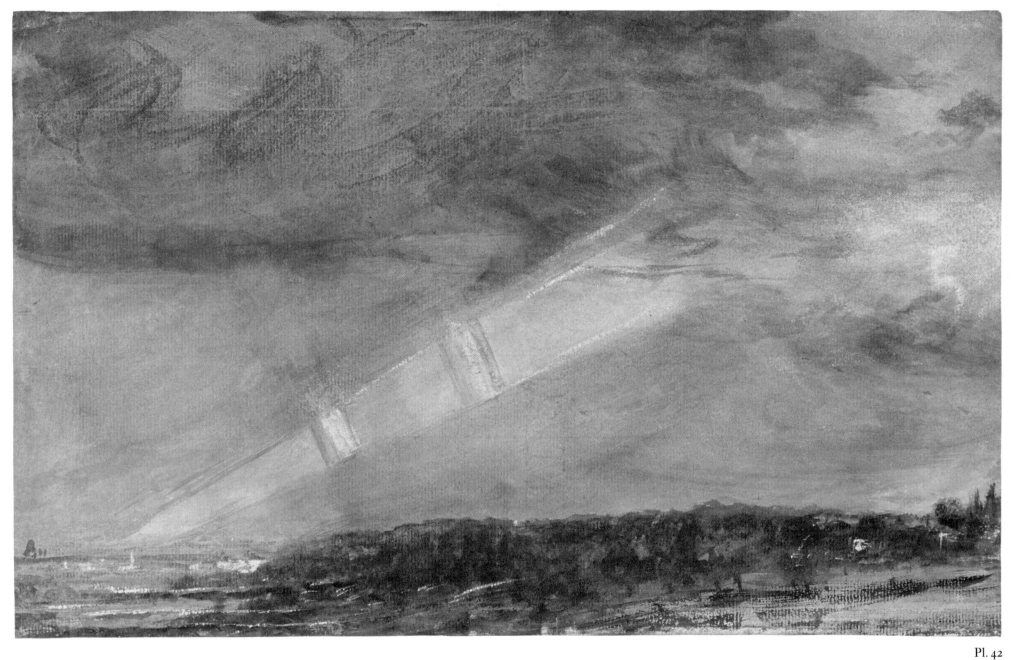

Pl. 42

Since going to press, 'London, from Hampstead', Fig.72, has been lifted from its mount by the Conservation Studio of the Department of Prints and Drawings at the British Museum. The following is inscribed on the back of the drawing: '10 to 11 oclock – Hamp^d Window Aug^t 1832'. The verso of a similar view (L.B. 31a) was found to be inscribed: 'Hampstead. drawing room 12. oclock noon Sep^t. 1830'.

1832

Englefield House, Berkshire Pl.43
Pencil, $12\frac{5}{8} \times 18\frac{5}{8}$ in (32.0 × 47.3 cm)
London, Victoria and Albert Museum (R341)

Englefield House Fig.73
Pencil, pen and watercolour, $4\frac{1}{2} \times 7\frac{1}{2}$ in (11.5 × 19.1 cm)
Inscr. '24 Augt 1832. 8–9 morg.'; verso 'Inglefield House Rd. Benyon de
Bouvir Esq. Berkshire. left London. for the above place Augt 22. 1832. with
Lane'
London, Victoria and Albert Museum (R340)

Englefield House Fig.74
Pencil, $11\frac{1}{8} \times 8\frac{7}{8}$ in (28.4 × 22.4 cm)
Paper folded horizontally, drawing on lower half, inscr.upper half '. . .
greenish slate roof . . . too narrow & too small altogether [of right-hand
turret] . . . Chimneys all the same size – only trace in the turrets larger'
London, Victoria and Albert Museum (R343)

It seems that the commission to paint Englefield House was obtained for
Constable by the deaf portrait painter, Samuel Lane, whom Constable had
befriended for a number of years. The idea had apparently been discussed
with the owner, Richard Benyon-De Beauvoir, in 1824 when Lane was
painting his portrait. Lane had probably thought he was doing Constable a
service when he introduced him to De Beauvoir, but as it turned out, the job
was one of the most unsatisfactory Constable ever undertook: he misjudged
his patron; the picture failed to please, and after numerous alterations was
finally rejected; the fee was questioned, and only grudgingly paid; and the
exhibiting of the work caused the artist nothing but anxiety.[1]

The drawings illustrated here are three of the five preparatory studies
Constable is known to have made when he and Lane went to Englefield
together in August 1832. The group is of interest as it doubtless represents
the sum of the information that Constable felt he would need when executing
a work such as this in his studio away from the subject. Fig.73 is near the final
work in appearance (see Fig.122), but the height of the canvas Constable used
was greater in proportion to the width and it was the resultant increase in the
area of the foreground that caused much of the trouble. For some reason the
artist filled this with cows and then, still more unwisely, not only enlarged
them but added another which was bigger than all the rest put together. The
owner said it looked as though he had his farm yard before his drawing room
windows. What he probably meant was that it no longer looked like the
country seat of a gentleman. Constable painted the cattle out, but it was too
late; now nothing was ever right with the picture.

Fig.

Fig. 7

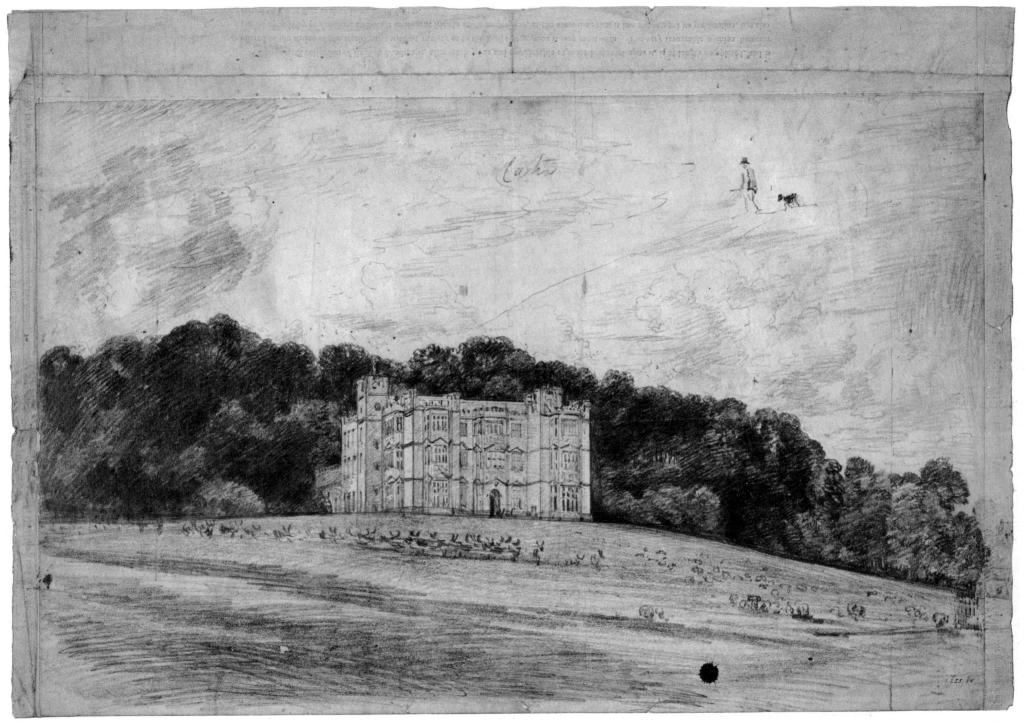

Pl. 43

1832

The Farmhouse near the Water's Edge Pl.44
Watercolour, $5\frac{5}{8} \times 7\frac{11}{16}$ in (14.3×19.5 cm)
London, The Trustees of the British Museum (1888–2–15–33)

A Willow Beside Water, a Church Beyond Fig. 75
Pencil, pen and watercolour, $8\frac{3}{4} \times 6\frac{1}{2}$ in (22.2×16.5 cm)
Inscr. 'John Constable R.A. 1832'
Private collection

The undated drawing opposite is closely related to a pen and ink outline sketch of the subject in the British Museum which is inscribed, 'Xmas day. Evening. 1829. Charlotte Street. Fitzroy Sq.'[2] Alike in subject but not in detail is a small composition in oils in the Victoria and Albert Museum (R403). Besides this last summarily painted study there are other oil-sketches which may be variants by Constable on the same theme. None of these paintings, however, can be of much help to us in dating our drawing. Nor can the pen drawing for although it may have been the initial sketch of the composition, it could equally well have been a copy made from the watercolour. In appearance, the watercolour has the character of a finished performance, of a work intended for exhibition. If this was the case, then a glance at the titles of the drawings he showed in the early '30s ought to provide an answer. In fact the Academy catalogues provide three: 1832, No.644 'Farmhouse'; 1833, No.639 'An Old Farm-House'; No.645, 'A Miller's House'.

There are many surprising sides to Constable's character. Not the least was his willingness to engage himself in tasks which a lesser painter would refuse as being beneath him. Examples spring to mind: the designing and painting of the Mermaid Inn sign for his old patron H.G. Lewis; the copying of a picture he despised, 'The Girl with the Dove', by Greuze, for a woman bereft of a child whom the girl in the picture resembled; the colouring of Stothard's illustrations and the insertion of a few of his own in a presentation copy to his goddaughter Harriet Leslie of Watts's *Divine Songs*. The drawing shown on this page (Fig.75), looking very like a design for a book illustration, may well have been intended as a gift for the daughter of some friend. In a letter of November 1830 to the bibliographer, John Martin, he says that he had been busy drawing of late, and adds the not uncharacteristically equivocal: 'Were it not for ladies [al]bums, I know not what we poor landscape painters would do.'[3]

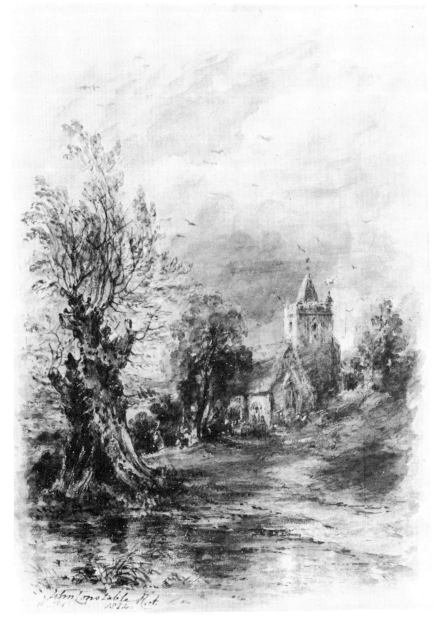

Fig.

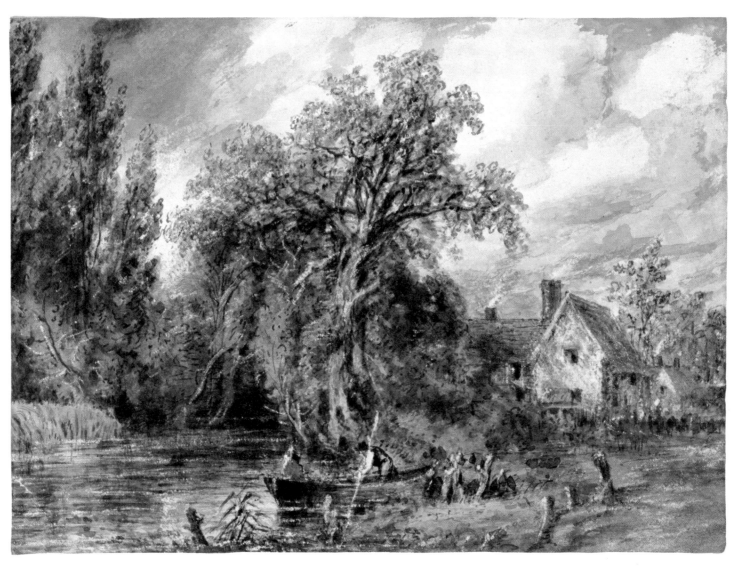

Pl. 44

1833

Design for Illustration to Gray's Elegy Pl.45
Pen (or fine brush?) and watercolour, $4\frac{5}{8} \times 6\frac{7}{8}$ in (11.8×17.5 cm)
repr. actual size
London, The Trustees of the British Museum (L.B.35b)

Frontispiece to a Select Collection of Epitaphs Fig.76
Engraving, J. Raw, Ipswich, 1806

A Churchyard Fig.77
Pencil, $3\frac{11}{16} \times 2\frac{15}{16}$ in (9.3×7.5 cm)
Dr David Darby

A Page from the Sketchbook of 1813 Fig.78
Pencil, $3\frac{1}{2} \times 4\frac{3}{4}$ in (8.9×12 cm)
London, Victoria and Albert Museum (R121, p.49)

Fig. 77

Fig. 76

Fig.76 shows the frontispiece of a book of Epitaphs published by the Ipswich printer, J. Raw, in 1806.[1] The engraving, by Chapman, was taken from a design by Constable for which there is a preliminary wash drawing in the Louvre. On the tomb-stone can be read 'HERE REST . ./A YOUTH . . .' These are the first words of the first two lines in the epitaph with which Gray concludes his Elegy: 'Here rests his head upon the lap of earth/ A youth to Fortune and to Fame unknown.' The frontispiece is Constable's earliest known design for a book illustration. He was able to turn to Gray and the elegiac theme again in 1833 when his friend John Martin, the bibliographer, asked him to design some illustrations for a new edition of Gray's poems which he was planning. Constable undertook the task with some enthusiasm and his designs for three of the stanzas appeared in the first edition of 1834. A second edition, with a further design by him on the title-page – a vignette of the west end of the church at Stoke Poges with Gray's tomb and a rising moon – followed two years later (see also Fig.81). In this design we are given a reasonably accurate rendering of Gray's church. This is not the case with the illustration to Stanza v. The idea for this seems to have originated in the pages of his sketchbook of 1813, where, on page 49, there is to be found a tiny composition with a man leaning on a fence under a crescent moon (Fig.78). In a larger drawing of this subject ($5\frac{3}{8} \times 4$ in; Mellon collection) the building has become a church; but for the church and tombs in the final designs Constable for some reason turned to another small sketch (Fig.77), although the church noted in this bore not the slightest resemblance to the church at Stoke Poges.

Fig.

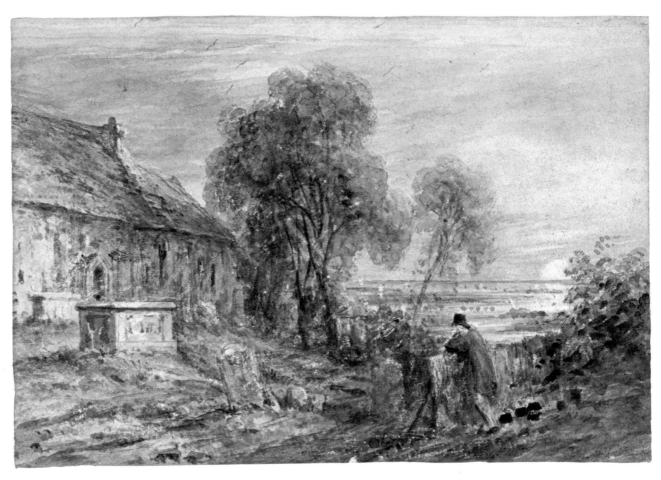

Pl. 45

The breezy call of incense-breathing morn,
The swallow twittering from the straw-built shed,
The cock's shrill clarion or the echoing horn,
No more shall rouse them from their lowly bed.

Thomas Gray (1716–1771) from 'Elegy Written in a Country Churchyard'

Folkestone Harbour Pl.46
Pencil, pen, watercolour, $5 \times 8\frac{1}{4}$ in (12.7 × 21 cm) repr. actual size
Inscr. 'All grey' in sky above stern of nearest boat
London, The Trustees of the British Museum (L.B.30b)

Folkestone Fig.79
Pencil, pen, watercolour, $5\frac{1}{8} \times 8\frac{1}{4}$ in (13 × 21 cm)
Cambridge, Fitzwilliam Museum

Having suffered from the treatment he had received as a boy from a brutal schoolmaster, Constable did not have a very high opinion of schools, and it was therefore with some reluctance that he allowed first his girls, one by one, and then the second boy, Charles, to be sent off to boarding school. The eldest boy, John, he could not bear to part with, but finally he too was allowed to leave home, and in August of this year, 1833, Constable took his two sons to Dr Pearce's school at Folkestone, Charles for his second term, John for his first. In October Constable learnt that the elder boy had injured himself while sleep-walking and immediately hurried down to his bedside. He found his son rather worse than he had expected and so decided to stay on until he felt he was well enough to be left. In all, Constable was there for nearly a fortnight.

During this time he made a dozen or so drawings, mainly of the harbour, foreshore and shipping. It is possible that some of these drawings were done to entertain and even to instruct his sons and their friends. Both his boys were keen draughtsmen. Charles had delighted his family with the drawings he had sent home during his first term, and a paint-box, complete with colours, brushes, crayon and holder, sponge, glasses, etc., had been sent on request for one of his new friends, who had apparently been infected by his enthusiasm for art. On his first stay at Folkestone, when he had brought the boys to school, Constable had presented one of their schoolfellows, a 'Mr Colvile', with one of his drawings (see Fig.81), and in the letters he wrote to John that autumn there are several references to the dispatching of artists' materials and manuals for Colvile.[2] The clear articulation of detail and the lively but elementary colouring to be seen in Pl.45 and in the Fitzwilliam drawing suggest that both were drawn for an audience, possibly even with an audience, a son and a friend or two, actually watching.

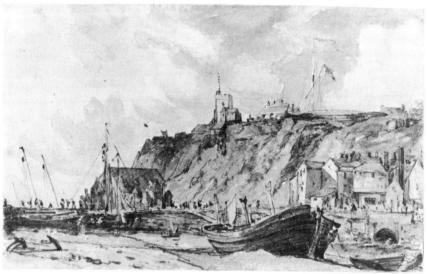

Fig.

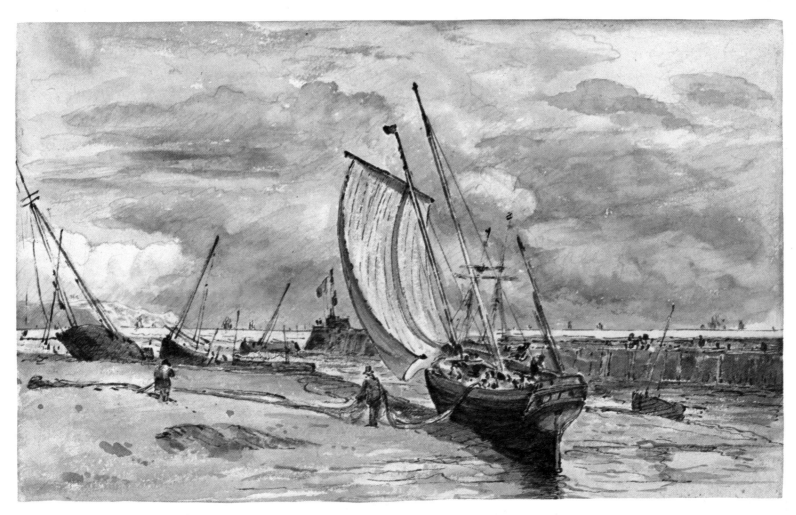

Pl. 46

View on the Stour: Dedham Church in the Distance Pl.47a
Pencil and brown wash, $8 \times 6\frac{5}{8}$ in (20.3 × 16.8 cm)
London, Victoria and Albert Museum (R410)

Trees and a Stretch of Water on the Stour Pl.47b
Pencil and brown wash, $8 \times 6\frac{3}{8}$ in (20.3 × 16.2 cm)
London, Victoria and Albert Museum (R411)

Stormy Landscape Fig.80
Brown wash and white heightening, $4\frac{5}{8} \times 7\frac{1}{4}$ in (11.7 × 18.5 cm)
Drawn on the back of the top part of a letter from the artist to his sister,
Martha Whalley; dated 19 December 1831
Whereabouts unknown

West End of Stoke Poges Church Fig.81
Brown wash, $3 \times 6\frac{1}{4}$ in (7.6 × 15.9 cm)
Inscr. 'July 6'; verso 'The Church of Stoke Pogis – near Windsor / in which
Gray wrote the Elegy / J. Constable R A to / Mr Colvile / Augst 23 / 1833'
Messrs Hazlitt, Gooden & Fox & Co. Ltd

Fig. 8

Fig. 8

Constable used a sheet of thin writing-paper torn in half for the two famous drawings illustrated on the opposite page. The watermark is thus halved: one drawing (Pl.47a) carrying 'GILLING &', the other (Pl.47b), 'ALLFORD 1829'. Writing-paper was also used by Constable for the stormy wooded hillside (Fig.80). If the letter on the other side of this sheet of paper antedates the drawing, as one would suppose, then the latter cannot have been drawn before Constable sat down to write to his sister on 19 December 1831. With the exception of the dated presentation drawing (Fig.81), for none of the other known examples of Constable working in this 'blottesque' manner do we even have a *terminus post quem*.

In a translation of Leonardo da Vinci's *Treatise on Painting*,[1] one of the first books on art that Constable is known to have read, we are told that it was a saying of the author's friend 'Boticello' (who held landscape in contempt) that 'a pallet of colours being thrown against the wall, would leave a stain behind it properly enough representing a landskip'. A few pages later, we are told of 'a new method of assisting the invention', of 'opening the mind'; 'if you look at some old wall covered with dirt, or the odd appearance of some streaked tones, you may discover several things like landskips, battles, clouds, uncommon attitudes, humourous faces, draperies, &c. Out of this confused mass of objects, the mind will be furnished with abundance of designs and subjects, perfectly new.'

It is almost certain that Constable had also read Alexander Cozens' remarkable treatise *A New Method of assisting the Invention in Drawing Original Compositions of Landscape* (*c*.1785).[2] This was the work which made

public a method of stimulating the visual imagination by means of ink-blots, a method which Cozens had employed with some success in his practice as drawing master at Eton. Even if Constable had not read the book, he would doubtless have been acquainted with this blot technique through Cozens' best-known pupil, Sir George Beaumont. In Cozens' method one worked towards recognisable landscape elements, clouds, trees, rocks, etc., from random or partly random blots. In the strictest sense, therefore, the drawings shown here are not really examples of the blot method, as at least two, we know – Pls.47a and b – derive from other works by Constable,[3] and the little Stoke Poges too must have been visualised as a scene in some way before it became a blot; but it is probably also true that all four owe something to Cozens' theories and practise – and perhaps, even beyond, to Leonardo.

Pl. 47a

Pl. 47b

III

North Stoke Pl.48
Pencil, $10\frac{7}{16} \times 14\frac{3}{4}$ in (26.5 × 37.5 cm)
Inscr. 'North Stoke 12 July 1834 Arundel'
London, The Trustees of the British Museum (L.B.13c)

A Farmhouse at Houghton Fig.82
Pencil and watercolour, $5\frac{1}{2} \times 9\frac{1}{4}$ in (14.0 × 23.5 cm)
Inscr. 'North Stoke 12 July 1834 Arundel'
London, Victoria and Albert Museum (R363)

The beauty of West Sussex seems to have come as something of a surprise to Constable when he went down to stay at Arundel in the summer of 1834. His host was a new friend, a brewer and maltster of Arundel, a namesake, George Constable, who has earned the artist's approval some eighteen months before when, a total stranger, he had written to ask for a set of the mezzotints Constable had published, the *English Landscape*. A collector of paintings and drawings, and a keen amateur artist, George Constable had later delighted the artist by giving his eldest son, John Charles, a collection of fossils. In a letter to Leslie of 16 July written from Arundel, Constable tells of further kindnesses: '. . . he has won John's heart by a present (the arrival of which in Charlotte Street I shall much dread) of an electrifying machine.'[1]

It is in a most revealing passage in this same letter to Leslie that we hear how deeply the surrounding landscape, the fertile Arun and its flanking downs and beech woods, had impressed Constable. 'The Castle is the cheif ornament of this place – but all here sinks to insignificance in comparison with the woods, and hills. The woods hang from excessive steeps, and precipices, and the trees are beyond everything beautifull: I never saw such beauty in *natural landscape* before. I wish it may influence what I may do in future, for I have too much preferred the picturesque to the beautifull – which will I hope account for the *broken ruggedness of my style* . . . The meadows are lovely, so is the delightfull river, and the old houses are rich beyond all things of the sort – but the trees above all, but anything is beautifull.'[2] By his exclamation that he had never seen such beauty in natural landscape, Constable probably meant that apparently unaided by the hand of man the countryside thereabouts, with its soft chalk hills and mossy cladding of beeches, had the stately character of parkland, a form of landscape which, perhaps because it was already a work of art, did not normally appeal to him as subject-matter for a painting, but which in this case, because it seemed to be the work of nature, he was finding much to his taste as an artist.

Though tempting, it is probably unwise to seize too eagerly on to his phrase 'broken ruggedness of style', for it is likely that only Leslie would have been able to take its meaning exactly as it was intended. But as it is evident that he felt he had swung too far towards the picturesque, towards broken

Fig. 8

ruggedness, and that it was the beauty of the Arun valley that had brought this home to him, we may not be far off the mark in seeing the two drawings shown here (both drawn on the same day) as illustrative of the two styles – the beautiful (i.e. the Claudian) and the picturesque, or rugged.

On one of their excursions from Arundel, Constable and his host and hostess visited Petworth. Constable had prepared himself with a letter of introduction from Thomas Phillips, the portrait painter, to Lord Egremont, and they were received most courteously, the Earl pressing him to come and stay straight away. Flattered by this show of friendliness, Constable said that he would much like to come, but that he would prefer to be there when their mutual friend Leslie was also a guest. 'Let it be so, then', said Egremont.[3]

South Stoke
12 July N 24 Arundel

Pl. 48

Cathanger, near Petworth Pl.49
Pencil, 8 × 13⁹⁄₁₆ in (20.4 × 34.5 cm)
Inscr. 'Petworth Sepr. 12 1834 – Cat Hanger –'
Private collection

Petworth House from the Park Fig.83
Pencil and watercolour, 8⅛ × 10¾ in (20.7 × 27.2 cm)
London, Victoria and Albert Museum (R372)

Fig.

C.R. Leslie, Constable's closest and most trusted friend in these years, was at Petworth with his wife and family for their annual holiday in August and must have written suggesting that Constable should now take up Lord Egremont's invitation and join him there. This, however, required a letter to the Earl reminding him of his invitation in July, and in his reply to Leslie, Constable told him that he could not bring himself to write such a letter: 'so we must give up the affair and let it stand over, sine die. It is extremely vexing to me but it cannot I fear be helped.'[4] In his next letter Leslie somehow managed to reassure Constable, probably by telling him that there was no need for him to write as he was already expected. On 10 September, therefore, Constable took coach for Sussex.

His apprehensions at the prospect of staying at Petworth cannot have been much allayed by hearing from Leslie that 'To day forty people dine here, most of them magistrates, and the house is as full as it can hold. Among them is the Duke of Richmond. I have just been looking at the table as it is set out in the carved room, covered with magnificent gold and silver plate.'[5] But there was another side to Petworth. All who stayed there seem to have been as struck by the lack of ostentation as they were by the splendour of the hospitality. The Earl himself dressed simply – so much so that on occasion he was mistaken for one of his own plainly-liveried servants – and his carriages exhibited neither arms nor coronet. It seems to have been the rule of the house that guests should feel as at home as they pleased (or almost as they pleased, for in fact a whip could crack pretty smartly around the ears of the socially presumptuous) and the Earl went out of his way to provide Constable with all that he might require, ordering a carriage for his daily use. He had even tried to get Turner down as well but had been told that he was 'off to the North on a bookseller's job.'[6]

Turner, of course, had been a regular guest at Petworth for the past twenty-five years, and had painted many pictures for Egremont. Quite a number of these were of the house and of the park that stretched away to the west as far as the eye could see. It was certainly an unusual experience for Constable, and it may have been a somewhat unsettling one, to have so many of Turner's paintings all around him, paintings some of which were of views that he could see for himself by just glancing out of the windows. It

may be reading too much into the drawing to say that his view of Petworth from beside the lake (Fig.83) is evidence of a certain uneasiness of mind, but whatever the circumstances in which it was drawn, when compared with the marvellous pencil study of the Rother valley at Cathanger (Pl.49) the watercolour is signally lacking in drive and conviction, and it is perhaps not drawing too long a bow after all to suggest that Constable was oppressed rather than stimulated by the presence of the Turners, and that it was not until he got well away from the house and its associations that he was able to work freely and with his accustomed confidence. Leslie was with Constable on his excursions in the Earl's carriage, and tells of his friend's delight in the valley nearby with its mills, barns and farm-houses. It is likely that Constable was referring to the day he made the drawing at Cathanger when he wrote to George Constable at Arundel: 'Yesterday I visited the river banks, which are lovely indeed – Claude nor Ruysdael could not do a thousandth part of what nature here presents.'[7]

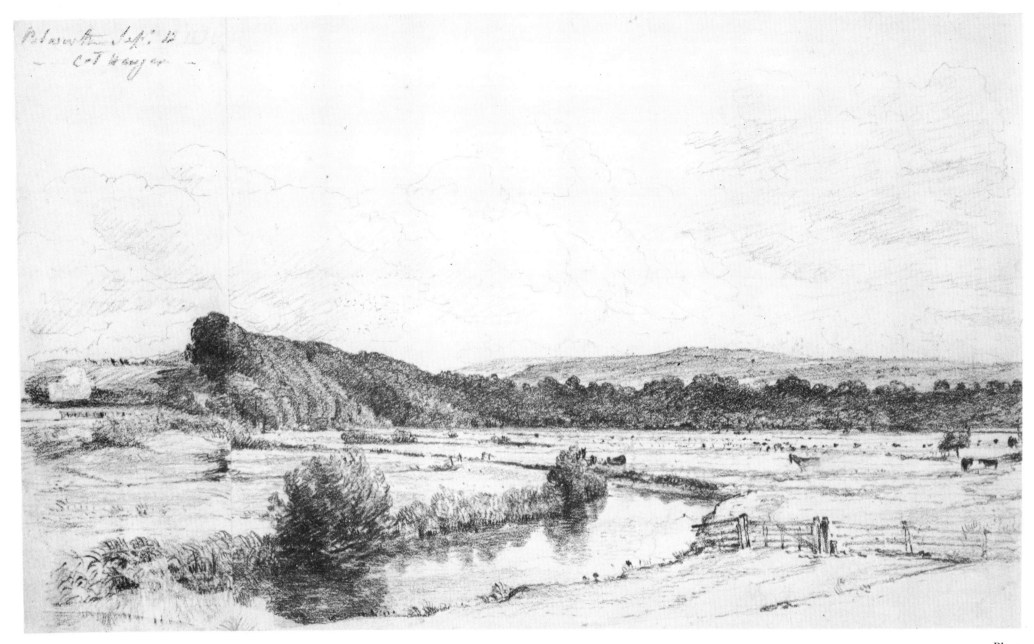

Polworth Sep.? 18
— Cat hanger —

Pl. 49

Arundel Mill and Castle Pl.50
Pencil, $8\frac{5}{8} \times 11$ in $(21.9 \times 28.0$ cm)
Inscr. 'Arundel Castle & Mill', and 'Arundel Mill July 9 1835'
London, Victoria and Albert Museum (R379)

Arundel Castle Fig.84
Pencil and brown wash, $4\frac{1}{2} \times 7\frac{3}{8}$ in $(11.4 \times 18.8$ cm) Page 33 in sketch-book
used in July 1835
Inscr. '19th. July 1835. Arundel – dear Minna's birthday.'
London, Victoria and Albert Museum (R382)

Stormy Effect, Littlehampton Fig.85
Watercolour, $4\frac{7}{16} \times 7\frac{1}{4}$ in $(11.3 \times 18.4$ cm)
Inscr. 'July 8 1835'
London, The Trustees of the British Museum (L.B.18a)

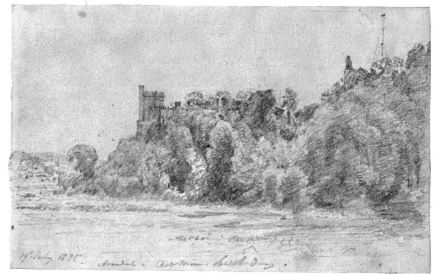

Fig.

In April 1835, the Constables of Arundel wrote to ask whether John Charles could join them on a trip to see their children in France. This the artist had to refuse on his son's behalf as he was attending Michael Faraday's lectures on chemistry. Later Constable received a most pressing invitation to come and stay at Arundel again, with 'as many as you like to bring.' This time he was able to accept. 'My poor boy John and myself are panting for a little fresh air', he said, 'I long to be amongst your *willows* again, in your walks and hangers, among your books of antiquities &c, &c, and to enjoy your society – all as I did before without restraint, coldness & form, which belongs to "no friendship", and "great houses". I am much worn by a long and hard winter's & spring's campaign – though a successful one.'[1]

Feeling that he deserved a holiday, on 7 July Constable caught the coach for Sussex, taking with him his two elder children, John now eighteen years of age and Minna within a few days of her sixteenth birthday. Drawings record a number of the expeditions made during their two weeks' stay. Some of the sketches are swiftly drawn and slight, but on others he was able to work at length with no apparent need for haste. Such a one is the water-colour that he made at Littlehampton, with its over-working and scratching and blotting out (Fig.85), one of two dated studies done on the first day of their visit.

For the future, the most important drawings Constable made during the fortnight were the two illustrated here – Pl.50 & Fig.84 – as it was from these (and possibly from an oil-sketch) that he painted the last of his major pictures, 'Arundel Mill and Castle' (Fig.123), the picture on which he was at work on the last day of his life. The idea for the picture had originated with John Charles; perhaps it was to please his own children that he added the two youngsters in the foreground with their fishing-rod.

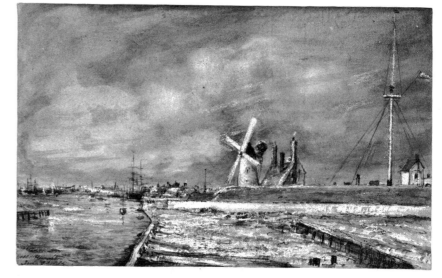

Fig. 8

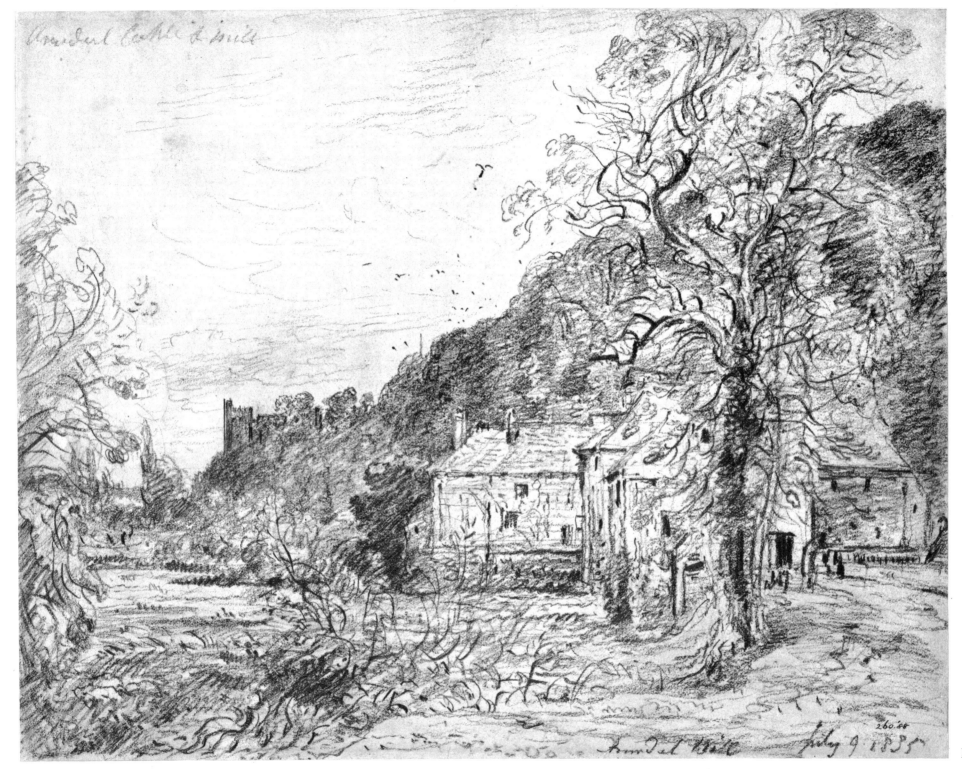

Arundel Castle & mill

Arundel Mill July 9 1835

260.88

Pl. 50

1835

Stonehenge Pl.51
Watercolour, $15\frac{1}{4} \times 23\frac{1}{4}$ in $(38.7 \times 59.1\,\text{cm})$
London, Victoria and Albert Museum (R395)

Stonehenge Fig.86
Pencil and watercolour, $6\frac{5}{8} \times 9\frac{3}{16}$ in $(16.8 \times 23.3\,\text{cm})$
London, Victoria and Albert Museum (R396)

Stonehenge Fig.87
Pencil and watercolour, $6\frac{5}{8} \times 9\frac{13}{16}$ in $(16.8 \times 24.9\,\text{cm})$
London, The Trustees of the British Museum (L.B.22a)

The watercolour of Stonehenge (Pl.51) was exhibited at Somerset House in 1836; together with 'The Cenotaph', the last of his works to be shown in his lifetime. Unlike many of his exhibits, on which he worked right up to the sending-in-day, 'Stonehenge' had been painted several months before.

For some weeks after his return from Arundel in July he was fully occupied with his children: taking Minna to stay with friends and then fetching her back; getting all four of his girls and the two youngest boys off to their schools; sending John off to Paris with the Arundel Constables; and, most difficult and heartrending of all, taking fourteen-year-old Charles to join his first ship at the docks prior to her departure for Bombay, and then bidding his son goodbye. 'Poor Charles hung about me when we left him'; Constable told Leslie, 'He asked if I could keep with the ship 'till next day, but I knew I must then part – so I shook hands – & saw him no more.'[2]

With Charles' departure he was left in a house empty but for Mrs Roberts, the children's nurse. Companionless (Leslie was at Petworth), he turned to his work, and in a sketchbook of 1820 found a subject that suited his mood 'the mysterious monument standing remote on a bare and boundless heath'[3] which he had sketched in company with his now dead friend, John Fisher (see Pl.27). As two of the preliminary studies show (Figs.86 & 87), the great stones in their lonely setting and the double rainbow overhead presented problems. The last was fresh in his mind when he wrote to David Lucas on 6 September about a plate the engraver was working on from his 'Salisbury Cathedral from the Meadows' (Fig.121). 'I wish to talk to you about the rainbow in the large print. If it is not exquisitely done – if it is not tender, and elegant – evanescent and lovely, the highest degree – we are both ruined. I am led to this having been very busy with rainbows – and very happy doing them – by the above rules.'[4] A few days later, on 14 September, in a letter to Leslie full of his sailor son's departure, he reports: 'I have made a beautiful drawing of Stone Henge. I venture to use such an expression to you.'[5]

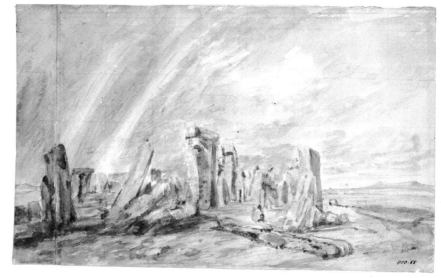

Fig. 8

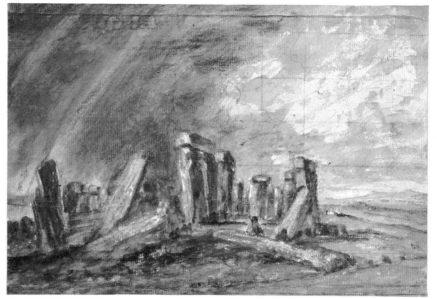

Fig. 8

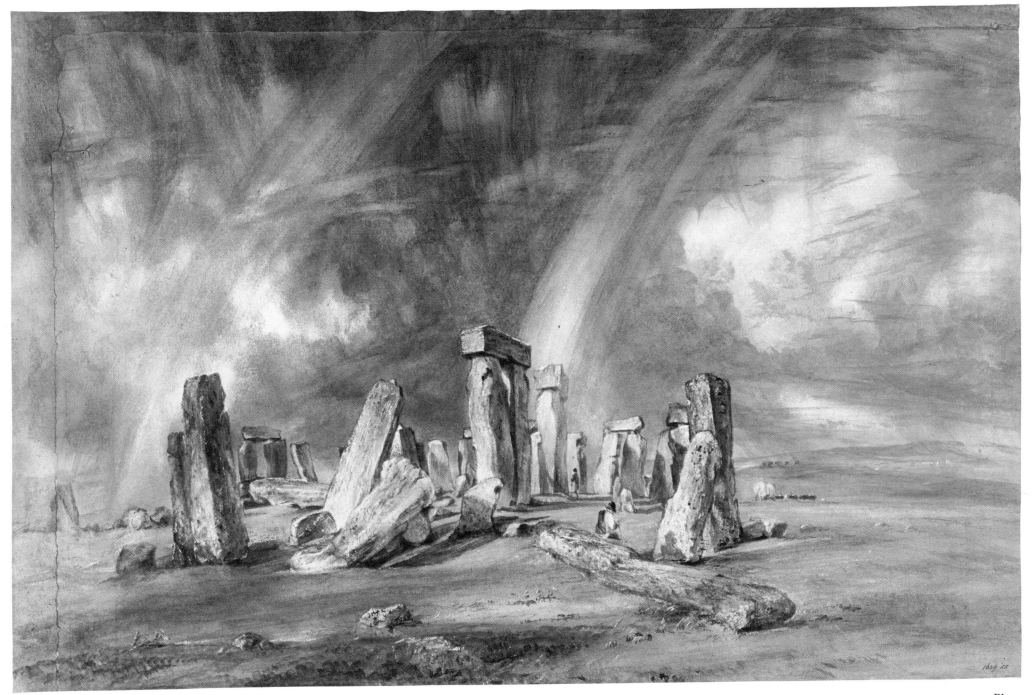

Pl. 51

Figures in Landscape and Details

Dock Leaves Fig.88
Pencil, $3\frac{1}{8} \times 4\frac{1}{2}$ in (8.0 × 11.4 cm). 1814 sketchbook, p.9
London, Victoria and Albert Museum (R132)

A Ploughman with a Team of Horses Fig.89
Pencil, $3\frac{1}{2} \times 4\frac{3}{4}$ in (8.9 × 12.0 cm). 1813 sketchbook, p.71
London, Victoria and Albert Museum (R121)

A Countryman: Teams Harrowing Fig.90
Pencil, $4\frac{5}{8} \times 7\frac{3}{8}$ in (11.7 × 18.7 cm)
London, Victoria and Albert Museum (R182)

Studies of a Sky, a Ploughman, etc Fig.91
Pencil, $3\frac{1}{2} \times 4\frac{3}{4}$ in (8.9 × 12.0 cm). 1813 sketchbook, p.72
London, Victoria and Albert Museum (R121)

Horses and Cart on Hampstead Heath Fig.92
Pencil, $2\frac{5}{8} \times 3\frac{5}{8}$ in (6.7 × 9.2 cm) repr. actual size. 1819 sketchbook, p.2
London, The Trustees of the British Museum (1972–6–17–15)

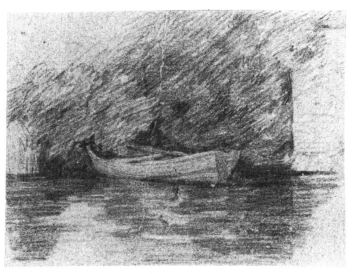

Boat at Flatford Fig.93
Black and white chalk on grey paper, $3\frac{9}{16} \times 4\frac{15}{16}$ in (9.0 × 12.6 cm)
Courtauld Institute of Art (Witt Collection)
The sketch from which the boat in 'The Hay Wain' was
painted (fig.124).

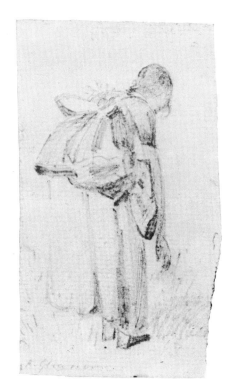

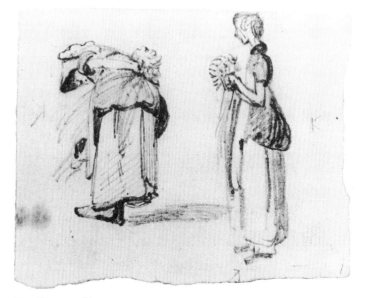

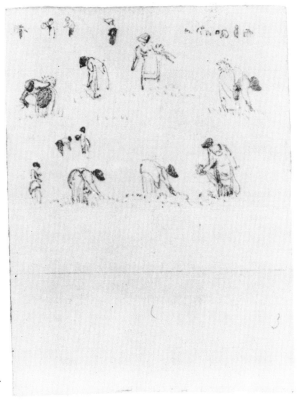

A Gleaner Fig.94
Pencil, $3\frac{3}{4} \times 2\frac{3}{16}$ in (9.5 × 5.6 cm) repr. actual size
Paris, Musée du Louvre (RF 06103)

Two Gleaners Fig.95
Pencil, $3\frac{5}{8} \times 2\frac{15}{16}$ in (9.2 × 7.5 cm) repr. actual size
Inscr. verso, part of a letter to Maria Bicknell(?): '. . . the
Drs not considering You any longer . . .' etc.
Paris, Musée du Louvre (RF 06099)

Gleaners Fig.96
Pencil, 4 × 3 in (10.1 × 7.7 cm) repr. actual size
Paris, Musée du Louvre (RF 06101)

Charles, Alfred & Lionel Constable

Figs.97–102, are the property of the Executors of Lt. Col. J. H. Constable

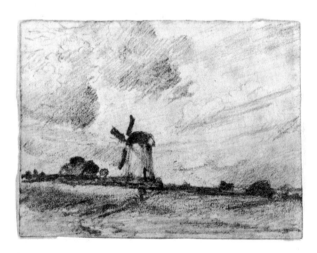

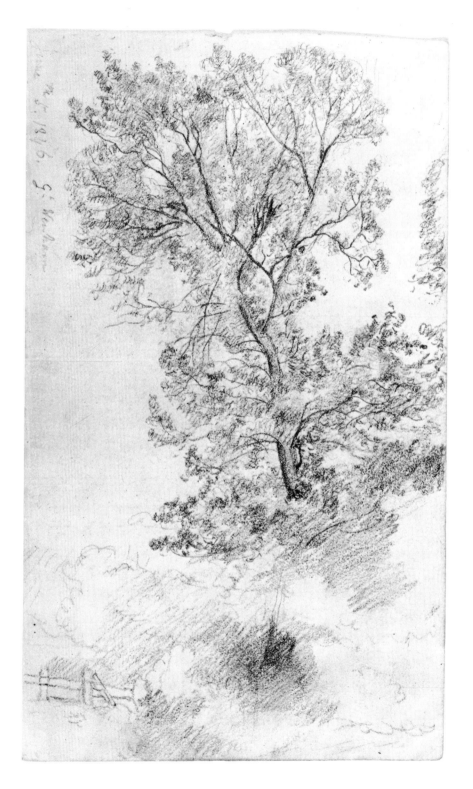

Lionel Bicknell Constable (1828–1887)
A Windmill Fig.98
Pencil, $2\frac{1}{8} \times 3$ in (5.4×7.6 cm) repr. actual size
Inscr. verso 'I did this on the spot as it is like that kind of
Mill' etc.

Alfred Abram Constable (1826–1853)
A Tree at Great Wenham Fig.97
Pencil, $9\frac{1}{16} \times 5\frac{7}{16}$ in (23.0×13.8 cm)
Inscr. 'June th 5.1846. Gt. Wenham'

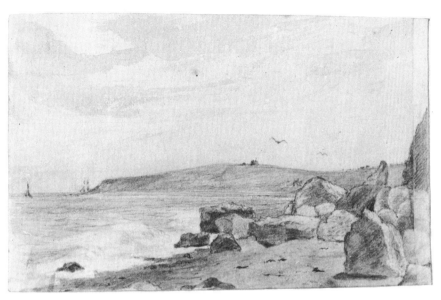

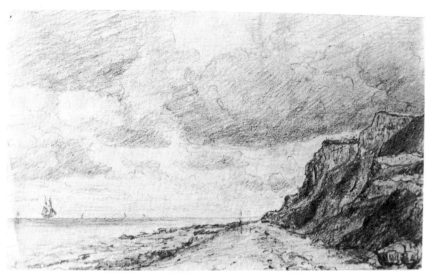

Charles Golding Constable (1821–1879) **A Rocky Shore** Fig. 99
Pencil and watercolour, $4\frac{9}{16} \times 7\frac{3}{16}$ in (11.6 × 18.2 cm) Inscr. verso 'C.G.C.'

Alfred Abram Constable **The Beach at Walton** Fig. 100
Pencil, $5\frac{1}{2} \times 9$ in (14.0 × 22.9 cm) Inscr. verso 'Alfred Walton 1845'

Lionel Bicknell Constable **A Lane Among Trees** Fig. 101
Pencil, $4\frac{5}{8} \times 5\frac{1}{4}$ in (11.7 × 13.3 cm) Inscr. 'Aug 1846'

Lionel Bicknell Constable **A Harvest Field** Fig. 102
Pencil, $4\frac{5}{8} \times 6\frac{3}{8}$ in (11.7 × 16.2 cm) Inscr. ['July' del.] 'Augt. 1846'

123

Early Friends

J.T. Smith (1766–1833)
Near Deptford, Kent Fig.103
Drawing for etching so titled in Smith's *Remarks on Rural Scenery*, 1797
Pen and wash, $4\frac{1}{4} \times 5\frac{1}{2}$ in (10.8 × 14.0 cm)
Coll. Dudley Snelgrove, Esq.

Fig. 103

Fig. 1

Sir George Beaumont, Bt. (1753–1827)
One House Fig.104
Pencil and wash, $6\frac{9}{16} \times 9$ in (16.7 × 22.8 cm)
Inscr. 'One house Monday June 28th 1790'
Private collection

Dr William Crotch (1775–1847)
Anatomy of a Tree Fig.105
Pencil, pen and ink
Inscr. 'Drawing remarks/1 Angles & lines/2 ['sub' del.] divisions/ 3 Subdivisions/4 Rotundity of ['Divisions' del.] ye whole/5 Do of ['Subd' del.] Divisions/6 Do of ye Subd[ivisio]ns./7 The Skeleton – Trunk[7] limbs[8] branches[9] boughs[10] & fibres[11]–& their characters in diff[eren]t trees.' etc
Page from sketchbook inscr. 'Holywell 1803', p.100.
Norfolk Records Office (MS11073)

Fig. 10

124

George Frost (1745–1821)
Shipping on the Orwell at Ipswich Fig.106
Watercolour, $7\frac{1}{2} \times 11\frac{7}{8}$ in (19.0 × 30.2 cm)
Coll. Stanhope Shelton, Esq.

George Frost
Woodland Path Fig.107
Chalk, $10\frac{1}{4} \times 13\frac{1}{4}$ in (26.0 × 33.7 cm)
Coll. Stanhope Shelton, Esq.

Fig. 106

Fig. 107

Fig. 108

Thomas Stothard R.A. (1755–1834) **Farms in a Wooded Landscape** Fig. 108 Pencil and watercolour $3\frac{7}{8} \times 9$ in (9.8 × 22.9 cm) *Coll. Andrew Wyld, Esq.*

Paintings by Constable mentioned in the text

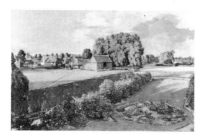

The Flower Garden of Golding Constable's House
Fig.109
$12\frac{1}{2} \times 19\frac{1}{2}$ in
Ipswich, Christchurch Mansion

The Dell in Helmingham Park Fig.110
$44\frac{5}{8} \times 51\frac{1}{2}$ in
Kansas City, Nelson Gallery Atkins Museum (Nelson Fund)

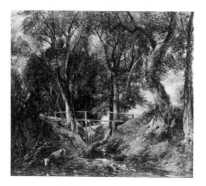

Landscape: Boys Fishing Fig.111
$40 \times 49\frac{1}{2}$ in
Anglesey Abbey, National Trust, Fairhaven Collection

Landscape: Ploughing Scene in Suffolk Fig.112
$20\frac{1}{4} \times 30\frac{1}{4}$ in
Private collection

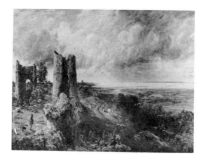

Hadleigh Castle Fig.113
$48 \times 64\frac{3}{4}$ in
From the collection of Mr and Mrs Paul Mellon

The White Horse Fig.114
$51\frac{3}{8} \times 74\frac{1}{2}$ in
New York, Frick collection

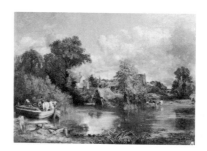

View on the Stour near Dedham Fig.115
51×74 in
San Marino, Henry E. Huntington Library and Art Gallery

Stour Valley and Dedham Village Fig.116
$21\frac{3}{4} \times 30\frac{3}{4}$ in
Boston, Museum of Fine Arts

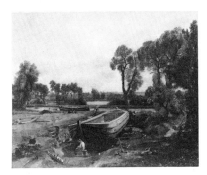

Boatbuilding near Flatford Mill Fig.117
20 × 24¼ in
London, Victoria and Albert Museum

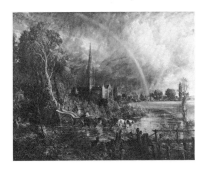

Salisbury Cathedral from the Meadows Fig.121
59¾ × 74¾ in
Lord Ashton of Hyde

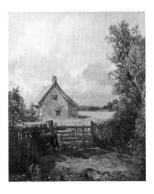

The Cottage in a Cornfield Fig.118
24½ × 20½ in
London, Victoria and Albert Museum

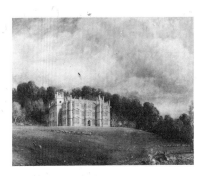

Englefield House Fig.122
40½ × 51¾ in
The Property of the Benyon Trustees

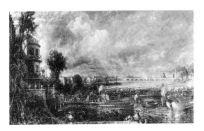

Waterloo Bridge from Whitehall Stairs, June 18th, 1817 Fig.119
53 × 86½ in
Private collection

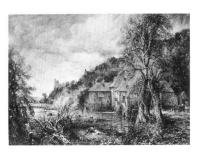

Arundel Mill and Castle Fig. 123
28⅝ × 39⅝ in
Toledo, Ohio, The Toledo Museum of Art

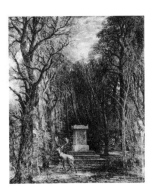

The Cenotaph Fig.120
52 × 42¾ in
London, National Gallery

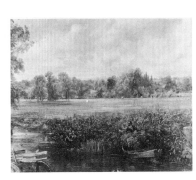

The Hay Wain, Detail Fig.124
London, National Gallery

127

NOTES

1795
[1] For Constable and Beaumont, see JC: FDC, pp.142–9.

1796
[1] For the Edmonton Circle, see ibid. pp.195–9.
[2] JCC II, p.5.
[3] Ibid. p.246.

1798
[1] Private collection.

1800
[1] Leslie, 1951, p.11.
[2] See *Henry Fuseli*, Tate Gallery, 1975, Nos.199 and 200.

1801
[1] See JC: FDC, pp.70–72.

1802
[1] For the view looking upstream, see Museum of Art, Rhode Island School of Design, *Selection II: British Watercolors and Drawings from the Museum's Collection*, No.60, 'An Extensive Landscape with a River'; for Fisher's drawing, see JCC VI, p.247.

1803
[1] Photograph in Witt Library.

1804
[1] Executors of Lt. Col. J. H. Constable

c.1805
[1] JCC II, p.16.

1805
[1] Farington Diary, 9 February 1804.
[2] Ibid. 1 June 1805.

1806
[1] Leslie, 1951, p.5.
[2] *Watercolours by Thomas Girtin*, Whitworth Art Gallery, 1975, No.22, 'The Tithe Barn, Abbotsbury, Dorset' (Leeds City Art Galleries) Pl.10.
[3] Leslie, 1951, p.18.
[4] JCC II, p.127.
[5] Ibid. p.129

1811
[1] Leslie, 1951, p.25.
[2] JCC I, p.56.
[3] MS. ibid. p.57.
[4] JCC II, p.48.
[5] Leslie, 1951, p.310.
[6] MS. JCC II, p.55.

[7] Ibid. p.53.
[8] MS. JCC IV, p.31.
[9] MS. JCC II, p.56.

1812
[1] MS. ibid. p.72.
[2] Leslie, 1951, p.32.

c.1812
[1] MS. JCC II, p.78.
[2] MS. ibid. p.81

1814
[1] Ibid. p.127.
[2] MS. ibid. p.133.
[3] MS. ibid. p.78.
[4] MS. ibid. p.132.

1815
[1] MS. JCC I, p.36
[2] See *Constable, the Art of Nature*, Tate Gallery, 1971, No.78.

1816
[1] MS. JCC VI, p.29.

1817
[1] MS. JCC II, p.304
[2] See Graham Reynolds, 'A Constable Discovery', *Country Life*, 1 November 1956.

1818
[1] The letter from Constable to Maria of 7 July 1817 is so addressed; JCC II, p.226.
[2] Identified by Reg Gadney; see *John Constable R.A.: the drawings and water-colours in the Fitzwilliam Museum, Cambridge*, compiled for the Architecture and Fine Arts Tripos, University of Cambridge; 1966, on deposit at the Fitzwilliam Museum.
[3] Coll. Mr. and Mrs. Paul Mellon.
[4] MS. JCC II, p.238.

1818 and 1819
[1] JCC II, p.9
[2] MS. JCC VI, pp.35–6.
[3] Ibid. p.229.
[4] JCC II, p.250.

1819
[1] Leslie, 1951, p.5.
[2] JCC II, p.254.

c.1819
[1] MS. ibid. p.225.
[2] JCC VI, p.45.
[3] Farington Diary, ed. J. Greig, 1928, Vol.VIII, p.225.

1820
[1] MS. JCC VI, p.46.
[2] Ibid. p.56.

[3] JCC IV, p.62.
[4] JCC VI, p.56
[5] Leslie, 1951, p.280.

1821
[1] MS. JCC VI, p.64.
[2] Ibid. p.71.
[3] Leslie, 1951, p.84
[4] JCC VI, p.77.
[5] MS. JCC II, p.272.

1823
[1] Leslie, 1951, p.328.
[2] Ibid. p.282.
[3] MS. JCC II, p.290.
[4] MS. ibid. p.296.
[5] JCC VI, p.143.
[6] *The Farington Diary*, ed. J. Greig, 1927, Vol.VII, p.127.
[7] JCC V, p.32.

1824
[1] JCC VI, p.171.
[2] R263.
[3] Private collection.
[4] *Catalogue of the Constable Collection in the Victoria and Albert Museum*, 1973, p.175.
[5] Leslie, 1843, p.51.
[6] Graham Reynolds, *Catalogue of the Constable Collection in the Victoria and Albert Museum*, 1973, p.177.
[7] MS. JCC VI, p.180.
[8] Ibid. p.181.
[9] Ibid. pp.184 and 187.
[10] Ibid. p.190.

1825
[1] MS. JCC II, p.297.
[2] JCC VI, p.71.
[3] Ibid. pp.149–50.
[4] London, National Gallery, 58.
[5] See M. Röthlisberger, 'Constable after Claude', *Master Drawings*, Vol.7, No.4, 1969, p.426.
[6] See Anthony Blunt, *The French Drawings in the Collection of His Majesty the King at Windsor Castle*, 1945, No.51, Pl.80. Lewis' engraving, dated 12 January 1809, is Pl.XLIV in J. Chamberlaine, *Original Designs of the Most Celebrated Masters… in His Majesty's Collection*, 1812.

1826
[1] JCC IV, p.138.

1827
[1] JCC II, pp.439–44.
[2] Sir George Beaumont's comment on the

boy intently watching his fishing-line in 'Stratford Mill'; see Leslie, 1951, p.77.

1829
[1] Colls. Mr. and Mrs. Paul Mellon; Port Sunlight, Lady Lever Art Gallery. All three drawings are illustrated in Selby Whittingham, *Constable and Turner at Salisbury*, 1973, Figs.34, 35 and 36.

1830 and 1831
[1] JCC VI, p.231.
[2] Leslie, 1951, p.282.
[3] Executors of Lt. Col. J. H. Constable.

1832
[1] For Lane and De Beauvoir, see JCC IV, pp.107–17.
[2] 1971-1-23-1.
[3] JCC V, p.88.

1833
[1] *A Select collection of EPITAPHS and monumental inscriptions with anecdotes of distinguished and extraordinary persons*, Ipswich, printed and sold by J. Raw, 1806.
[2] JCC V, p.171; JC: FDC, pp.86, 91 and 94.

c.1833
[1] *A Treatise on Painting by Leonardo da Vinci…a New Edition*, 1796; see JCC II, p.5.
[2] See JC: FDC, p.29.
[3] Graham Reynolds, 'Constable at Work', *Apollo*, July 1972, pp.12–19.

1834
[1] JCC III, p.111.
[2] Ibid. pp.111–2.
[3] loc. cit.
[4] Ibid. p.114.
[5] Ibid. p.117.
[6] JCC IV, p.419.
[7] JCC V, p.19.

1835
[1] Ibid. p.23.
[2] JCC III, p.130–31.
[3] 'The mysterious monument of Stonehenge, standing remote on a bare and boundless heath, as much unconnected with the events of past ages as it is with the uses of the present, carries you back beyond all historical records into the obscurity of a totally unknown period'. This quotation is written in a formal hand on the mount of the exhibited watercolour (R395), and was also printed in the Academy catalogue.
[4] JCC IV, p.421.
[5] JCC III, p.131.